EROTIC ART TODAY

EROTIC ART TODAY

Volker Kahmen

New York Graphic Society Ltd.
Greenwich, Connecticut

English translation by Peter Newmark
Editorial assistance on the English-language edition
by Jacqueline Lambe and Vivienne Menkes

Standard Book Number 8212-0430-0

Library of Congress Catalog Card Number 72-181340

English translation © Studio Vista Publishers 1972

First published in Great Britain 1972 by Studio Vista Publishers
Blue Star House, Highgate Hill, London N19
First published in the United States of America
by New York Graphic Society Ltd., Greenwich, Connecticut
Translated from the work published by Verlag Ernst Wasmuth
under the title *Erotik in der Kunst*
© 1971 Volker Kahmen

Set in 270-12-13 (Bembo)
Printed and bound by Passavia Passau
Printed in Western Germany

CONTENTS

INTRODUCTION

I should say straightaway that this book is not simply a catalogue of erotic pictures. I want to examine to what extent eroticism has penetrated the visual arts, whether it is sublimated in the theme, or in the medium used or in the technique; or whether it may even be negated when it is expressed as art and so lose its capacity to arouse.

Definition of eroticism

What then is eroticism? It is defined in a German *Encyclopaedia of sexual research*[1] as 'the aesthetic elements which can restrict or modify our total experience of sexual or sensual desire. Eroticism corresponds to the sex drive in the way that appetite corresponds to hunger ... It indicates the measure of freedom that a person has acquired, the extent of his intellectual control over his instinctive and emotional experiences.' Sexuality merely denotes the physical functions of the sex organs, while eroticism refers to the sensual impulses which are at work in the mind. For this reason the term 'sexual', which refers to basic physical reactions, should not be used in connection with works of art; 'erotic' on the other hand refers to the creation of a work of art from an initial sexual impulse, however concealed this initial impulse may be.

Definition of the field of erotic art

If we admit the existence of erotic art, we must be prepared to admit the possibility of non-erotic art, and we must consider what is lost in non-erotic art.

The vital impulse in all great art can always be traced to the sensual, and this is especially true of the visual arts. A sensual impulse drives the artist to work, urging him to achieve his best: his reward is originality. And yet the creative process is an intellectual one, even if the artist is unable to perceive this in the fervour of creation: what he portrays changes as he attempts to define it, and the change seems almost

7

to be caused by the intervention of his intellect. Artistic creation gives concrete, objective form to the primary sensual impulse released by the artist's creative urge.

If, however, an artist concentrates on sexual experience, his efforts may be wasted in the trivial stimulation of the sex drive; this is erotic art at its most banal, and since it is unsuitable for any particular form it soon degenerates into pornography. Alternatively, the original motivation of a work may be neutralized or it may remain as a zone of erotic tension beneath the threshold of consciousness. In the creative output of every artist there are works that have an erotic effect, regardless of whether or not a sexual impulse is apparent. Moreover we must remember that even when a work of art is regarded as erotic, in the sense of sensually exciting, different people will have different and perhaps even contradictory reactions to it; one person will be stimulated by something that leaves another person cold. Individual reactions to art must remain personal – and this is particularly true of erotic art, because the various possible reactions to eroticism have not as yet been codified by social convention. For this reason I have not limited my study of erotic art to works with specifically erotic themes.

In the work of almost all painters there are specifically erotic works. These are very often intimate drawings, which are carefully preserved as private property – either by the artist, who does not want them to circulate among art dealers, or by collectors. The artist painted the picture because he had to: for him it is an expression of his most intimate fantasies, his desires, his lust. In the visual arts these pictures generally represent the most personal statement the artist has ever made. Moreover the integrity of erotic art becomes suspect as soon as it tries to be commercial, for then it adapts itself to a social need – this is an elevated form of titillation which is naturally a great commercial success.

Stylistic devices

I shall now attempt to describe the areas in which erotic art can express itself. In the visual arts we can distinguish four stylistic devices which are rarely used on their own but are often interrelated, and we shall see that all of these devices are used to express eroticism.

The first device is the symbol. This is a sign which always replaces a word concept, expressing an idea which is known to be behind the visual appearance.

The second device is the deceptive likeness. This device attempts to introduce external reality into the picture. At the same time the composition of the picture has an intrinsic value – whereas if we try to reinterpret the picture, we can only concentrate on one single idea.

8

The third device is the association. This involves certain social references, but it is largely based on feelings and impressions shared by the artist and the person who is looking at his picture.

The fourth device is the image. It is an object which derives its artistic value from the way it is presented in a work of art. However this distinction is debatable, for the symbol and the deceptive likeness also seem to have intrinsic artistic value.

The social significance of erotic art

Eroticism is not only a measure of individual freedom but also of social freedom. 'The most extravagant and unacceptable sexual images can to some extent be socialized, if given artistic form, so that even if they are not exactly suitable for the home they are at least presentable. In the long run this may be beneficial to the individual and to society.'[2] However, society reacts to the possibility of freedom being achieved in this way by suppressing erotic art; it then motivates its aggression with moral, religious or sociological scruples. In order to make these new restrictions seem convincing it is explained that society had previously been deceived with false social values. Artists however do not take kindly to regulations and supervision; erotic art has always existed – if not officially tolerated, then it has been concealed. Art has even succeeded in outwitting those who wanted to suppress it; in the Middle Ages for instance 'ironically enough, it took refuge in the territory of its persecutors and expressed itself in religious themes – more sensually than ever before.'[3]

When a work of art gives offence to the public, this is usually only because it was produced at the wrong moment, for the impression that a work makes depends on when it is written. Moreover society's hostility disappears as time passes, so that the work is merely regarded as a work of art, until finally it is established as an object of cultural value. 'Every art scandal – for instance the famous public outcry over Manet's *Déjeuner sur l'herbe* – dies down as soon as the work loses its ability to provoke public hostility. People simply have to get used to it first. Manet's *Olympia* has not in any way become less indecent, but because it has been endlessly reproduced on postcards and in art books it has finally been accepted by even the simplest minds. Today, if anyone tried to draw attention to the explicitly obscene character of this painting, he would most probably be rejected by the philistines themselves, as a philistine.'[4]

Sensuality and hedonism in art

It is very interesting to study the social reactions to erotic art and to discuss the motivation of the artist, but it would be a mistake to regard works of art as mere 'psychograms of their creators' impulses and instincts' (Gorsen). Indeed a work of art must not merely express a sublimated need for the trivial.

In 1908, in an essay entitled *The natural history of art*,[5] Eduard Fuchs asserted that art is above all the 'creative imitation of the sensual'. 'The principle, the fire, the element, in a word the essence of art is sensuality. For art is sensuality, sensuality in its most potent form. Art is sensuality expressed in form, sensuality expressed in visual terms, the highest and most noble form of sensuality.'[6] The artistic treatment of erotic themes should accordingly contain the highest possible degree of climax, for 'eroticism is sensuality in action, sensuality carried to its logical conclusion'.[7] Fuchs maintained that 'erotic motifs have a sensual effect on the observer when expressed in a work of art'. He thought that this sensual effect was 'one of the most important criteria of the quality of erotic motifs; the more intense the effect, the greater its artistic quality'.[8]

The criterion here is the intensity of sensual experience. But if pleasure is to be a measure of artistic merit, this means that ideals are no longer relevant to art. 'A hedonistic attitude to art always gives greater weight to the spectator's experience of happiness than to the permanent, cultural value of a work as an exhibit. A work's suitability as a museum piece is not so important as the problem of artistic enjoyment in a consumer society, a problem which art historians have neglected up to now … The sensuality of the spectator who needs art and consumes art – for this is how the consumer society conditions the masses – is in complete contrast to the remote aestheticism of the cultured man, of spiritual Christian tradition, who was both protected from and deprived of a sensual abandonment to hedonism.'[9] (Gorsen.) However Gorsen also defined the danger of the hedonistic principle: 'It may appear that complete personal happiness has been achieved, and yet this impression is in a sense false, because hedonism cannot conceive of a happiness outside itself, greater than itself.'[10]

The purpose of this book is to examine works of art in relation to their erotic content. I do not propose to adopt blindly a progressive, hedonistic attitude, any more than a traditional, idealistic attitude. Neither shall I confine myself to an objective study of art: my study will be subjective and intuitive, and I shall make qualitative judgements. My clearly defined aim is to show the degree of truth hidden in a work of art, even if it is rooted in eroticism – and in many cases it is precisely because it is rooted in eroticism that a work of art contains truth.

SYMBOLS

Freud's analysis of dream symbolism

In his *Introductory lectures on psycho-analysis* Freud discusses dream symbolism and he examines the relationship between the 'manifest dream' and the 'latent dream-thought'. He says that distortion in dreams is caused by 'a censorship, directed against the unacceptable, unconscious wish-impulses'.[11] But there are also other causes of distortion in dreams: sometimes association in dreams fails altogether, with the result that there are 'constant translations' for a number of dream-elements. Freud says 'We call a constant relation of this kind between a dream-element and its translation a *symbolic* one, and the dream-element itself a *symbol* of the unconscious dream-thought.'[12] He distinguishes four possible relations between dream-elements and the thoughts underlying them: substitution of the part for the whole; allusion; imagery; symbolism. It is interesting to see that this grouping corresponds, in reverse order, to the stylistic devices analysed in the introduction. According to Freud 'The symbolic relation is essentially that of a comparison, but not any kind of comparison. We must suspect that this comparison is subject to particular conditions, although we cannot say what these conditions are.'[13]

Freud maintains that 'the dreamer has at his command a symbolic mode of expression of which he knows nothing, and does not even recognize, in his waking life ... We can only say that the dreamer's knowledge of symbolism is unconscious and belongs to his unconscious mental life.'[14] He goes on to examine some of the symbols which occur in dreams, showing how the majority of these symbols are sexual symbols. This analysis of dream symbolism is derived from Freud's study of fairy tales, myths and speech usage. He says 'We get the impression that here we have to do with an ancient but obsolete mode of expression, of which different fragments have survived in different fields'.[15]

Conscious symbolism

Freud defined the symbol as a comparison, and he later enlarged on this definition: 'comparisons between different objects, in virtue of which one idea can constantly be substituted for another'.[16] However this definition can also be applied to the deliberate, conscious use of symbols. For example, Christian theology regards the cross in the first instance as an image of Christ's passion and then in a more general sense as an image of Christ. Similarly, the fish as Christ's symbol is derived from a biblical reference (Matthew 4: 19). The subtlety of Christian symbolism reached its highest point in the medieval art of the fifteenth century, when theologians presented painters with a carefully contrived programme – so that they never portrayed an object without giving it a symbolic reference.

It is also interesting to see how conscious symbols and unconscious symbols were frequently used together. For example, the candle, an allusion to Christ as the Light of Life, standing in the candle holder, was also an allusion to Jesus in Mary's womb.

Symbolism as a means of artistic expression

When artists have wanted to say more with a picture than can be conveyed by mere picture-making, they have always had recourse to an intellectual superstructure. In medieval Christianity this superstructure became rooted in a symbolic theological language. The Baroque produced the allegory, a pictorial representation of abstract concepts with significant expression concealed in personification. On the other hand nature symbolism, which permeates the works of the Romantics, is full of atmosphere: the landscape is filled with pantheistic exultation, which gives it an elevated metaphysical quality and contrasts with any kind of naturalism. Finally there is Surrealism which refers back to Freud, the dream and the Unconscious. André Breton produced the following formula: 'Surrealism is based on the belief in the superior reality of certain forms of association heretofore neglected, in the omnipotence of the dream, and in the disinterested play of thought.'[17] It is obvious, from the Surrealists' devotion to 'psychic automatism', from their surrender to the dictates of the unconscious mind, that they felt impelled to use symbols – particularly those symbols which had already been interpreted in Freudian terms.

Symbolic art remains predominantly tied to the representation of objects. Thus, if we are looking for sexual symbols in works of art, a major part of twentieth century art is at once excluded. Surrealism is however a promising source, and also possibly Pop art which often recalls Surrealism. Freud discovered that 'An overwhelming majority of symbols in dreams are sexual symbols. A curious dispropor-

tion arises thus, for the matters dealt with are few in number, whereas the symbols for them are extraordinarily numerous, so that each of these few things can be expressed by many symbols practically equivalent.'[18] And this rule also applies to symbolism in art – in fact there are really only two objects: firstly the male and female sexual organs and secondly their union in the sexual act.

Sexual symbolism in art

I defined a symbol as a sign which replaces a word concept, and if we examine individual works of art we will be able to see how different artists make use of symbols; we will also find certain symbols recurring in the work of different artists.

In a 1948 gouache *La folle du logis* (colour ill. I) Magritte shows a burning candle in a bird's nest surrounded by three eggs. The candle and the eggs are the same colour. The title is obviously emphasizing a connection and bringing it to the attention of the conscious mind. But how can we understand this properly? We could compare it with a symbolic caricature of the mania for flagellation which was very common at the end of the eighteenth century;[19] in this caricature there is a wall candle-holder on which 'male potency flames' with the penis as candle. Magritte, unlike the caricaturist, avoids explicitness: his 'inspired thought' indicates a relationship but at the same time leaves it in the balance. The nest which alludes to female security not only shelters the eggs, but also shelters something which is unrelated but relevant. The fact that there are three eggs makes it harder to understand the picture, until we realize that, according to Freud, the sacred number three is an old symbol for the male genitals.[20] The eggs are the connecting link in this picture, for they explain the significance of both the nest and the burning candle.

Paul Delvaux illuminates *The girls at the water's edge (Les filles au bord de l'eau)* 1966 (ill. 1) with three burning lamps. In the foreground of the picture three girls are posing in the wings of a stage; the stage opens onto the water, with a hilly landscape behind it. Freud tells us that water signifies birth,[21] while the numerous mirrors signify virginity. The girls stand on the river bank, practising alluring poses, in a mood of expectation. They have opened the doors wide and the lamps are burning brightly. According to Freud, the room can be interpreted as a womb, with the doors as the orifices of the sexual organs.[22] When looking at this picture we should remember the parable of the wise and foolish virgins (Matthew 25:1 ff.) Only those virgins who have provided enough oil for themselves can have a wedding, for their lamps will not go out. The bridegroom lets them in, but behind them 'the door was shut'.

Roses

A few sketches of roses which Magritte made in 1940 show how carefully he investigated the symbol content of a single object. Freud said that blossoms and flowers, indicate the female sex organ and virginity.[23] If the rose loses its petals (ill. 3) this can only mean loss of virginity. The abandoned bird cage (ill. 2) shows the same thing:[24] the prisoner has fled, the rose has been broken, blood is trickling down. Tetsumi Kudo's bird cage in *For your living-room* 1965 (ill. 7), a cruder paraphrase of this idea, has an evocative sub-title: *For nostalgic purpose*. We are tempted to enlarge on this – homesickness for lost innocence, homesickness for a more poetic realization. The broken rose crops up again and there are three sticky phallus shapes locked in the cage; one of them has pierced straight through the ring and is now rocking itself inside the ring.

Another Magritte drawing (ill. 4) shows a rose pierced by a dagger. Below he shows, as though by way of explanation, two functions and the relationships initiated by these functions. On the left we see the cutting power of the knife as it penetrates the foreign matter and sticks in it, while on the right the rose is identified with a young girl. The drawing of the rose pierced by a dagger symbolizes nothing other than the sexual act. In a revised version which he called *The blow through the heart (Le coup au coeur)* 1945 the unequivocal meaning of the drawing is poetically transfigured. The same dagger is here an oversize thorn which grows out of a bush, next to a sumptuous rose in full bloom.[25]

The last Magritte drawings (ill. 5) show the rose in the night sky as a comet with a long tail, while above is a rose growing from the head of a swaying key. Freud says that the key (which opens up the room, which is a female symbol) is a male symbol.[26] There is also an allusion to another function of the penis, that of erection, for the key is flying through the air and the path of the comet illustrates the movement of erection.[27] It is the 'inspired thought' which here too dissociates the essential meaning from naïve symbolism: the key does not open up the rose but the poetic meaning of the picture conveys this idea. Later, in 1965, Magritte wanted, as he put it, to play a trick on those who love the symbol. He therefore put a key upright in a keyhole but distorted the relative sizes of the objects. Since he had managed to avoid the symbol relationship by suspending it in an ironical manner, the key became again what it had originally been: the 'absolute thought' indicated in the picture.[28]

And in Bruno Goller's *Girl with a rose (Mädchen mit Rose)* 1970 (ill. 6) a rose is also a symbol. Goller, unlike Magritte, is using symbols unconsciously but their meaning is nevertheless perfectly clear. A young girl is stretched out coquettishly with her left arm bent so that it supports her sinking body. A twisted towel stands erect: leaving the pubic hair exposed, it frames the tensed, youthful body challen-

14

gingly as if it wanted to possess it. It looks as though it was the towel which led the attack and first made the body subside. The proceedings now move to a second picture level – as though the whole process were reflected in a mirror. A flesh-coloured rose occupies the foreground: it stands on its own, overlapping the oval edge of the mirror. The part of the girl's body that cannot be seen, but which is the focus of the whole picture, is represented in the symbol of the rose. Even the row of ornaments in the lower half of the picture, which almost seem to belong to the frame of the mirror, allude to the female sexual organ – for there are squashed concentric rings with convoluted shapes on either side.

Keys

Artists are often motivated by an unconscious feeling for symbolism. Fernand Léger described the genesis of *The Mona Lisa with keys (La Joconde aux clés)* 1930 (ill. 8). 'One day I put my bunch of keys on the canvas. I didn't know what to put next to them.' Later he saw a postcard of the Mona Lisa in a shop window. 'I realized at once that this was what I needed. What could have provided a sharper contrast to my keys? And so I put the Mona Lisa on my canvas.'[29] As well as the decorative accessories, there is a sardine tin and also a massive ring dominating the picture which seems to absorb the central ring of the bunch of keys. It is certain that Léger was not intending to paint symbolic objects, and yet they are there. He realized at once that this was what he wanted. In fact he was particularly fond of this picture: 'It is a picture which I like looking at and I shan't sell it.'

In *Exile* 1962 (ill. 9) Robert Rauschenberg has two keys fastened together by a chain, one in a keyhole, the other hanging down. This on its own would not suggest any symbols. But when it is combined with Velazquez' *Rokeby Venus*, with a repeated ring motif, and with a glass case in which an insect is imprisoned, we are justified in identifying symbols.

Rings

The ring is a familiar sexual symbol. Roy Lichtenstein made it the subject of his picture *The ring* 1962 (ill. 10). A wedding ring is surrounded by an aureole and a male hand is holding it while the female hand approaches it with all four fingers. The socially approved defloration of the virgin is performed symbolically when the finger pierces the ring. However the work which Rauschenberg completed in 1960 is much more allusive (ill. 12). He has combined the lid of a chest with a car tyre.

The lid of the chest is pushing itself into the hollow centre of the tyre. The double arrow painted across the chest slows down the rate of movement, but in so doing it intensifies the force with which the chest penetrates the tyre. We feel as if something had been injured, for there is paint trickling down from the arrow and the tyre is spotted with paint.

Targets

Concentric rings make up a target. However it is generally difficult to see a precise symbolic meaning in the works of Kenneth Noland. In *Provence* 1960 (ill. 11) individual colour-rings create a vivid effect of deep suction: red, green, yellow and blue. The outer ring, which is blue, is not even properly formed but is trying to consolidate itself as it rotates. In Jasper John's *Target with four faces* 1955 (ill. 13) a frieze of faces at the top of a target – or more accurately a frieze of four plastic mouth and nose sections – indicates how the work is to be interpreted. The mouths[30] and noses represent the female and male sexual organs respectively while the target is waiting for the shot, for the thrust. In Richard Lindner's work *Target no.1* 1962 (ill. 14) the symbol is personified. He shows the top half of a woman's body, with a man in a hat standing behind her. The title introduces the symbolic reference: the breasts and a few geometrical shapes immediately make us think of a target. In addition, the strong outlining concentrates our attention in the direction of the targets.

Feet and shoes

In another painting (ill. 15) Lindner put the notice *Adults-only* above a breast-target which stands on a woman's laced boot. The verbal message indicates that something indecent is being concealed. The target, which is easily interpreted, is also emphasized by the shoe. For feet and shoes have for centuries been symbols of sexual fertility;[31] the female shoe is a symbol for the vulva, the high heel for the phallus. A watercolour by Hans Bellmer dated 1923 (ill. 16) bluntly shows the link between a shoe and the female sexual organ. Symbols are unnecessary here for the artist expresses himself plainly.

Walking up a staircase

In *La sheer* 1968 (ill.18) Allen Jones isolates two stocking-covered female legs from a body. The legs are wearing shoes with extremely high heels and they are striding up a staircase. According to Freud, walking up a staircase symbolizes sexual intercourse.[32] It is interesting to compare *La sheer* with Marcel Duchamp's famous picture *Nude descending a staircase (Nu descendant un escalier)*[33] which he painted in 1912 and with Gerhard Richter's picture *Emma – nude on a staircase (Emma – Akt auf einer Treppe)* 1966 (ill. 17). In Richter's work the fleeting instant is preserved, thanks to his special method of blurring the paint which is certainly vindicated here. Jones however has debased the theme with trivial 'trendy' jargon, although admittedly he has done this with great impact.

Sliding or falling

Sexual intercourse is not only symbolized by striding upstairs but also by sliding or falling, even when there are no stairs in the picture. In *Figure falling* 1964 (ill.19) Allen Jones depicts a figure plunging from the yellow horizon, down into a deep expanse of blue. A red comet-like streak, indicating the path of the falling figure, cuts through both the yellow zone and the blue zone. We cannot identify much that looks like a human figure – just a foot with a shoe on it, an arm. Otherwise there are only dissolving contours and solidified contours, for the subject of the picture is the dynamics of the fall.

But whereas Jones' picture merely alludes to sexual intercourse, the title of one of Max Ernst's drawings from *Woman with 100 heads (Femme 100 têtes)* 1929 indicates its subject quite openly: *Daylight robbery or: when you are in need any port will do (Öffentliche Entladung)* 1929 (ill. 20). Two human figures, closely intertwined, are falling down into the street out of a cab. The cab has been cut open so that it folds back like a book.

Plants and fruit

Plants and fruit[34] are generally recognized as symbols of fertility, and they may represent the female sex organ or the male sex organ, depending on their appearance. Thus the cluster of bananas in Giorgio di Chirico's *The poet's disquiet (L'inquiétude du poète)* 1913 (ill. 24) should certainly be given a phallic interpretation – especially since it is placed next to a voluptuous female torso. For there is a sexual quality in

the disquiet which the picture expresses and which the poet feels. The gaping arch-openings suggest tunnels, through which the railway engines on the horizon might drive. Similarly, Chirico's *The philosopher's conquest (La conquista del filosofo)* 1914 (ill. 25). The allusion is unmistakable: there is the barrel of a cannon with two artichokes lying in front of it, and on the horizon the phallic form of the barrel is repeated in the chimney and the column. Again we have a railway and arcade-openings, while the clock over the empty shaded square adds a new dimension, of time.

In a collage by Max Ernst dated 1919–20 (ill. 26) a correctly dressed young man sits dreaming at the foot of a flight of stairs, with a polar bear beside him. He holds an outsize corn cob firmly locked in his hands. This monumental phallus is aimed at a vision at the top of the stairs: a couple flirting intimately beneath an open umbrella. But Freud discovered that the umbrella is also a symbol for the phallus.[35] And so the stairs which symbolize sexual intercourse become an ideal.

The tapestry of plants in *Water-melons (Pastèques)* 1966 (ill. 27) by Piero Gilardi is not meant to be symbolic – but we are surely allowed to associate it with a fertile garden (the female sexual symbol) which has erotic fruits hidden among its tendrils.

Guns

The gun according to Freud is a symbol for the male sex organ[36] – and we may compare this with the target which is a symbol for the female sex organ. In *Stylistic exercise no. 1 (Exercice de style no. 1)* 1968 (ill. 22) Jacques Monory shows a woman hurrying along in her wedding dress. But the picture begins below her shoulders, so that her head cannot be seen. Bridal shoes, a floating white veil, a revolver in the left hand: a bride of the Wild West. There is a bright streak at the top right-hand side of the picture which cuts the veil in two, so that it looks as though there is a crack going right across the picture. It is as though we were only catching a reflection in a pane of plate-glass. The meaning of this wedding picture is not stated plainly, but it may be that the crack in the mirror represents lost innocence, the revolver the penis and the shoes the vulva.

In a silk screen print dated 1965 (ill. 21) Allen Jones uses the same picture postcard three times. The postcard shows a girl in a Wild West costume standing languidly in the midst of some cactuses; she has drawn her Colt and is aiming it at a fictitious target. The postcards are arranged so that the top one penetrates the horizon of the painted cactus landscape. The symbolic, sexual character of the Colt is emphasized by the phallic shape of the cactuses.

The cannons in Pino Pascali's *Arms (Armi)* 1966 (ill. 23) do not appear to have a deliberate symbolic meaning. But if we look for phallic symbols we can add a new

dimension to this painting of a smooth metal pipe connected to a substructure and a camouflage net. However the revolver in Andy Warhol's *Elvis Presley* 1964 (ill. 28) is clearly intended as a symbol of masculinity. Elvis Presley is presented as a male idol, and he stands with his gun ready; Warhol has printed two overlapping images here. And Warhol's *Marilyn Monroe* 1967 (ill. 29) is seen as a female idol; Warhol has again printed two images, and he has emphasized the area around her mouth.

Bottles and glasses

In a drawing by George Grosz (ill. 30) the brutalized bourgeois, who is very far removed from the chubby peaceful ideal at the bottom right-hand side of the picture, carries a revolver fastened to his coat jacket. What he wants is prostitutes. He has a cigar between his fingers and there is a corked bottle and a glass in front of him. The bottle and the glass are female sex symbols,[37] but the cork with its aggressive point is a male symbol. The shape of the cork is repeated in the tower next to the row of house fronts on the horizon.

A glass flanked by a pepper pot and a salt cellar alludes to what is happening at the table in the waiting-room: a man is clasping a woman possessively with his arm and kissing her. In Kitaj's *Where the railroad leaves the sea* 1964 (ill. 31) it is certainly not accidental that these three objects are grouped together on the table. We cannot assume that the artist is using symbolism consciously, but this group of three objects is the element in the composition which removes the scene mysteriously from everyday life. Marisol on the other hand is clearly using the bottle as a sex symbol in *Love* 1962 (ill. 35). The mouth is wide open and the bottle neck penetrates deeply into it. The only parts of the face that we can see are the mouth and nose, and this reminds us of Jasper John's picture (ill. 13). The Coca Cola bottle is a female sex symbol but here, frivolously, it assumes the role of the phallus.

In a comic, burlesque style Bill Copley's *Casey strikes out* 1966 (ill. 39) sets together two bottles and a massive club. For the baseball-playing family the bottles are merely missiles hurled by indignant spectators and the club raised in the air is merely a baseball bat. But it is certainly not unreasonable to find symbols in this lively scene. Ben Nicholson creates an aesthetic effect by standing back from his bottle in *Pale grey bottle* 1965 (ill. 34). Here it is the line that creates tension. The outline of a female figure appears to have been transformed into the contours of the bottle. In the same way Magritte turned a bottle into a woman in *The lady (La dame)* 1943 (ill. 36).[38]

In Giorgio Morandi's *Still life with large targets (Natura morta a grandi segni)* 1931 (ill. 33) the bottles stand on their own as elements in the still life. They are objects from everyday life, but they seem remote because they are isolated or set in groups.

Their high necks accentuate the bulging lower parts. These bottles become individuals who may perhaps even have a sex life. In a later etching by Morandi entitled *Still life with nine objects (Natura morta con nove oggetti)* 1954 (ill. 32) two bottles with clearly defined necks are placed, together with a flat oval tin, in front of six tall boxes. All these objects share one quality with the female sexual organ: they enclose a cavity into which something can be inserted. And indeed Louise Nevelson's wooden case (ill. 42) and Ursula's fur-covered jewel case (ill. 275) should be mentioned here, for they also have this characteristic.

Wood

Wood has a special significance, which Freud pointed out.[39] The Latin word *materia* has the specific meaning *wood*, as well as the generic meaning *matter* or *material*. But the word *materia* is derived from the word *mater* meaning *mother*: Freud says that the material from which a thing is made can be conceived of as giving birth to it. Thus there is a symbolic connection between wood and the female sex organ. This means that when wood is used to make a case both the material and the shape symbolize the female sex organ. The interior of Louise Nevelson's wooden case (ill. 42) shows a large number of phallic shapes pointing from all sides towards the middle of the cavity, as though they had penetrated the walls of the case from outside. There are two particularly sturdy wooden plugs, with a clearly defined trunk shape, in the back wall and these are pointed at the spectator. A smooth wooden form lies on the floor of the chest, and it looks almost as though blood is dripping down and forming a puddle.

Violation

Jim Dine's silk screen print (ill. 41) captures the moment of violation. A ripping chisel sits aggressively on top of a closed cigarette box. Around this central point cuttings from a fashion journal form a collage consisting of women's arms and legs. The symbolism is quite obvious here. A drawing by Dieter Stein (ill. 40) locates the violation as an ideal in the mind of the artist, who is staring in the mirror at one of his drawings of a nude. The spike above his head is a stove pipe but the association with the penis is obvious.

Hats and coats

According to Freud, hats and coats are also sexual symbols.[40] In the middle of a landscape is a large gathering of people, all in hats and coats. They are gazing fixedly at the menacing emptiness of a wall of cloud which occupies the larger, upper area of the picture. The name of this picture by Richard Oelze is *Expectation (Erwartung)* 1935–6 (ill. 37). At first sight it does not seem important to know what these people are expecting, for the artist is trying to convey a sense of waiting. But isn't there also a sense of longing, a feeling of non-fulfilment which might eventually become sexual?

In *Angels for Lorca* 1966 (ill. 38) Jim Dine crams a hat onto a rod and then places two of these impaled hats next to an impaled wooden cap. The arrangement of this group has a certain charm, which a single object could not have achieved because it would have seemed simple and banal. The motif of the impaled hat appears to be an insipid paraphrase of the symbol Rembrandt used in his etching *The couple on the bed* 1646, where a couple are making love on a bed and the lover's feathered hat is rammed tightly onto the bedpost. The symbolism is obvious, for the moment of sexual union is clearly shown in the picture.[41]

Ties

Freud said that 'A *tie*, being an object which hangs down and is not worn by women, is clearly a male symbol.'[42] Domenico Gnoli illustrates this in his *Man: back and front view (Homme double-face)* 1964 (ill. 43). We immediately look away from the rear view of the man, on the left-hand side of the picture, for there are very few lines or joints to break up the pictorial surface. Instead we look at the right-hand side which shows a front view. The tie is the dominant feature, but our glance is directed further down, over his two jacket buttons, to the gusset between the legs. The picture shows no head and no limbs. It is a detail of what a man sees in the mirror when he looks at the virile, masculine parts of his body.

A burlesque drawing in coloured pencil by Magritte (ill. 44) exaggerates the tie's length until it comes right down over the feet. Birds' masks look out of the hunter's head as he fires off his pistol with his right hand. He is holding a dead bird in his left hand. Little clouds of smoke rise up on the horizon and there are also clouds around the hunter. A mask with a long nose hangs at his left side while the outline of his right side forms a comical expression, with his arm as the nose. His hand merges with the pistol, as though he were shooting from his own finger. The male symbols are accumulated in this drawing as follows: tie, weapon, large noses. Since large noses

have always been regarded as the sign of highly developed virility, the masks with long noses are, by extension, sexual symbols.[43] At the same time the connection between the nose and the pistol emphasizes that the nose is a symbol of highly developed virility – while the dead bird in the hunter's hand symbolizes loss of virginity.[44]

Noses

The phallic character of the nose is evident in Schröder-Sonnenstern's drawing *The brand mark of the moon culture (Das Mondkulturschandmal)* 1960 (colour ill. II). Peter Gorsen has examined the pictorial world of Schröder-Sonnenstern in detail.[45] He states that this schizophrenic artist has links with the 'mythical originality and integrity of the unconscious imagination'. But Gorsen thinks that 'this sort of art cannot link picture and meaning in the way that symbols can, because symbols are immediately intelligible'. He thinks we still have to study in detail to what extent the symbol expresses universal truths and also to what extent the need for making symbols springs from a purely subjective biographical attitude. Gorsen refers to Schröder-Sonnenstern's 'hunger of the senses' which is revealed in his fetishistic use of symbols. Schröder-Sonnenstern himself said: 'I just can't paint enough round forms in my pictures – I don't want any sharp edges because then I would be painting life itself. All round things stand for perception.'[46] In his work he expresses in symbolic terms 'a concept of wholeness and unity'; for he has started from the archetypal primitive model and created forms which have both male and female characteristics. Thus in *The brand mark of the moon culture* we find primeval hermaphroditic symbolism. The artist has found the reverse side of the 'world of sun and stars' suggested by his surname – the side of sexual excesses, the 'moon world'. The winged demon is made up of highly symmetrical, swelling rounded forms. It is surrounded by lines which branch out to form aggressive arrowheads and it is gaping at the spectator with a broad grin. Two yellow birds are sitting on the demon's head: they seem to be escorting a drop which is moving down into a crack in the head. This drop passes between the spiral formations at the mouth of the crack and then moves on down towards the phallic arrow of the nose. Phallic and vaginal shapes are interwoven in this picture, for the snake shape[47] of the middle axis is aimed at the eye-vagina shape in the centre of the picture.

Pipes

The pipe is another exclusively male sexual symbol. Man Ray gave a clay pipe the inscription: *What we all need (Ce qui nous manque à tous)* 1935 (ill. 45). There is a glassy soap bubble at the head of the pipe and this extremely fragile glass ball represents the female sex organ. That is what we all need: sexual intercourse. A wooden box by Joseph Cornell entitled *Ocean Hotel (Hôtel de l'Océan)* 1959–60 (ill. 46) uses the same props, but here the ball is dissolved into rings which hang from a rod. The gaping cracks in the back wall suggest the vagina, while the elephant's trunk playfully alludes to the penis.

In Magritte's work the pipe, together with the sub-title *This is not a pipe* plays an important part. One of Magritte's drawings (ill. 49) has a stopcock on the mouthpiece of the pipe, so that the mouth of the pipe turns into a water tap. According to Freud,[48] straight objects with water flowing from them represent the penis. Thus the stopcock makes the phallic symbolism of the pipe much more potent.

Stopcocks and hoses

Konrad Klapheck connects the stopcock to a hose with a number of twists and bends in it, which has a spray on the end of it. The title of the picture is *Love-song (Liebeslied)* 1968 (ill. 47) but the artist also called it 'Saxophonist in profile'. The form may have been dictated by this image of a saxophonist in profile, but this does not mean that we should rule out the subconscious use of symbols. The stopcock, together with the long hose and the spray, is clearly a phallic allusion while the image of the saxophonist represents the artist's attempt to intellectualize his work. A small detail in the picture focuses on the zone of sexual tension: this is a ring attached to the spray which slides over a peg sticking out from the wall, so that the spray can be hung on the peg. Klapheck again identifies his symbols in another picture: *The sex-bomb and her escort (Die Sexbombe und ihr Begleiter)* 1963 (ill. 48). He says: 'the fittings represent the voluptuous beauty, the spray is the diminutive man with a thick wallet who is escorting her'. It is quite clear why the shower plays the male role, but the idea that the fittings represent a voluptuous beauty remains a conscious projection on the part of the artist. He first adopted the mechanical gadgets intellectually and then projected his associations onto them. It is significant that the critics who attempted to interpret the sense of the picture from the title were easily misled. They wanted to know where the sex bomb was hiding. But the artist has given a satisfactory answer to this question, for he has indicated to us the associations at work in his mind.

Machines

Freud[49] pointed out that 'the imposing mechanism of the male sexual apparatus lends it to symbolization by all kinds of complicated and indescribable *machinery*', and we can apply this to Jean Tinguely's machines: indeed we can immediately understand his sculpture made from a hosepipe (ill. 51) and also the sketch for *Stedelijk Fountain (Fontaine du Stedelijk)* 1968–9 (ill. 50). Even Tinguely's sculpture made from a machine which is not water-powered (ill. 52) suggests a relationship with the male sexual organ. Bernhard and Hilla Becher's photograph of the wind-heater at Gute Hoffnungshütte, Oberhausen (ill. 54) is also relevant here, for it seems almost like an illustration of Freud's statements about machines as symbols.

Fernand Léger created his own love song with *Big Julie (La grande Julie)* 1945 (ill. 53) which appeared as an episode in Hans Richter's film *Dreams that money can buy*. Julie stands on the left, against a dark background. She is holding an open flower in her right hand, while her left hand is reaching across towards the male side, groping around in the gears of the bicycle. The handlebars of the bicycle are shaped like a penis. There are two butterflies flirting with each other, one on the female side and the other on the male side of the picture. In this picture Léger has given expression to all the poetry within him. In the film the process of wooing is described in the scene showing models in a shop window, but this is a scene in which the artist's achievement is distinctly inferior to his purpose.

Landscapes

It is quite easy to understand why 'The complicated topography of the female sexual organs accounts for their often being represented by a *landscape* with rocks, woods and water'[50] (Freud). Carlo Mense's *Girl by the lake (Mädchen am See) c.* 1930 (ill. 55) seems almost to illustrate this remark, for the girl lies there, as open as the country-side in which she is resting. In a drawing by Ulf Maier dated 1963 (ill. 56) the woman's naked back can scarcely be distinguished at first, for the body is closely interwoven with the landscape. The girl stands like a nymph in the midst of the trees and bushes. A bright streak in the texture of the drawing indicates water, perhaps a river, and towards the horizon mountains form a line. A shy sensitivity has found its way into the landscape.

René Magritte approaches the theme from a different angle in his drawing of two nude women lying closely entwined (ill. 57). For here it is the bodies which become the landscape. Dieter Stein takes this even further. In his drawing of a nude (ill. 58) the head is missing and the torso can only be distinguished because there is a

24

foot hanging down. The artist has released the dynamic forces which govern landscapes. These forces reappear, reconstructed, as the topography of the body.

Teeth

Jasper Johns has given the title *The critic smiles* 1959 (ill. 61) to a sculpture. Lying on a stand is a toothbrush whose bristles have been replaced by four teeth. It is difficult to know whether this work is merely meant to make the critic smile – the invention would be worthy of Magritte – or whether it is a portrait of the critic showing his teeth as he smiles. Perhaps the artist is paying the critic back for smiling, by deliberately showing the teeth as sexual symbols. Then, according to Freud,[51] this would indicate castration as a punishment for masturbation, implying that the critic is an artiste manqué. But in this case the smile would belong to the artist, not the critic.

Richard Hamilton took up the same theme in a less poetic way in *The critic laughs* 1968 (ill. 59). In his picture the critic is also laughing: there is a denture balanced on an electric toothbrush. Moreover this idea has a formal precedent. A pastel by Toyen dated 1943 (ill. 60) shows a monumental denture shaped like a leaf growing out of a meadow. The teeth are growing in a neat row from the fleshy edge. The broad molar teeth have cracks on the underneath which suggest the hymen. A little girl is climbing carefully up the teeth and she seems to be busy looking after them. It seems clear that there is a sexual allusion here even if the theme of castration is ruled out.

Castration symbols

The broken scissors in Christian d'Orgeix's *Assemblage c.* 1955 (ill. 62) can certainly be interpreted as a castration symbol. The stump of the scissors can be seen through the oval opening of the cupboard, between two metal elements, one star-shaped and compact, the other wiry and spiral-shaped.

The castration motif is particularly important in Salvador Dali's work. In a drawing dated 1933 (ill. 63a) a figure uses a sharp knife to cut slices from a part of its own body, which looks like bread. Another bread-like shape sits on the narrow neck, forming the head, and at the same time serving as a base for an inkpot with a fountain pen inside it. The second figure is holding a violin bow in its other hand and stroking its thigh with it: violin playing can be interpreted as the completion of the sexual act.[52] Another of Dali's drawings from the same period (ill. 64) shows an erect phallus of monumental dimensions, with the lower part cut up into slices; the

flexible upper part is supported by a fork. The castration motif is accompanied by fears of impotence, which require reassurance and support. On the back of the first Dali drawing (ill. 63a) is a picture of *The Fall of Icarus* 1933 (ill. 63b). Here flying figures symbolize the erection of the penis and the completion of the sexual act. But Icarus lies dashed to the ground, his strength broken. The hermaphroditic figure set on a pedestal in the foreground is also like a crumbling ruin; its genital area appears maimed and deformed and so does the genital area of the athletic figure standing behind it. Dali has used every kind of symbolic variation to express the theme of impotence and castration – according to his biographers Dali had a mania for jumping from high walls and stairs when he was young.

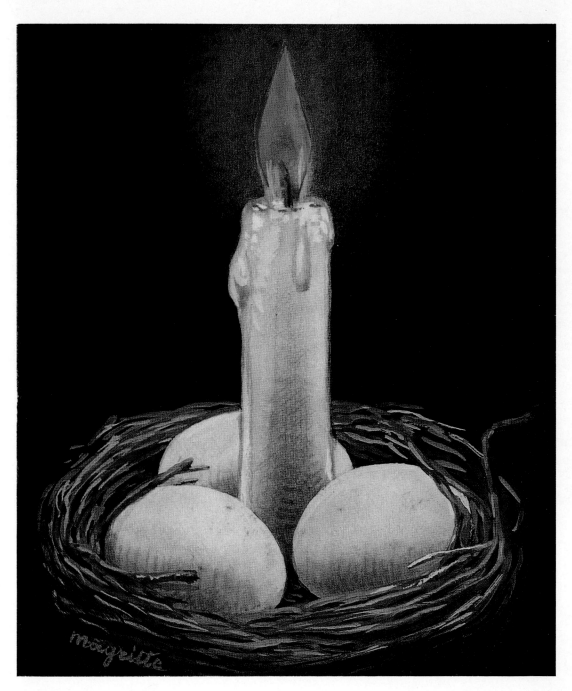

Magritte, La folle du logis, 1948

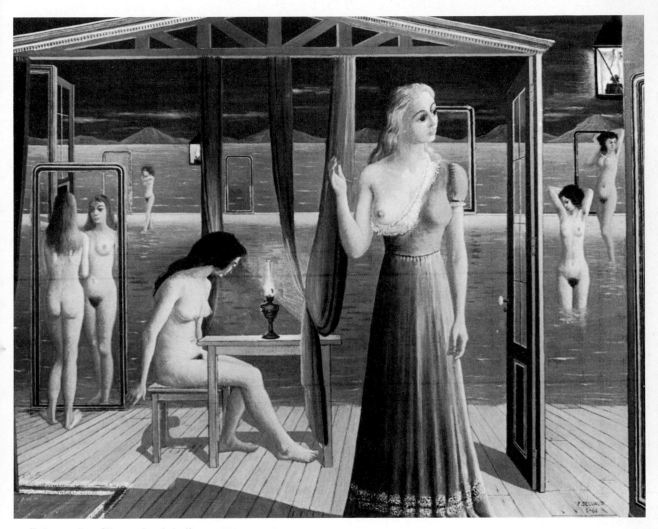

1 Delvaux, Les filles au bord de l'eau, 1966

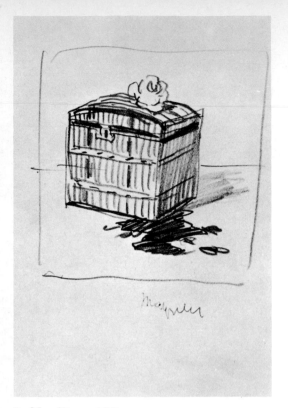

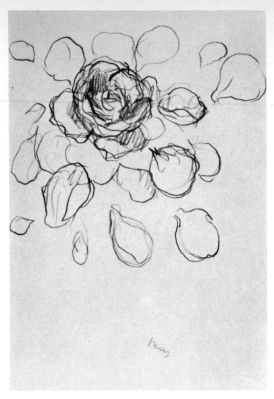

2 Magritte, ca. 1940

3 Magritte, ca. 1940

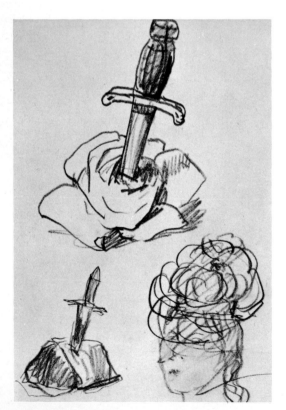

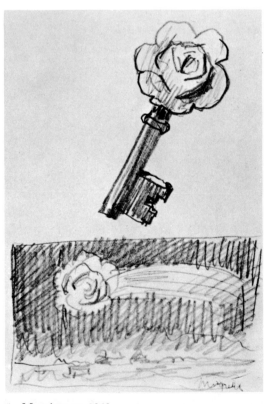

4 Magritte, ca. 1940

5 Magritte, ca. 1940

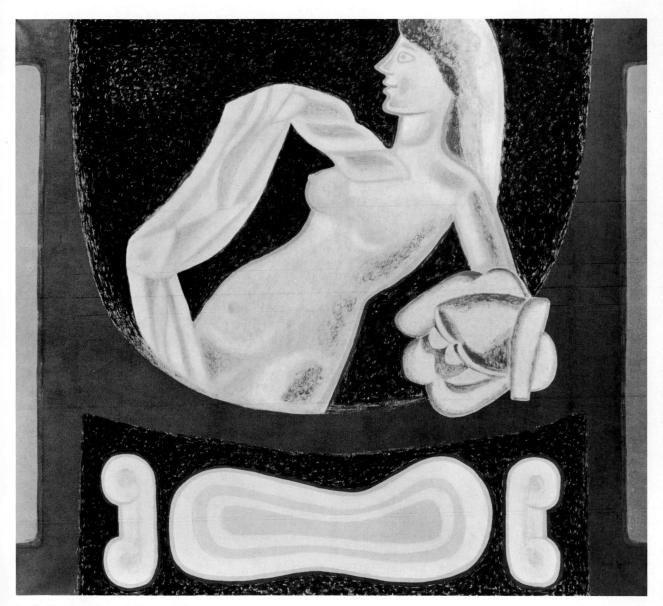

6 Goller, Mädchen mit Rose, 1970

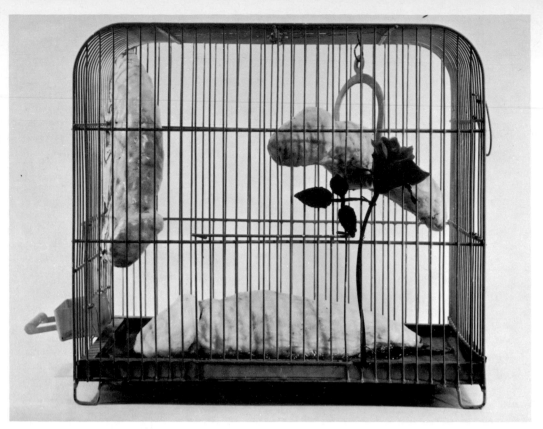

7 Kudo, For your living-room, 1965

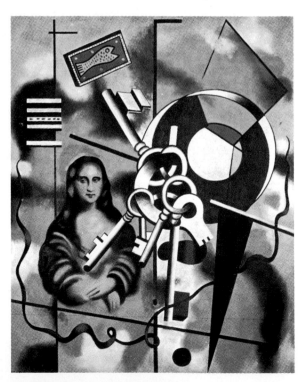

8 Léger, La Joconde aux clés, 1930

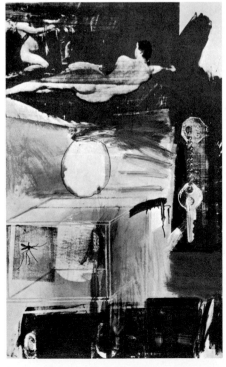

9 Rauschenberg, Exile, 1962

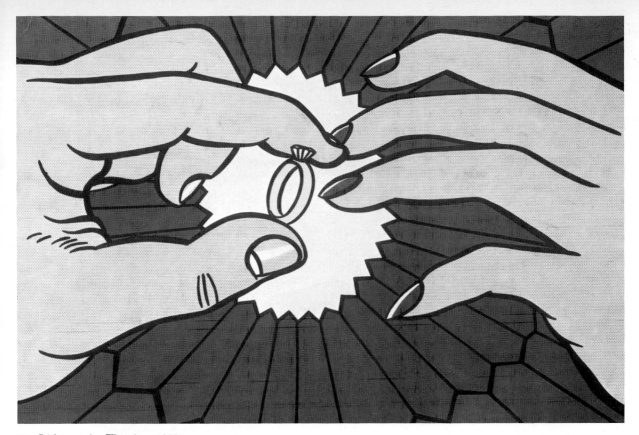

10 Lichtenstein, The ring, 1962

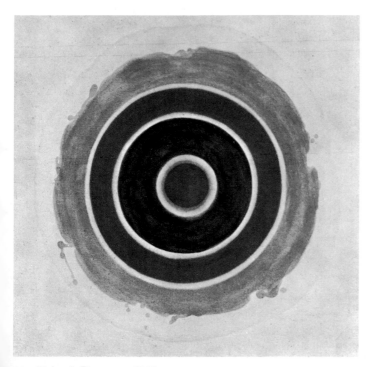

11 Noland, Provence, 1960

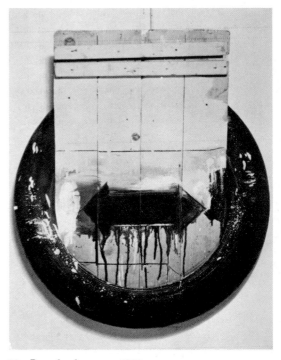

12 Rauschenberg, ca. 1960

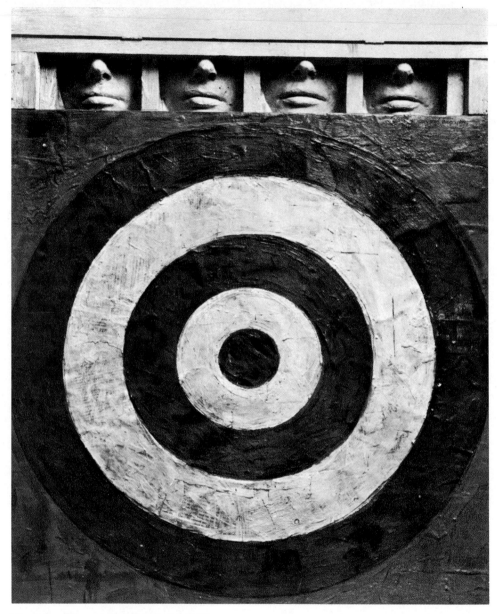

13 Johns, Target with four faces, 1955

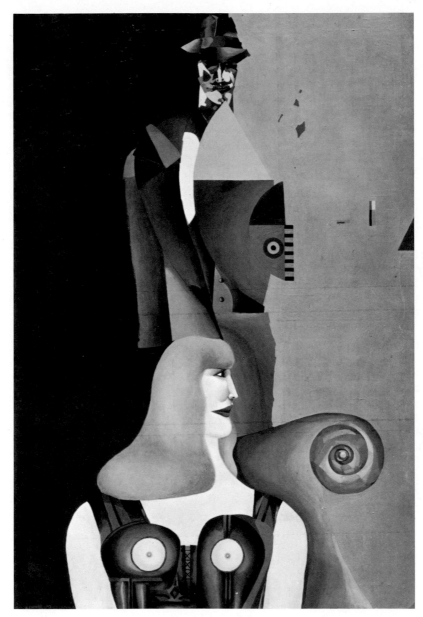

14 Lindner, Target No 1, 1962

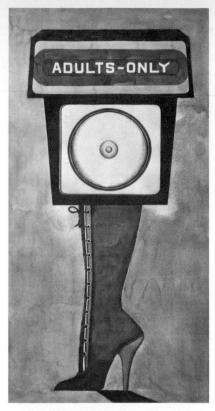

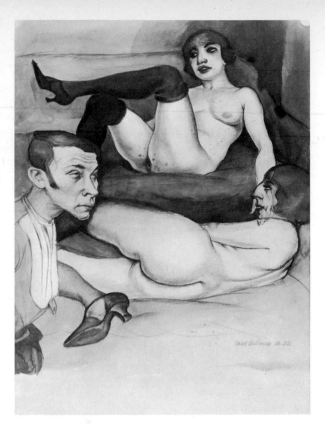

15 Lindner, Adults-Only, 1967 16 Bellmer, 1923

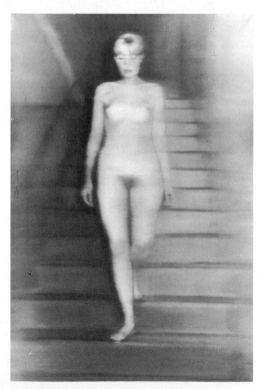

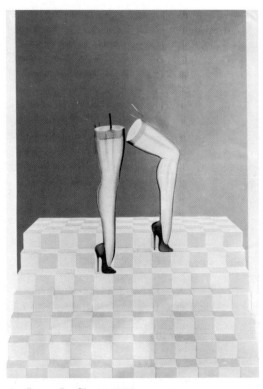

17 Richter, Emma – Akt auf einer Treppe, 1966 18 Jones, La Sheer, 1968

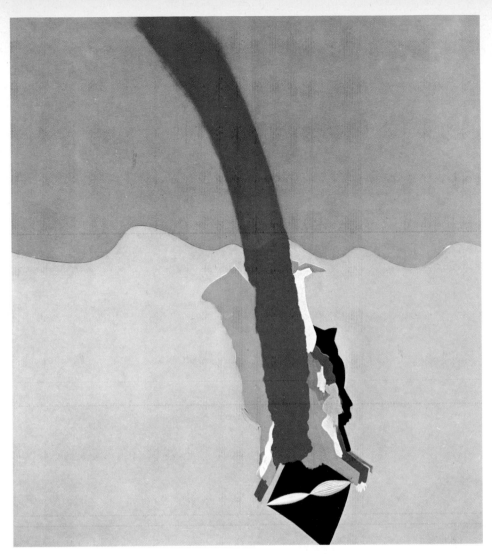

19 Jones, Figure falling, 1964

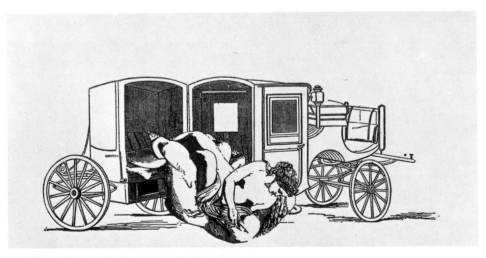

20 Ernst, Öffentliche Entladung, 1929

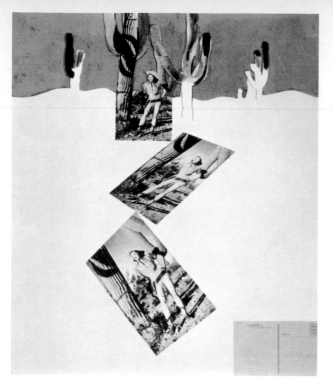

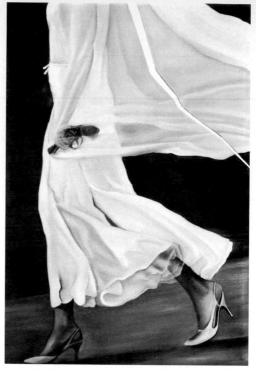

21 Jones, 1965

22 Monory, Exercice de style No 1, 1968

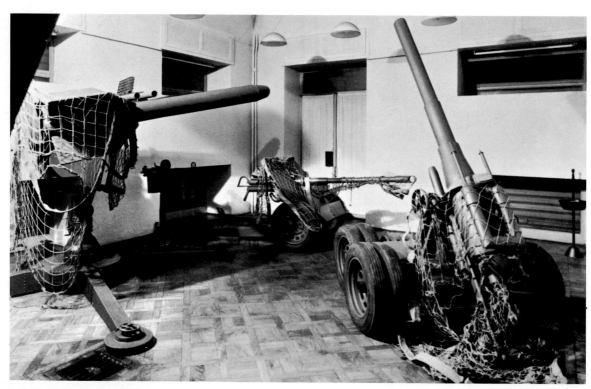

23 Pascali, Armi, 1966

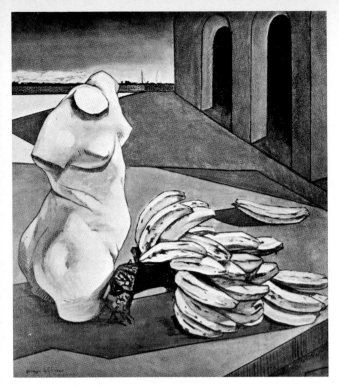

24 Chirico, L'inquiétude du poète, 1913

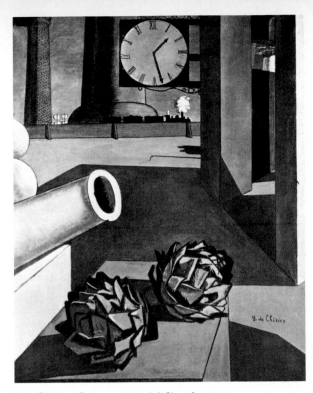

25 Chirico, La conquista del filosofo, 1914

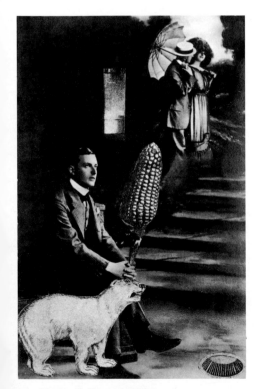

26 Ernst, Collage, 1919/20

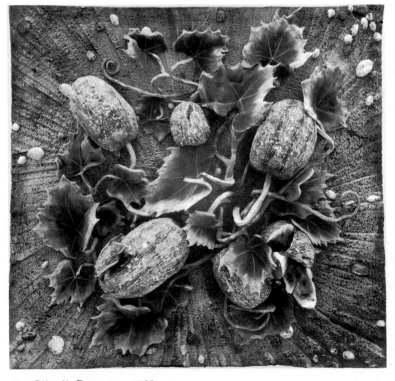

27 Gilardi, Pasteques, 1966

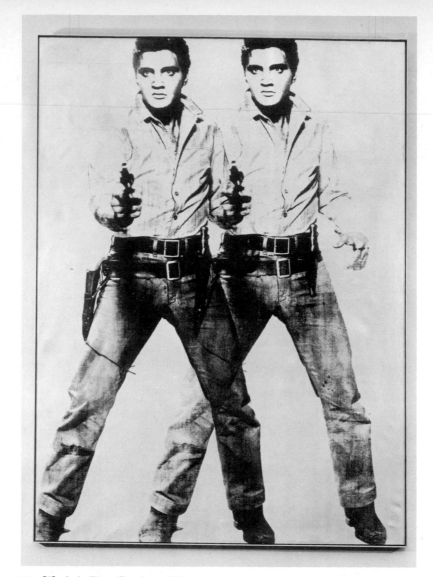

28 Warhol, Elvis Presley, 1964

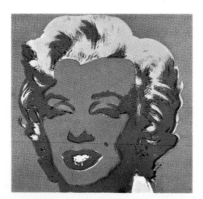 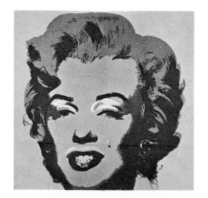

29 Warhol, Marilyn Monroe, 1967

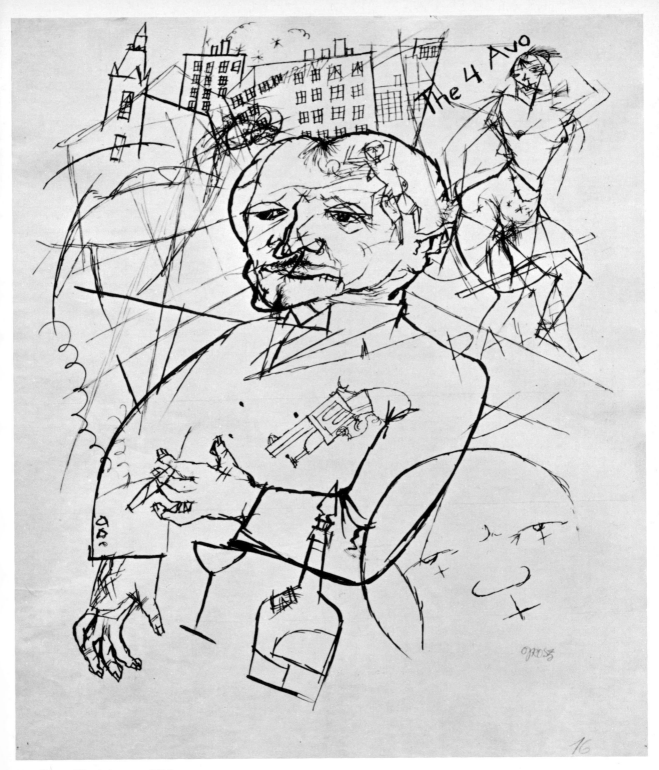

30 Grosz, The 4 Avo, ca. 1916

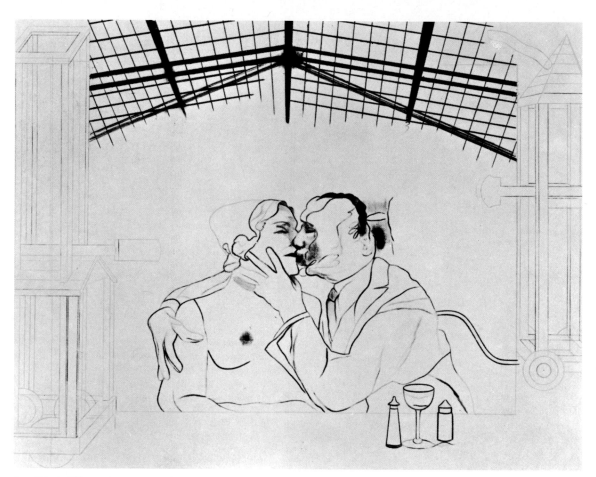

31 Kitaj, Where the railroad leaves the sea, 1964

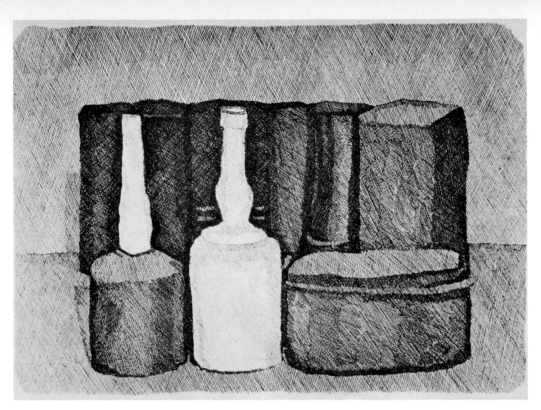

32 Morandi, Natura morta con nove oggetti, 1954

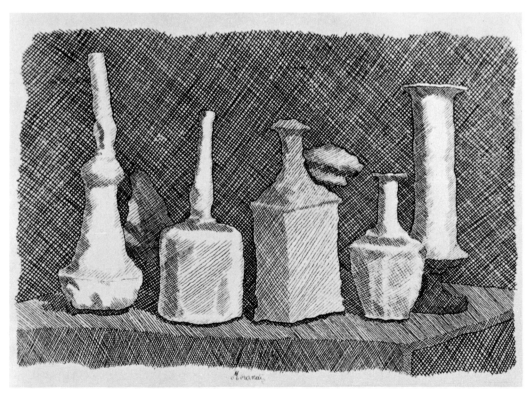

33 Morandi, Natura morta a grandi segni, 1931

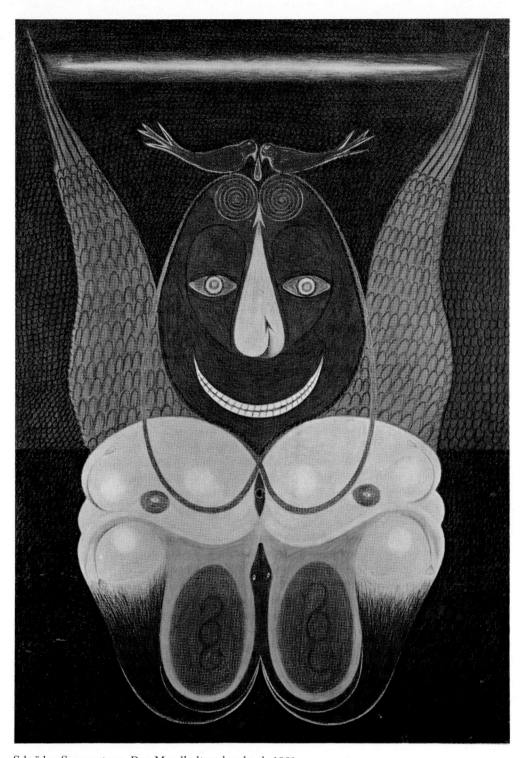

Schröder-Sonnenstern, Das Mondkulturschandmal, 1960

34 Nicholson, Pale grey bottle, 1965

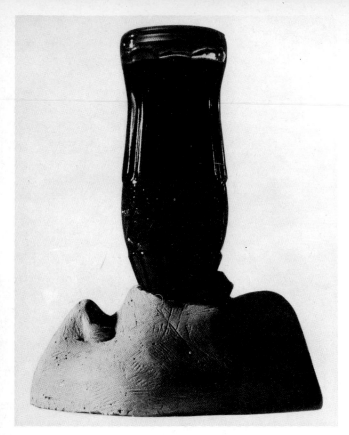

35 Marisol, Love, 1962

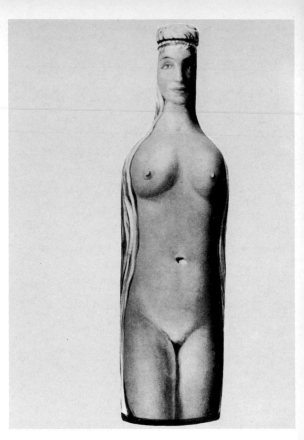

36 Magritte, La dame, 1943

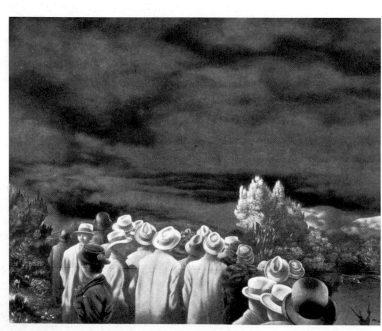

37 Oelze, Erwartung, 1935/36

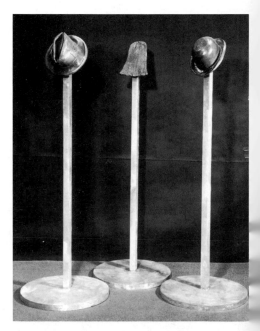

38 Dine, Angels for Lorca, 1966

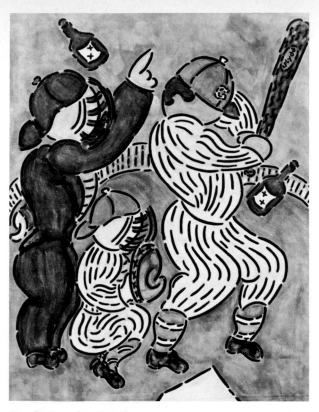

39 Copley, Casey strikes out, 1966

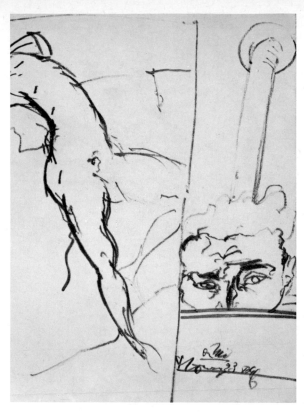

40 Stein, 1966

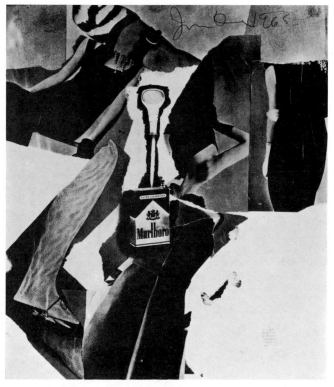

41 Dine, 1965

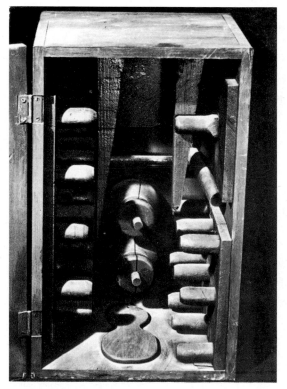

42 Nevelson, Le tronc, 1954

43 Gnoli, Homme Double – Face, 1964

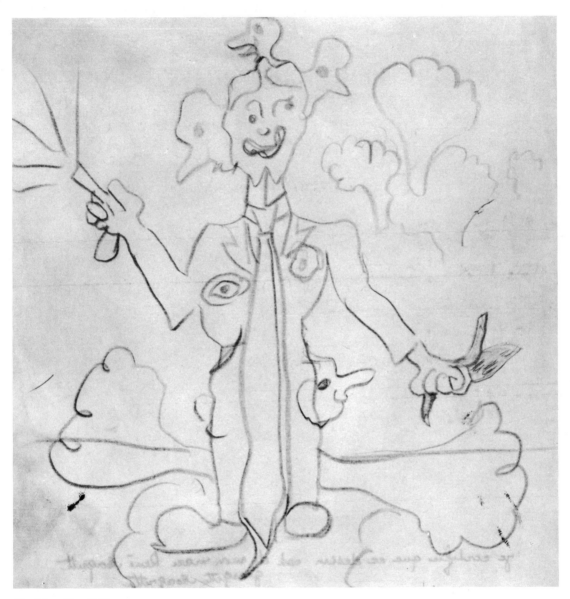

44 Magritte, 1947

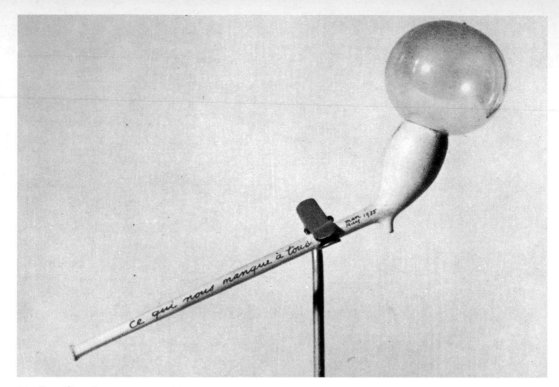

45 Ray, Ce qui nous manque à tous, 1935

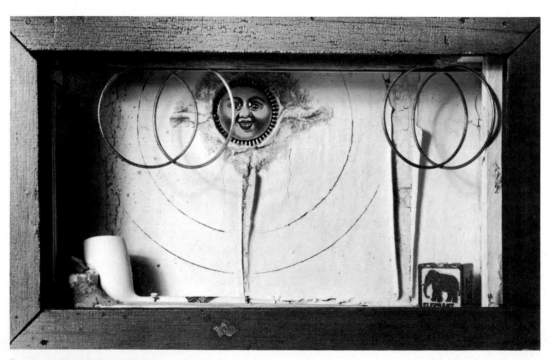

46 Cornell, Hotel de l'Ocean, 1959/60

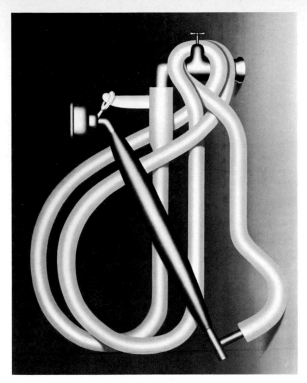

47 Klapheck, Liebeslied, 1968

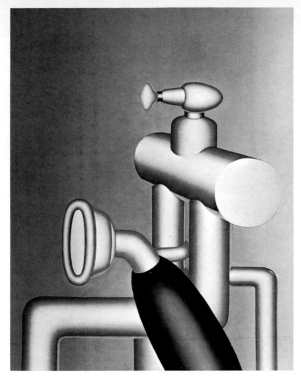

48 Klapheck, Die Sexbombe und ihr Begleiter, 1963

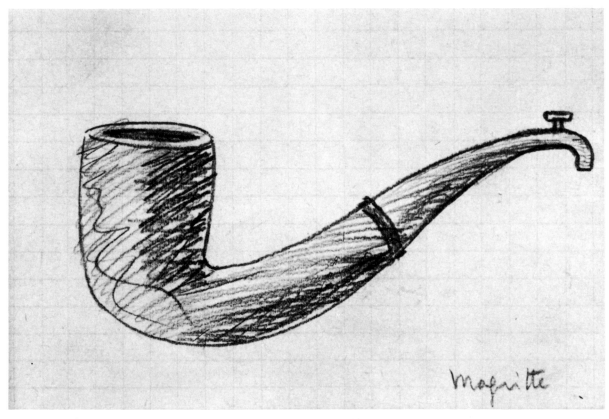

49 Magritte, ca. 1940

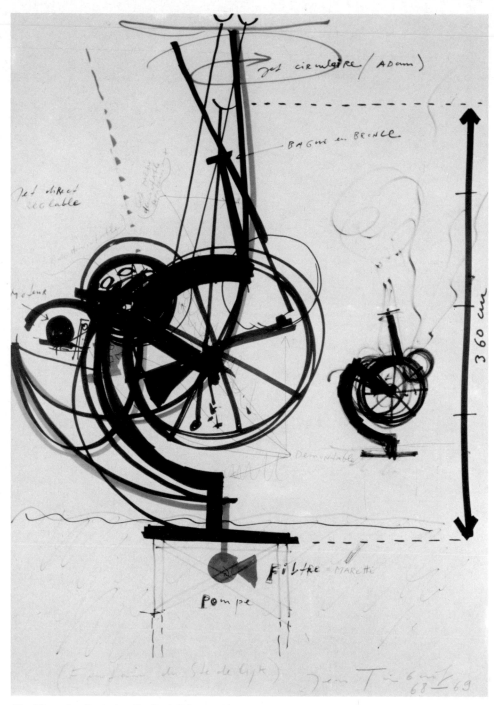

50 Tinguely, Fontaine du Stedelijk, 1968/69

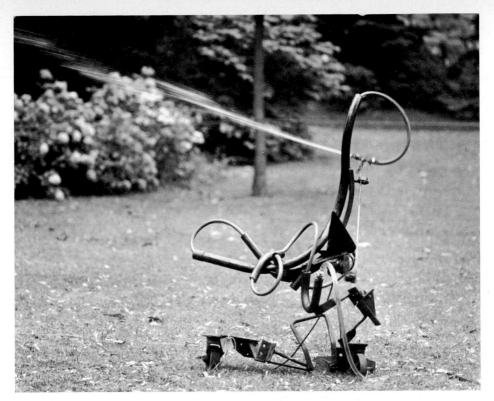

51 Tinguely, 1966

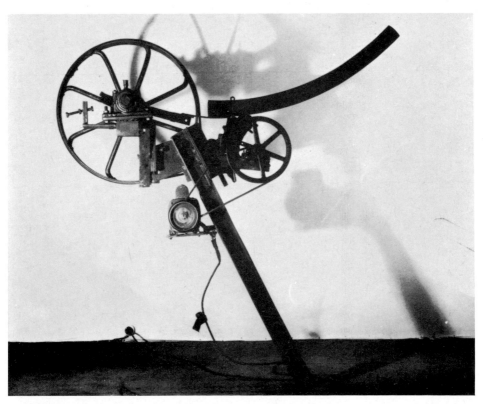

52 Tinguely, ca. 1967

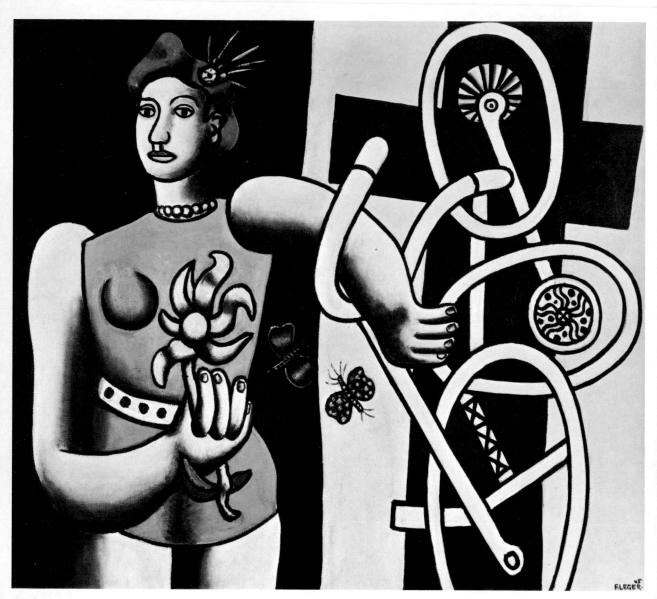

53 Léger, La Grande Julie, 1945

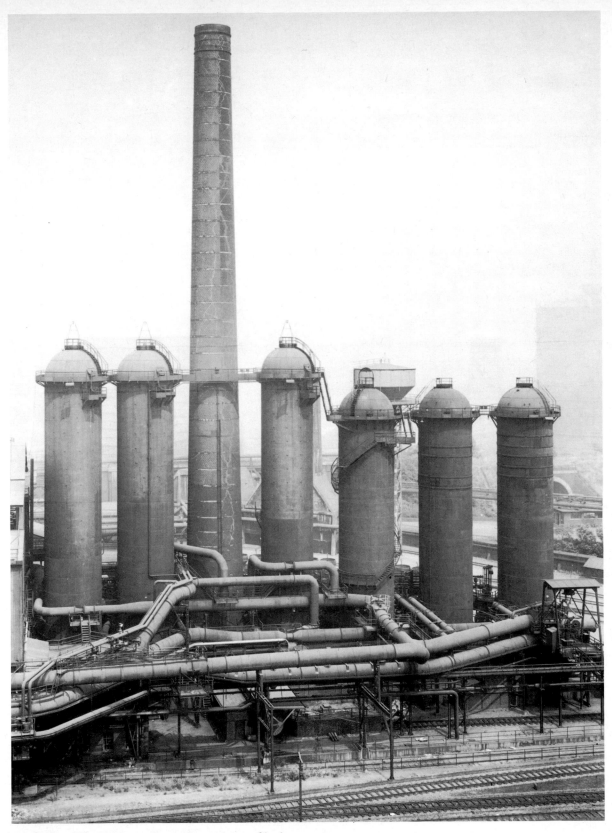

54 Becher, Winderhitzer, Gutehoffnungshütte, Oberhausen

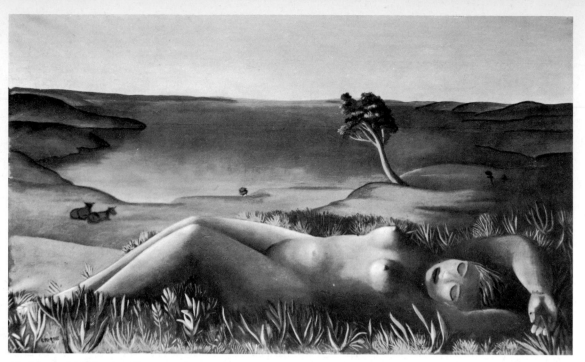

55 Mense, Mädchen am See, ca. 1930

56 Maier, 1963

57 Magritte, ca. 1945

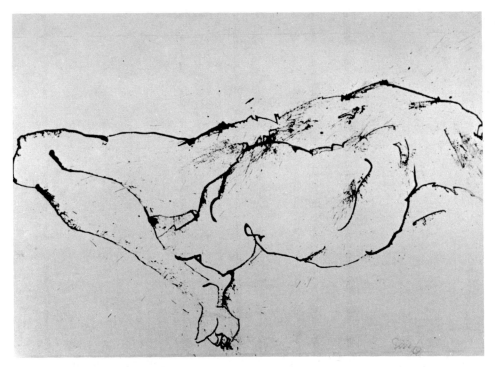

58 Stein, 1968

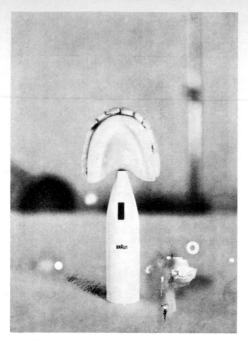

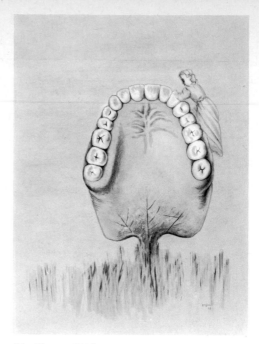

59 Hamilton, The critic laughs, 1968 60 Toyen, 1943

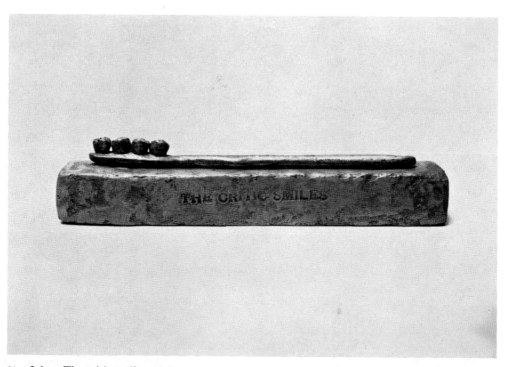

61 Johns, The critic smiles, 1959

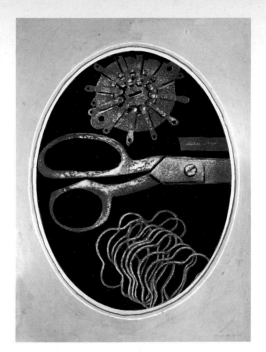

62 d'Orgeix, Assemblage, ca. 1955 63 a Dali, 1933

64 Dali, ca. 1935

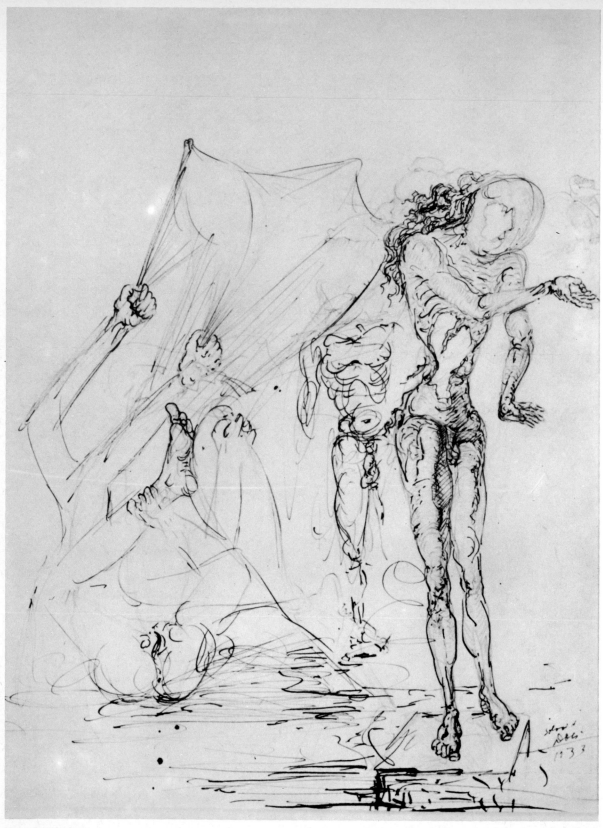

63 b Dali, 1933

LIKENESSES

External reality as a source of eroticism

In my introduction I said that an important source of eroticism was the deceptive likeness: the introduction of external reality, of sexuality and sensuality, into a picture.

De Sade sees sensuality as movement: 'Ah, we should have had an engraver to preserve the divine image of sensual delight for posterity! But the final sensual enjoyment comes upon one so quickly that the artist would not have had time to portray it. Art which is itself motionless finds it difficult to reproduce an action whose innermost essence is movement.' It is indeed true that if the transitory element in erotic experience is to live on in a picture, it must be concentrated in a moment. We tend to use speech when we want to reproduce action, and indeed description is generally the most direct way of expressing sensuality. Speech puts the erotic power of the word to a direct test, insisting upon the physical accomplishment of the actions described. Whereas, if the visual arts try to achieve a realistic likeness, we only give them passing attention and this exposes them to the illusions of the voyeur. This applies both to the artist who sizes up his models and to the spectator faced with the completed work. However we shall see that the illustration of an event, in which content is generally communicated at the expense of artistic skill, is not the only way of capturing eroticism in art.

Sensuality and sexuality in Dali's work

In his book for painters, *Fifty secrets of magic craftsmanship*, Dali gives the following advice: 'Remember, then, absolute abstinence during the period of conception and love during your periods of realization.'[53] In *Diary of a genius* he says: 'Yes, sleeping and painting make me slaver with pleasure.'[54] He recommends abstention during the period of inspiration, but he exalts the process of painting to a sensual act, stimulated by regular sexual intercourse. We can see the effect of masturbation in

Dali's work from a pencil drawing (ill. 65) later worked over with a pen. In her biography of Dali, Fleur Cowles describes a meeting between Dali and Gala:[55] 'His passion nearly reached the limit of dementia; one day he was tempted to push Gala off the cliff on which they stood. Aware there was something she wanted him to do, he threw back her head, pulling her by the hair. Trembling in abject hysteria, he commanded her to tell him what she wanted him to do to her. "But tell me slowly, looking me in the eyes, with the crudest, the most ferociously erotic words that can make both of us feel the greatest shame!" "I want you to kill me," she calmly replied. The effect of her words was electric. Dali grew calm instantly. By intuitively inviting Dali to follow his own secret desire, she suddenly robbed him of all wish to do so.' The drawing (ill. 65) appears to be autobiographical: an erect outsize ideal penis which signifies masturbation, the motif of falling from the rock which we found in *The Fall of Icarus*, and at the same time the painful pulling back of Gala's head. The artistic merit of this drawing is debatable, but this is not because of its biographical content or because of its offensive nature – it is because there is an element of caricature, especially in the penis and the nipples. The sexual impulse appears to have run away with the artist here, for the drawing is far below the stylistic level of the other Dali drawings.

The drawings discussed here were executed in Dali's first artistic period, in the early thirties, when he was entirely under Freud's influence. Gala warned Dali at this time: 'you run the risk of reducing your work to a mere psychological document.' She was referring to his nauseating pictures with excrement, painted in minute detail, scattered everywhere. He replied: 'I swear to you, I'm not coprophiliac ... I consciously loathe this type of aberration ... but I consider scatology as a terrifying element.'[56] Various heaps of excrement appear in the drawing with the propped-up phallus (ill. 64) and in ill. 63b Icarus displays his anus quite openly. In *Diary of a genius* Dali sums up his relationship to the Surrealists in the following words: 'I had understood that the point was to transcribe thought spontaneously, without any rational, aesthetic or moral checks.'[57] However he soon began to sense the censure of his Surrealist friends: 'Blood they allowed me. I could add a bit of shit. But shit on its own was not allowed. I was authorised to represent the sexual organs, but not anal fantasies. Any anus was taken in very bad part ... They did not like anuses! I tried to trick them by giving them lots of anuses, carefully dissimulated, and preferably Machiavellian ones. If I constructed a surrealistic object in which no fantasy of this type appeared, the symbolic functioning of this object would be anal. I opposed pure and passive automatism with the active impulse of my famous method of paranoiac-critical analysis.'[58]

60

Bellmer's Dolls

Another Surrealist artist, Hans Bellmer, realized his intentions most successfully in a book called *The doll*. Here theoretical texts are accompanied by explanatory drawings, and although this does not represent Bellmer's main artistic achievement it does offer some insight into his working methods. The most significant elements in Bellmer's work are the photos of dolls reproduced in the book.

Bellmer began his 'Recollections of the doll theme' as follows: 'The pornographers, magicians and confectioners possessed that secret quality, the beautiful sugary quality, which we call nonsense but which brings us joy. They banished that displeasure which, in my experience, is usually linked with a functional purpose, and they indicated less familiar paths for my curiosity.'[59] On these less familiar paths the artist discovered 'the joy of producing pictures'. 'Perhaps the forbidden photos were really dangerous – but why were we not allowed to reproduce any of them? However my new enthusiasm finally caused me considerable irritation, and it's enough for me to remember that this is how girls came into my thoughts.'[60] 'But the thought of them left too many desires which insidiously, persistently, started moving towards a more definite target.'[61] 'If there was no promise here, it was reasonable to look for it in the mind: like the panoramas in my black boxes. But the girls – and this was the point – were neither little boxes nor alarm clocks, and therefore they did not offer the slightest opportunity of converting these desires aroused by their charm into destructive and creative activity.'[62] 'Certainly in the years that followed a fragment of what had been dreamed of was caught at times in a drawing, or in play with an oblivious woman, and yet how much escaped! ... But the doll, which only lived on the ideas one projected onto it, which in spite of its boundless adaptability must be destined for despair: could I not find in the creation of this doll-like quality all the lustful delight and climax which my imagination was looking for? When my aggressive fingers, following the shape, slowly created limb by limb what my mind and my senses had distilled, did I not achieve my final triumph over the girls, with their large eyes quickly glancing away whenever a conscious predatory look ensnared their charms? Fitting joint to joint, testing the number of different childish poses to which the doll could be adjusted, softly following the hollows, savouring the pleasure of the curves, losing my way in the shell shape of the ear, creating prettiness and also rather vindictively seasoning my creations with deformities.'[63] It is quite clear from these quotations that Bellmer was projecting his sexual impulses onto the dolls he created.

Jan Haworth has succeeded in creating a realistic fetish: she shows (ill. 66) a maid sitting indolently in the corner of a sofa. The concrete objects which surround her – the sofa, the cushion, the carpet – give an impression of reality, which then spreads

to the doll. It is distance which maintains the illusion, so that an erotic stimulus is produced. Both Bellmer and Haworth use the fetish and the sexual responses it evokes as a starting point for a work of art

Bellmer's 'The doll's games'

But for Bellmer the doll fetish was not an end in itself. He used it to create his ideal pictures, for he knew how to draw pleasure from these pictures. He therefore produced the coloured photographs entitled *The doll's games* 1937 (ill. 67 and 68). The sphere of the belly always forms the centre to which he later adds spherical joints invented by his artistic fantasy. The putting together of the doll's body is a creative act and it precedes the fulfilment of his artistic intention, for this is only achieved when he has decided how the doll is to be displayed. His unrealistic, meagre use of colour has an alienating effect on the tangible objects which we can see in his pictures; for example the bedclothes in photo XI (ill. 67), and the breakfast table, carpet, bed and clothing in photo XII (ill. 68). The perverse attraction of Bellmer's dolls is due to the fact that all the limbs are interchangeable. The possibility of dismantling the doll is suggested, for draped ball joints which have no apparent function lie near the stump of the body (ill. 67). Ill. 68 offers an inimitable image of the fusion of the male body with the female body. In visual terms a synthesis has been achieved. This synthesis, which is reversible, outlines an ideal picture of the 'hermaphroditic encapsulation of the male and female sex organs'.

Woman seen in Bellmer's dolls as a projection of the phallus

Bellmer expressed this idea of a synthesis in a more superficial manner, in a puzzle-picture (ill. 71) which was one of the illustrations in his book *The doll*. The text which goes with this picture reads as follows: 'Up to now we have probably never considered seriously enough to what extent the image of the desired woman is conditioned by the image of the man who desires her. So that in the last analysis there are a whole row of phallus projections, progressing from a detailed picture of the woman to an overall picture of the female species. So that the finger, the arm, the leg of the woman are coloured by his masculinity; so that the woman's leg squeezed into a tight stocking, with the thigh protruding, is coloured by his masculinity; so that the egg-shaped pair of buttocks from which the flexible spine gets its tension are coloured by his masculinity; so that the two breasts which hang from the elongated neck or which hang freely from the body are coloured by his

masculinity, as she sits with a hollow back, with or without a hat, or stands upright ...'[64]

However it is only in Bellmer's post-war work that the woman is seen, from the man's point of view, as a projection of his phallus. A drawing dated 1964 (ill. 70) shows a girl kneeling; her body is a phallus and her breasts are propped up on this phallus, as though she were drawing her pullover up with her hands, before pulling it over her head. The vagina shape of the upper part of her body thickens, and the drawing becomes much wilder as it moves up towards the girl's butterfly hairslide; in the background an ornamental wall is drawn in very faintly. The legs 'squeezed into the tight stockings' repeat the phallic image suggested by Bellmer in his book. In between her legs is the vague outline of a second phallus, while the suggestive shape of her shoes repeats the image of the vagina.

Another drawing from the same period entitled *After the weekly early closing (Après la fermeture hebdomadaire) c.* 1965 (ill. 69) gives a realistic picture of the interior of an inn when the drinking hours are over. The door is locked, the chairs are heaped on top of one another and the lamp is burning. An almost naked girl is resting her head on the table, while a phallus is trying to penetrate her from behind. It is not clear whether this phallus belongs to the girl's body or to the chair on which it is poised, in erection. Phallic shapes predominate: every chair leg is a penis and the exaggeratedly high heels worn by the girl repeat the penis shape. Moreover the entire foreground is taken up by a huge male member which has no thematic relationship to the scene. The portrait of a woman can be seen in outline in the oval wall mirror, for the mirror is an image referring to the female sex organ. Even the lamp appears to have been eroticized – the bulb surrounded by the lampshade is reminiscent of the phallus surrounded by the vagina.

Bellmer went on to exploit the direct erotic tension present in these drawings, using it to produce commercial prints. The loose structure of these drawings is strengthened by the decorative graphic line. Lines drawn at random have been systematized into hatching, so that the character of the drawing is determined by the ornamentation – in the crudest ones you would think you were looking at erotic paper patterns from fashion magazines. We can scarcely guess from these drawings the artistic intention which was expressed in the original works, because it has been made 'aesthetic' for general consumption.

Interchangeability of different parts of the body in Bellmer's work

'Since we must assume that the entire alphabet of the body is always at the ready in the brain, even after amputation, it follows that the parts of the body which lie within the framework I have described (ie. the chin, the shoulder, the arm) can in addition to their intrinsic significance be overlaid with analogies. These analogies are images of the sexual areas and of the legs and so on, and they have become available because they were repressed.'[65] Bellmer later developed this discovery further: 'As soon as the analogy: sex organ – shoulder is indicated by the intuitive position of the chin, the two images overlap and blend their content. The image of the sex organ is projected onto the shoulder, the image of the leg is projected onto the arm, the image of the foot onto the hand and the image of the toes onto the fingers. Thus there occurs a strange blending of the real and the potential, of the permitted and the forbidden from both components; and the one gains in realism while the other becomes less realistic. The result is an ambiguous amalgam of 'pure perception' and 'pure imagination', a double-layered image with iridescent contours. For both images, although intended to cover the same areas, are only approximately like each other.'[66]

A drawing dated 1942 (ill. 72) illustrates this idea. The theme of interchangeability is worked out on a series of figurines. The idea is that the arm enjoys simulating the leg and vice versa. However all these figures have one thing in common: their torso has been destroyed so that their extremities – head, arms and legs – grow from a central joint.

In *I and me (Je et moi)* 1949 (ill. 73) Victor Brauner has brought himself face to face with himself. On the left we see his genitals, attached to an animal's head. On the right we see his head with a crown on it; it is standing on crooked legs, with the genitals hanging limply between the legs and the arm growing out of the chin. Both the figures have been deprived of a torso. The animal demon leads the attack. He loads his spraying gun from his enormous sacks of munitions, and he is even sticking his tongue out aggressively. They are looking each other in the eye. The ornamental leafy wallpaper fills every free corner in the picture: as though on a puppet theatre stage, both figures are acting against a wooded background.

Horst Antes has rigged up a similar monster in his *Black-and-white figure (Figur Schwarz-weiss)* 1967 (ill. 74). This figure is a sort of trade mark which can be found in all his pictures. The large head set on sturdy legs creates a gnome which has raised its hand awkwardly in a Hitler salute. This being is extraordinarily sexless. The pipe under the chin may well be for drainage only, and the mark on the forearm which resembles the trace left by a kiss very quickly loses its magic in such ill-defined surroundings. In this picture eroticism has been eliminated by a shrinking

process – so that the interchangeability no longer has the erotic effect that it has in Bellmer's work.

Physical sublimation in Bellmer's work

Gorsen has shown[67] how Bellmer's works prove that 'we can also sublimate with our bodies, that a physical need can not only be transposed into a psychic need but can also be converted into a new physical need. We can begin to resemble the object we desire – and I do not mean this in an absurd metaphorical sense, for this change is so real that the physical nature of our desire is modified. It is possible to attain, within the everyday physical world, what appears to be unattainable, and indeed we find it subtly more attractive to satisfy a physical need in this way. For if we try to sublimate our physical need, to transpose it to the supposedly higher and more exalted plane of spiritual works, we find that spiritual works only increase our discontent, in their efforts to appease a consciousness which demands to be satisfied at any price – even with stale thoughts and the debris of Weltanschauung and culture. In fact the creator and anatomist of the sensual and pictorial rightly finds this elevated spiritual plane disturbing.' This statement would imply that the 'body schemata' which Bellmer invented are in fact 'sublimation schemata'.

A hand-coloured photo-montage of 1936 entitled *The doll (La poupée)* (ill. 75) reminds us that the doll is Bellmer's artistic ideal. The numerous spheres of the breast are moveable and they provoke us to play tactile games with the doll. In the photomontage the limb-joints above the head become a projecting hat, decorated with graphic ornaments in the pointillist manner. The attraction of this work comes from the strange blending of different levels of reality. The realistic, though rather flat, photograph of manufactured dolls' limbs makes the collage seem alien, but since the sharply defined outline stands out freely against its background, the montage gives an impression of three-dimensional reality and we believe in the existence of the doll.

Varying ways of capturing eroticism in art

Many other artists, whose approach is quite different from Bellmer's approach, have also succeeded in capturing eroticism in art. The impact of Eva Aeppli's doll (ill. 76) is just as strong as that of Bellmer's dolls, but this doll has a different kind of attraction. For the work is not an illustration but a real doll. Here eroticism has changed to horror. Her hands are clapped to her face with the fingers spread open so that she can look through them, and her mouth is open as though she were about

to cry. The hands belong to the face and they are an integral part of the cheeks, but we do not have the feeling that the arms are missing – and this conforms to Bellmer's principles. But in time the feeling of horror subsides: then the mouth and nose only too easily become symbols of the genitals, while the hands cover the eyes in a final impulse of shame – while making quite sure that they can still see everything.

Paul Harris sewed together his *Woman smelling her roses* 1966 (ill. 77) from coloured materials. This doll is far less alarming than Eva Aeppli's. The intention here is aesthetic: our curiosity is aroused by the way the woman's body blends in with the flowery chair, so that the upper part of her body seems to grow out of it. The way her head is buried in a phallic bunch of flowers is incidental, though not without erotic charm.

The Surrealists discovered a game which they called 'exquisite corpse' ('cadavre exquis'). André Breton explained it as follows: 'Game of folded paper played by several people, who compose a sentence or drawing without anyone seeing the preceding collaboration or collaborations.' The Surrealists were very excited at this 'infallible way of holding the critical intellect in abeyance, and of fully liberating the mind's metaphorical activity'. The resulting sentence or drawing always 'bore the mark of something which could not be created by one brain alone'.[68] If you play this game with drawings the human figure is obviously the best thing to draw, because it can easily be divided into head, trunk, legs and feet. In 1961 Lilo and Konrad Klapheck and Eva and Joseph Beuys together produced a series of these 'exquisite corpses' (ill. 78–81). It is interesting to see how the theme becomes progressively more erotic during the game. In the first drawing (ill. 78) we have a full frontal view of the figure and the thing we notice is the slender athletic trunk; the genitals are still a warning triangle and the figure has inordinately long toes which are locked together. The remaining drawings in this series have been given titles. The second drawing (ill. 79) is called *Goethe secretly observed by Eckermann*. Here the breasts are pointed and the head has also become active, but the real action is limited to the feet. We can see a shoe, a bare foot, two toes holding a cigarette. There is also a naked man with an erect penis sliding himself along the floor, with his tongue thrust right out so that he can lick the woman's huge toe. The third drawing (ill. 80) is called *Odysseus observing Circe*. Circe is holding a phallic jewel in her hands and it looks as though she is about to put it away in her bedside cupboard. There is hair under her armpits and around the genital area. There is a monster armed with a phallic arrow which has its jaws wide open, ready to bite into her rounded buttocks. In the fourth drawing (ill. 81), *Callas*, there is a gigantic phallic tongue hanging from her neck and she is pulling her sexual organs wide open with both hands. A naked woman dressed in shoes and stockings is being ejected from a hole in Callas' bottom. Callas' right foot is a long winding phallus.

Paul Klee sometimes attempts to give a drawing an intellectual note by using an allusive title. These titles often refer ironically to our cultural heritage, and this is the case in *Joseph's chastity arouses the displeasure of the gloomy regions (Josefs Keuschheit erregt den Unmut der trüben Regionen)* 1913 (ill. 82). Joseph is running along the bottom of the picture towards the right. His right arm is raised as though to defend himself and his genitals are exposed to our eyes. A figure which must be Potiphar's wife has just fallen to the ground and is stretching out its hands, snatching at his penis. Above them are three figures, gesticulating wildly with their arms and legs, who look as though they had come rushing through the air from a long way away. It is difficult to distinguish all the dangling genitals – but there is no doubt that the thighs surround the genital regions, the gloomy regions, in their displeasure.

Gerhard Altenbourg's drawings were initially inspired by Klee, but he then adopted Wols's style. In *No man is born a master of his craft (Es ist kein Meister vom Himmel gefallen)* 1949 (ill. 83) Ewald is trying to prove his manhood. We can see the moon and the stars in the sky behind him. There are little men falling to the ground, landing in the place where they want to be masters, in the slit of the rhombus-shaped sheath. Similar childish sex symbols are scrawled around the edges of *Boy at puberty (Knabe in Pubertät)* 1949 (ill. 85) – like notes in the margin of a manuscript. This picture is a self-portrait: it shows the artist in his puberty. He remembers how his surroundings caused him anxiety and how he could only see them from one specific viewpoint. His awakening sexuality not only changed the functions of his body but also made the whole world appear in a new light. The boy is turning to symbolic images in an effort to banish what oppresses him.

Pubescent boys are the main theme in Otto Meyer-Amden's work – hermaphroditic figures who in their childish innocence are still hardly conscious of their bodies. The artist first of all established virginity as an ideal for himself. He thought a man should be as pure as his work and he insisted on asceticism, even in sexual matters, and the renunciation of good living and comfort. He was convinced that an artist could only keep his art pure if he kept away from women. And yet his work is full of sensuality: he restrains his sensuality but this only makes it all the more intense. The pencil drawing *Nude youth in the pine forest (Nackter Jüngling im Tannenwald)* 1912–4 (ill. 86) shows a slender boy's body moulded by the light, against a dark background of plants. The swelling form of the boy's body is motionless, as though he himself had become a plant.

Oskar Schlemmer's style was very similar to Meyer-Amden's in some sketches which he did for the murals for the Folkwang Museum, in 1928. The prescribed theme was 'the National Youth Movement of our time'. In one of these sketches (ill. 87) we can see three youths with outstretched arms, each one standing a little higher than the one in front of him. The striking feature is the spatial quality of the

bodies: the boys seem to sway like suspended spatial elements as they lean towards one another. The picture entitled *Entry into the stadium (Eingang zum Stadion)* 1930 (colour ill. IV) takes up the same theme, with its naked male figures between clothed female figures. Schlemmer has modelled his work on classical Greek art and has marked out the space in his picture, and it is through the positioning of the human bodies that he has achieved an illusion of space. Sensuality is expressed initially in the dancing movements but it is than expressed more definitely in the modelling of the bodies with their bright colours. Colour gives a light, swaying quality to the swelling shape of the limbs, softening the structural element and giving a vivid impression of space.

Dance is the most distinctly erotic element in Schlemmer's work. In a letter to Meyer-Amden dated 11 February 1918 he wrote: 'Recently I read of Kierkegaard's theory that the most abstract idea imaginable is the sensual, erotic originality of genius, whose one and only means of expression is music. Dance must also be included in this category, since like music it represents eroticism directly as a succession of moments, unlike painting and sculpture which concentrate on one moment.'[69] And this is exactly what Schlemmer is trying to catch in the dance poses in his pictures: a succession of movements. In his pen and ink drawings the volume of the bodies is reduced to an outline, with flat surfaces stretching in between. These drawings express the most abstract conception of eroticism in concrete form. Examples of this are: *Two swaying figures in counter-movement (Zwei Schwingende in Gegenbewegung)* 1928 (ill. 90) and *Suspended kneeling figure (Knieender in Schwebe)* 1928 (ill. 91). Another example is *Three figures (Drei Gestalten)* 1928 (ill. 88): Schlemmer also called this *Standing youths (Stehende Jünglingsgestalten)* but the figure on the left is obviously a girl, for we can distinguish the outline of a dress from the horizontal line at the neck and from the curving line at the hips with vertical folds beneath it.

A pen and ink drawing by David Hockney dated 1966 (ill. 89) shows two naked youths in bed together. They are looking towards us; their arms are folded behind their heads and the lower part of their bodies is covered by the bedclothes. The eroticism in this drawing is concentrated in the artist's impression of the situation, but it is also expressed in the young men's eyes. The drawing is a sketch for sheet 11 of a cycle of etchings illustrating fourteen of Cavafy's homosexual poems. Another drawing dated 1969 (ill. 84) shows a young man dressed only in bathing trunks sitting idly. Here too erotic homosexual feelings are excited by the direct but veiled look, and particularly by the promise of what is concealed in the bulging bathing trunks. The attraction of the drawings lies in the simplicity of line which dispels any oppressive, sentimental associations.

If we compare two drawings by Henri Laurens we can see how well eroticism

68

can be hidden in a sensitive line. At first sight the drawings are so alike that they could easily be confused – indeed one of the drawings must be a copy of the other. They have the same title: *Striding female nude* 1948 (ill. 92 and 93). The voluptuous nude is stretching and her arms are entwined above her head, while a shadowy phallus is thrusting up into her. (It is interesting to see how, in a small sculpture called *The awakening (L'éveil)* 1952 (ill. 94), Laurens has used the same position of the arms but has conceived the seated body as a male sexual organ, so that the theme of the sculpture is the fusion of male and female.) In the two drawings the subject-matter is identical. But the nude on the right (ill. 93) is drawn in pencil while the one on the left (ill. 92) is drawn with chalk, so that the one on the right is more suggestive. And if we study the lines, we can see that the drawing on the right is tauter in all its details, for the line follows the shapes closely: the elbows, the buttocks the breasts, the face with nose and mouth and eye and hair. The drawing on the left looks rather tired, its lines more uniform, less tense. There was nothing more for the artist to accomplish because he had already mastered the forms at his disposal. Instead the drawing has become much slicker because he softened the roughness as he repeated it. It is easy to see what he has lost in his attempts to beautify the lines: he has lost the woman's movement as she stretches upwards and this is what gave the first picture its note of truth. Even the shadow phallus has lost its tension and now has a purely decorative function.

The female nude as a means of introducing sexuality and sensuality into art

The female nude has always been one of the central themes in the visual arts. It is also one of the most important ways of expressing eroticism, because it immediately evokes sensuality. In an attempt to shock us René Magritte reduced the naked female body to its sexual function, by transposing the torso onto the features of a woman's face, while preserving the hair around her face. The picture is called *Rape (Le viol)* 1934 (colour ill. III). But the 'rape' or 'violation' is ambiguous for the picture could mean that in the man's eyes the woman's face has been transformed into the part of her body that he desires. We can compare this painting with a drawing by Magritte (ill. 96) where the girl's head has a challenging erotic look and the curves of the eyebrows make the eyes seem wide open. Here the suggestive nakedness of the face makes it seem all the more suited to rape.

In his picture *Brother and sister (Die Geschwister)* 1931 (ill. 99) Bruno Goller shows the top half only of two nude women who stand together, one slightly behind the other. Their bare breasts are shaped like buds and the breast of the girl who is half hidden shimmers through the curling leaves of a branch. Thus the breasts become

rounded fruits above the frills of her dress while the erotic element concentrated in the nakedness of the two faces is more powerful than any picture of naked genitals. In a first sketch for his picture *Large female head (Grosser Frauenkopf)* 1959 (ill. 97) Goller transferred the centre of erotic attraction to the bewitching eyes. The peculiarly slanting mouth and eyes; the openness of the face which only appears as a whole when our imagination works on it; the statuesque contrast between the base of the neck and the band ornamenting the picture which vividly repeats the shape of the eyeballs – all this gives the head a monumental appearance and yet preserves its sensual, living quality.

In 1962 Goller painted a life-size female nude (colour ill. V) but concealed the lower half behind a screen – and so we again have a half-portrait of a nude woman. The girl's right arm is bent so that her right hand seems to be touching her left shoulder. Her body does not offer any erotic stimulus, for her breasts are veiled rather than prominent. But again her glance has an open sensuality and it is this which suddenly transforms the area around her eyes and nose into a male sexual organ, as if in fulfilment of a hidden desire. And from now on any attempt at innocence ends. The girl's plait sticks out from her shoulder at an odd angle, as though in erection. There is an ornamental pillar behind the girl, composed of rods and round shapes balanced on top of one another, and the plait is pushing aggressively into the pillar, making it sway. There is another pillar in front of the girl, but this one is more static. The rods in the pillars remind us of the penis while the round shapes suggest the female sexual organ – indeed in the bottom left-hand corner of the picture the oval is actually pierced by the rectangle. The ornamental strip on the folding screen seems almost to be a projection of the girl's pubic hair.

In *The primacy of matter over thought (Primat de la matière sur la pensée)* 1931 (ill. 98) Man Ray used a photographed nude as 'matter', in order to show that matter is superior to thought. But he used the photographic process of solarization which has veiled the realism in the photograph and given the recumbent body an immaterial quality – which would seem to contest what he asserts in the title.

In *Woman bathing (La femme au bain)* 1966 (ill. 101) Jean Ipoustéguy wants to show a female nude in the bath. The open end of the bath harmonizes with her body. Her bronzed skin is polished and shining; her mouth is opened lustfully and her hands are sweeping the suds from her hair. She has stretched out her left leg but her right leg is folded under her. The foam-lid is hinged and it can be fitted over her body. There is a certain neo-classical realism in the nude figure which makes a stronger impression than the superficial note introduced by the hinged lid. It softens the impression of perfection, of unartistic, streamlined elegance created by the polished material – so that the spectator is reminded of the structural, three-dimensional quality of the work. However it is only in the foreground that eroticism is expressed.

70

Eugène Dodeigne's *Torso (Torse)* 1962 (ill. 95) is completely different. The forms of the female torso are sensed in the rough block of blue-black Soignies granite but they are not physically tangible. Only the breasts are smooth, as though they had been polished by a lot of handling – and this is what creates the erotic attraction, for the sculpture suggests that we should try to grasp these breasts.

The woman's body in Enrico Baj's *Reclining nude (Nu couché)* 1960 (ill. 100) is equally massive. The attraction of this collage lies in the contrast between the dark felt texture of the voluptuous nude and the striped mattress and flowery wallpaper in the background. Philip Pearlstein used a similar contrast in *Nude on Kilim rug* 1969 (ill. 104) where a female nude is lying on an oriental carpet. The aggressive arrow pattern of the carpet indicates the male sexual organ.

In Howard Kanovitz's *Nude Greek* 1965 (ill. 102) the woman is standing there openly, her hand on her hips. In this pencil drawing the artist is trying to show realistically how the light models the naked body. The decorated bedcover and the cushions, on the sofa in the background, are almost like a landscape. In the finished version (ill. 103) the forms are cruder. The nude is decorative and challenging. It is almost as if she had been cut out and stuck in front of an ornamental piece of scenery, depicting a bed. The proportions have been changed: the nude is smaller and therefore more compact in relation to the surrounding space. The background has become dark and the ornamental cover now has the aggressive quality we noticed in Pearlstein's work.

The pose adopted by the female student in Gerhard Richter's painting is even more open. In *Female student (Studentin)* 1967 (ill. 105) the nude is seated and her wide-open thighs direct our eyes to her sexual organs. As is often the case in Richter's work, the fuzziness of the picture is intended as an embellishment and it is not an essential part of the picture. In *Emma – nude on a staircase (Emma – Akt auf einer Treppe)* 1966 (ill. 17) Richter used the same technique of blurring the paint to achieve a similar effect. It is interesting to compare *Female student (Studentin)* with Jochen Hiltmann's drawing dated 1965–6 (ill. 106) which shows only the trunk of a female body. The details are all emphasized with great precision. The corset contrasts with the naked parts of the body: breasts, pubic region, thighs. The woman's sexual organs are drawn in the same style as the clasps of the suspenders – so that this object lying amidst the physical mass of the thighs, in an almond–shaped aureole of pubic hair, is like a technical tool and its mechanical functionality makes us feel uneasy.

In a drawing by Joseph Beuys dated 1957–8 (ill. 108) a naked girl stands with her legs crossed and her left hand is playing with her sexual organs. Her nervous movements are emphasized by the loose pencil lines, especially by the repeated outlining of the forearm. The drawing focuses on the crossed thighs, localizing the centre of sexual pleasure. Behind the girl looms the silhouette of a huge ideal penis with a

dark tip. However in Dieter Stein's drawing (ill. 107) the woman's hand is posed peacefully between her legs. The breast, arm, belly and thighs are clearly outlined and these contours convey to us the volume of the body. The drawing becomes looser in the pubic area and the curling hair emphasizes this. The ring on the woman's finger is pointing symbolically at her genitals, with her fingers acting as a substitute penis.

The three-dimensional smaller than life-size female nudes by Frank Gallo, of which *Quiet nude* 1966 (ill. 109) is an example, are realistic. But they retain their self-conscious, doll-like quality: their look of boredom and their strong physicality reminds us of the 'girlie' pictures in popular magazines. The artistic element is severely restricted. The lifesize figure *Woman no 2 (black)* 1969–70 (ill. 110) by John de Andrea can hardly be surpassed in its realism. It looks as if it had been cast from nature and then trimmed with hair. But it has about as much artistic value as a wax-work, for the artist has the limited, manual dexterity of a make-up man. This kind of picture is only impressive at first glance. William Bailey's nudes, on the other hand, have a certain cool realism which saves them from banality. The simple poses are emphasized by the realistic background, both when the nude is sitting as in *Italian* 1966–8 (ill. 112) and when she is standing as in *French room* 1967 (ill. 111). It is strange how the bodies become living organisms although they are surrounded by emptiness.

In Francis Bacon's nudes there is no attempt at realism. In his *Nude* 1960 (ill. 113) the naked body has been reduced to a pictorial gesture. The nude is resting on pillows with her arms behind her head and her contours are outlined with swift, shadowy brushstrokes. Her face is distorted by movement. Indeed in both *Nude* (ill. 113) and *Two figures* 1953 (ill. 114) eroticism has been turned into a sort of fetishism with deformity as its outstanding feature. In *Two figures* the pictorial space is marked off by lines of perspective. There is a bed in the centre with two naked figures on it engaged in a struggle. The movement is so violent that we cannot see clearly what is happening or what their motives are, but we can still see that there are two people involved in this complicated procedure. There is no doubt that the photograph of two wrestlers which Bacon used as a model has been translated into a sexual struggle here.

There are even stronger sexual associations in Eugène Dodeigne's sculpture *The couple (Le couple)* 1963 (ill. 116). Two crudely carved granite blocks have been laid one on top of the other. It is the position of the two blocks – rather than deliberate allusions such as the squared-off leg – that makes us think of sexual intercourse, for in their sensual fury the two bodies are dashed against each other. In George Segal's life-size group entitled *Legend of Lot* 1966 (ill. 115). Lot is lying on his bed in a drunken stupor and his elder daughter is bending over him, because she wants to sleep

with him. The younger daughter stands waiting for it is not her turn yet. But in the background is Lot's wife who is stiffening into a pillar of salt because she turned back to look at Sodom and Gomorrah. Segal's naturalistic casts are in rough white plaster. The texture of the casts and the way the figures are isolated somehow makes them seem less realistic. The plaster also emphasizes the subject-matter – it reminds us that Lot's wife is turning into a pillar of salt.

The subject of Christian Schad's *Self-portrait with model (Selbstbildnis mit Modell)* 1927 (ill. 118) is the meeting of a man and a woman. The painter and his model are sitting naked, half leaning on a bed; the woman is slightly behind the man, so that her genitals are obscured by the upper part of his body. The man is wearing a surrealistic skin shirt. The heads and breasts set the tone, but the objects in the picture also refer to their sexual organs – the flowers to the woman's and the factory chimneys to the man's. The picture has a fresh, astringent quality which increases the erotic tension.

In Pearlstein's *Standing male, sitting female nudes* 1969 (ill. 119) the poses are clearly defined. The area which the artist has chosen to include in his painting is more random and this makes the foreground more realistic. The bodies are the only significant elements in the picture: they are modelled by the light and the genitals are more exposed than in Schad's picture. And yet the erotic element seems to have been neutralized, so that we simply see two people, one sitting and one standing – after all they are only models and they are not expecting anything from each other.

In an etching from Picasso's *Vollard* sequence of 1933 (ill. 117) a nude woman is turning to a triumphant monster who is seated on a throne. The title mentions a 'surrealistic sculpture'. But this sculpture appears to have come to life under the penetrating glance of the girl, who is crowned with a garland. The monster's arms are moving busily. The objects displayed on the cushion in front of it remind us of its sexual organs.

In *Pygmalion* 1939 (ill. 120) Paul Delvaux shows a nude woman passionately embracing a male torso carved in stone which stands on a wooden chest. Greek mythology tells how Pygmalion fell in love with an ivory statue of a girl which he had carved himself and how she came to life at the touch of his hands. In Delvaux's work the roles are reversed for it is the woman who is trying to arouse a man made of stone. The shadow cast by their two bodies makes it look as though this fusion has already been completed. The surrounding landscape is surrealist in its direct illumination, which casts clear shadows. The court-yard in the foreground is enclosed by a kind of wooden studio but we can still see through to the landscape of dunes and to the sea. Through the open door of the wooden studio we can see a burning lamp hanging above a table, and to the left, in the open part of the studio, there is a life-size male sculpture. On the right-hand side of the picture is a woman

bearing a branch from a tree: perhaps Daphne. There is also a man with a black frock-coat and a bowler hat. They have both stopped in front of a boldly drawn house front, as though frozen in the act of walking. In spite of this deliberate attempt to divert our attention the dominant activity is concentrated in the middle group, thanks to Delvaux's economy of style in the presentation of these two figures. The woman is plunged in thought and she is looking away from the object of her love. But her whole body is turned towards him and so we are all the more urgently aware of her desire to bring him to life.

In *Simple and gentle picture (Tableau simple et doux)* 1965 (ill. 123) Martial Raysse, with his own individual charm, has paraphrased François Gérard's famous picture *Amor and Psyche* 1798 which is in the Louvre. He has cut out a photograph of two figures, mounted it on a simplified collage-landscape and retouched it. Amor is holding an illuminated heart in his hand: this is a pleasant way of presenting a classical theme without any sentimentality. And at the same time Raysse manages to convey a feeling of intimacy in this picture.

Hands

In the title of his sculpture *Alfa and Romeo* 1964–8 (ill. 122) Miguel Berrocal is alluding both to Romeo and Juliet and to the racing car. Thus two worlds are linked: a human world and a technical world. A female torso and a male torso are joined to each other, but their shapes have been reduced to a minimum. The hands are very clearly defined and they give cohesion to the structure, which can in fact be split up into its component parts. There is sensuality in the hands, which gives a little warmth to this relic of a pair of lovers.

In Bruno Goller's picture *The bridal veil (Der Brautschleier)* 1952 (ill. 121) the chaste sensuality is concentrated in the motif of the hands in the right-hand section of the picture. The girl leans her cheek tenderly on her husband's hand and all we can see of the husband is his hand and his sleeve. The girl is pressing his hand, but his is the only hand we can see – almost as though the one hand belonged to both of them. In the left-hand section of the picture is an ornamental stand with a bridal veil and a myrtle twig. Decorative ribbons frame the two sections of the picture.

In Marisol's group *Double date* 1963 (ill. 124) hands again predominate: they are reaching over the packing cases which form the body of the sculpture. Two couples are dancing in front of a simply decorated wall which probably represents a nightclub. The two bodies of each couple have been fused into one packing case, with only the heads and legs and hands defined. The couples' intimacy is concealed by the packing cases, in a bourgeois fashion – this possibly stimulates our imagination but

74

there is nothing immediately erotic in this work. It is interesting to compare it with Warhol's *The kiss* (ill. 125) which is completely different – Warhol maintains the tension of a kiss, like in a filmstrip. And Dodeigne's sculpture *The couple (Les deux)* 1965 (ill. 127) is different again, for he manages to give a three-dimensional representation of the coming together of two bodies.

Sexual intercourse

Edward Kienholz uses an illusionistic style in *The backseat dodge'38* 1964 (ill. 128). The props are real – the car, clothing and beerbottles. But the couple on the back seat is a combination of (female) plaster and (male) wire doll – with a common head. This immediately destroys the realism of the work. A breath of macabre decay lies over the pair, as though all this had happened a long time ago; as though there were nothing left but the outer framework and a pair of indestructible relics who still conjure up what their memory has preserved.

For Cesare Peverelli sexual union is like a return to paradise. The title of his picture *Birds of paradise (Les paradisiers)* 1962–3 (ill. 126) conjures up this image. He uses hatching very effectively to absorb the interlocked bodies into the area of the picture (ill. 130) or to concentrate our attention on the action of the bodies (ill. 126). A new organism is being formed from the union in *Birds of paradise*, an organism that it would be difficult to analyse anatomically.

The drawing *Violation during the night (Nächtliche Vergewaltigung)* 1945 (ill. 129) by Roberto Sebastian Matta shows two phantoms violently clawing each other, while their bellies seem to be joined together by suction. The female phantom is defending herself desperately with her arms and pushing away the intruder. It is her gesture that fills the picture with tension.

In a drawing dated 1929 (ill. 131) Joan Miró shows the male partner, charged with vitality, in full action: it looks almost as though he were turning his limbs inside out. He has penetrated the motionless outline of his female counterpart. In another drawing dated 1933 (ill. 136) Miró again gives the aggressive role to the male, for the phallus is aimed at the woman's genitals. But it is the penetrating horizontal shape which intensifies the thrust, while the circular female shape illuminates the night sky, like a moon.

Jean Dubuffet shows the sexual act with disarming nonchalance in *Variation XIII 1949* (ill. 135). There is a naivety, which reminds us of children's drawings, in the way he reduces sexual intercourse to a functional process. But there is a mastery and a concentration in his brushstroke outlines unlike that of any child. The woman's head is tilted to one side with an orgiastic grin, the widely spread legs, the hands

pulling open her genitals, the powerful movement of the man's legs. In a lithograph (ill. 134) the tension is shifted upwards to the hands, which are fused in a tongue kiss. What is happening in the genital area is now less important, for sexual union has taken place long ago. A gouache called *Man urinating on the right IV (Pisseur à droite IV)* 1961 (ill. 133) is equally powerful in its realism. A man is urinating openly and his concentration is reflected in his face and in his pose.

Robert Graham's small wax figures are the last word in realism. Four polaroid photographs (ill. 132) of one of his wax figure groups, taken by the artist, show a man and woman having intercourse on a bed. The photograph creates a distance between the action and the observer and at the same time prevents us from realizing that these are only wax figures. Graham offers us a simulated realism which a tiny, doll-like group of figures could never achieve.

Eroticism in Picasso's work

There is an entry in Brassai's *Conversations with Picasso* dated 15 May 1945 which reads:[70] 'Picasso leads Paul Eluard and me into his little adjoining apartment, and tells us, with an enigmatic smile: "I am going to show you something." And he takes his private notebook from a drawer. It is this book to which he confides his very first sparks of inspiration, and also – primarily, in fact – his sexual obsessions. All of his work that can be placed under the sign of Eros undoubtedly stems from these masculine preoccupations. And an astonishing anthology could be made from all of those female bodies in which the sex is underlined, the points of the breasts aggressive, the line of the buttocks opulent and quivering. Even *Les Demoiselles d'Avignon* the painting that gave birth to cubism and long since a classic – would be part of it. Was the painting itself not born of an erotic dream, and originally titled *Le Bordel d'Avignon?* And yet, in all these images of desire, a light veil of modesty disguises and transposes his obsessions into the symbolic, the magical, the mythological ... It is only in his intimate notebooks that Picasso gives free rein to his eroticism. Like the majority of great masters he has a stock of works that are kept 'under the counter' and completely apart from the main body of his work. There is a little notebook always within reach, to receive his most immediate and intimate confidences. "Art is never chaste", he told me one day as he was showing me some erotic woodcuts of Utamaro – prints of a rare beauty in which the organs of sex figured prominently but were stripped of all crudity and emerged as so many strange vegetable forms, part of a strange landscape, shaken by a strange wind of emotion ... The notebook he shows us now is undoubtedly just a sample. Paul Eluard and I leaf through it'.

But in 1968, when he was an old man, Picasso published something which was just as erotic as his 'diary': a series of etchings entitled *Painter and model* which were intended for reproduction. In the etching of *31 August 1968* (ill.137) the voluptuous model lies with her thighs spread wide open. The painter has put aside his palette and he is lying down too. His powerful penis is pointing upwards, and it is so big that it looks more like a bull's than a man's. The painter's expression reminds us of Salvador Dali's, although his costume is reminiscent of Raphael. There is no action yet, but a bearded old man wearing a crown is looking with great interest at the painter and the model, through the drawn curtain. In the etching of *3 September 1968* (ill.138) they are not just kissing: the painter is about to penetrate the woman. He holds his palette in his right hand and he seems to want to repeat the thrust, with the brush in his left hand. The economy of line in this etching emphasizes their nakedness. The etching of *7 September 1968* (ill.139) again shows the bearded voyeur behind his curtain. The painter, who is dressed this time, has forced his model to make love with him. He is holding his brush in his right hand, while his left thumb, inserted in the palette with the three fresh dabs of colour, reminds us that his penis has just recently inserted itself in the woman.

Erotic allusion in American Pop art

Peter Gorsen has unmasked the erotic element in American Pop art as a 'refined variant of sexual adjustment through fun; the Pop artist sees this type of sexual adjustment as a repressive way of removing inhibition in the American way of life'.[71] John Wesley's naked girls in monotonous rows in *Six maidens* 1962 (ill.141) stimulate nothing except boredom. The ornamental frame encloses them as though they were soldiers marching in a stage production. In *Captives* 1962 (ill.140) the girls again sit close together, as if they were in a revue. The rings of their dark eyes move in a Micky Mouse style. It is interesting to see how Mario Ceroli produces a completely different impression when he exploits the same idea of putting girls in rows in *Venus (Venere)* 1965 (ill.142). The brittleness of the wooden material helps to make the picture more lively. At the same time he gives us an impression of movement, through the repetition of a single element in overlapping layers, which spreads the picture out in space. We can see this repetition in *Venus* where he has used the silhouette of Botticelli's Venus and also in *The he-man (Il mister)* 1965 (ill.143) where a powerful man is flexing his muscles.

Tom Wesselmann said of the eroticism in his work: 'To me, a tit is erotic but the painting isn't. I've got a certain long range program about sex, though, that may put me in prison in five years ... I am involved with eroticism but more in the

painting. I suppose my nude will become more erotic in time … the form intensifies the eroticism, you might say.'[72] In the details from Wesselmann's *Great American Nude* 1968 (ill. 147 and 148) the open mouth and the budding breasts of the reclining woman stand out; the face is entirely dominated by the mouth – otherwise it is empty. However the mouth is obviously meant to allude to the female sex organ, and it is interesting to see how Martial Raysse also emphasizes the area of the mouth in *Elaine Sturtevant* 1968–9 (ill. 146), using a neon light. If we compare Wesselmann's four girls drawn in 1963 (ill. 153) with the two 1968 drawings (ill. 147 and 148) we are inclined to think that the vital spontaneity of the rough pencil sketches communicates a greater erotic impulse than the monumental later versions, with their decorative smoothness which is conciliatory and neutral. If this is so then Wesselmann's nude is not becoming 'more erotic in time' and Wesselmann should be classed with the Pop artists Gorsen describes.

Larry Rivers also expressed his views on eroticism: 'I admire Indian erotic art, the soft, symbolic female and all that. But my view of woman is completely different. The little comic books we bought as kids influenced us more than anything else – those fantastic asses and phalluses. They were funny!'[73] But in fact Rivers' paintings show few features which could be regarded as fun. In the collage *Parts of the body* 1962 (ill. 145) actual pop elements can hardly be detected – unless we regard the words in the collage as pop elements. It is no longer the nude which arouses our interest but rather the different parts of the body.

The worst example of 'sexual adjustment through fun' is Mel Ramos' paintings. His phoney nudes flirt ostentatiously with consumer goods, as if they were touting for publicity. *Catsup queen* 1965 (ill. 150) and *Lucky strike* 1965 (ill. 151) and *Chic* 1965 (ill. 149) are all examples of this. The phallic contrast suggested by the catsup bottle is brought out quite clearly in *The great red kangaroo* 1968 (ill. 152) by the kangaroo's solid tail.

As soon as the English began to get to grips with the American pop scene they introduced a European note of social criticism. A small collage by Richard Hamilton was the pioneering work here. It appeared as early as 1956 and had the title *Just what is it that makes today's homes so different, so appealing?* (ill. 154). This picture poses the essential question about the world we live in and our critical sense is forced to react. In Hamilton's *Adonis in Y fronts* 1963 (ill. 144) the title underlines his ironical, aloof attitude towards the popular body-building ideology. And Kitaj shows the same critical attitude when he attempts to capture the world of *The Ohio gang* 1964 (ill. 155). He describes the seamy side of the American way of life, the underworld of gangsters and prostitutes. It is as though a number of scenes had been superimposed – so that a whole story finds its way into the picture.

Richard Lindner's work has become progressively more integrated in the

American scene, although he was originally inspired by the European tradition of art – and this is one of the reasons for his enormous success. The banal gaiety of his pictures is well suited to the American consumer market. He uses broad, carefully balanced canvases which are decorative and symmetrical, as in *Disneyland* 1965 (ill. 156).

Allen Jones has done the same thing: carried away by success, he felt more and more impelled to surrender to success. In *The table* 1969 (ill. 162) the life-size female doll's body clothed in enticing lingerie has become a mere support for a glass table-top. To use a woman as a support for a table is quite a witty idea – but in the mirror we are reminded of what has been lost by this. In *Woman (Frau)* 1968 (ill. 160) Paul Wunderlich has used the same theme but has given it a completely different treatment. The atmosphere he conjures up is much more disquieting. The upper part of the body, sprayed in various colours, stands against a blue background. The torso is made of strips of onyx but the lower part of the body is a polished mahogany console. 'Good living' could not be more kitschy.

The fantastic realists

In their use of mannerisms the painters known as 'fantastic realists' exploited the style discovered by the Surrealists. Their deceptive strength comes only from a brilliant technique – and it is well to point out the phoneyness of this technique. Their sophisticated erotic themes distinguish them from philistine academic paint-ers, but this in itself is of no great merit. Ernst Fuchs's work for instance opened up a new market which is extremely questionable. Examples of his work are *Death and the girl (Der Tod und das Mädchen)* 1967 (ill. 158) and *Pan* 1969 (ill. 161). While Dado has conjured up macabre, corpse-like gnomes which might well fill an associative dream world but which seem rather irrelevant (ill. 159), Horst Jannsen has produced a few humorous drawings and has characterized his figures very suggestively. *Geile Milli* 1968 (ill. 157) and *Souvenir* 1965 (ill. 163) are examples of his work. However as soon as he attempts to perfect his drawings his brilliant technique pushes him into a chic style and the subject-matter becomes merely a pretext for displaying his skill.

Paul Wunderlich : 'pornographic works of art'

Paul Wunderlich's work is in many ways similar to that of the fantastic realists. According to the American press he is: 'more elegant than Beardsley, more graphic than Grünewald, more phantasmic than many of the Surrealists'.[74] Peter Gorsen has also analysed Wunderlich's work. He wrote: 'In Paul Wunderlich's series of lithographs *Self-explanatory (Qui s'explique)* 1959 (ill. 164 and 167–9) sex appears as pure genital power, as though we were seeing the reversed, mirror image: an impotent extraneous growth which is represented by a dozen erect, monstrously enlarged penises. Their size and hardness is clearly shown to be in contradiction to the maimed anatomy of the rest of the body. For Wunderlich does not confine himself to procreation and natural sexual intercourse. His pictures also describe lust and perversion and indeed he contrives to make the very genital power of the phallus a subject of perversion. His uninhibited expression of power-hungry sexuality expresses the potency of impotency rather than the actual absence of potency. Thus when his pictures go further than simply describing the procreative function of the phallus, they become polemical.'[75] Gorsen considers that Wunderlich has created 'pornographic works of art'. But Gorsen also says: 'In fact the pornographic element is not so much a characteristic of human nature as the expression of a sensuality which has turned away from the sensual heights of art, to natural sense impressions.'[76] Gorsen concludes that there must be an 'aesthetic difference between the phenomenon of pornography, which we find in everyday life, and the expression of its intensified individual essence in art'.[77]

If we compare Wunderlich's graphic art with some of Matta's drawings (ill. 165 and 166) with similar themes then we can see how impressive Matta's power is. Out of a group of bodies he creates an organism which claims its own aesthetic environment, quite independently of the subject-matter. Whereas in Wunderlich's drawings the corpses finger their genitals in a weary, indecisive manner.

And it would be more than tasteless to compare Wunderlich's pictorial world with that of Grünewald. The colours in *Leda and the swan (Leda und der Schwan)* 1966 (colour ill. VI) have an iridescent quality, which somehow makes us think of the East, which enhances the perverse image of Leda copulating with the swan. The elegance of the curves reminds us of Beardsley, although in Beardsley's case the clarity of line gives structure to the picture, in spite of all his decadence. Grünewald's curved lines prevent his colours from seeming harsh or offensive even though they have a sickly, morbid, glow.

Magritte, Le viol, 1934

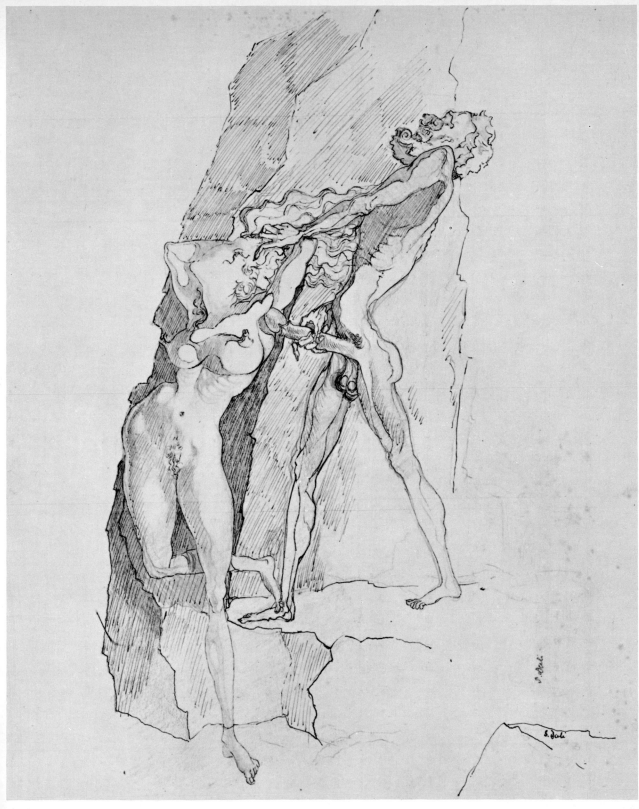

65 Dali, ca. 1932

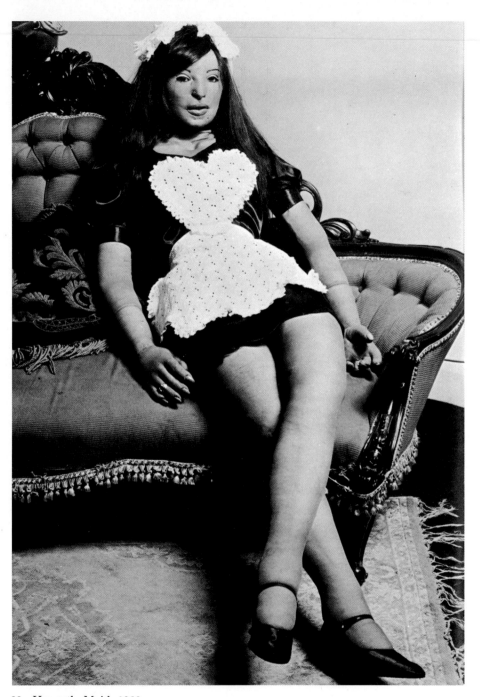

66 Haworth, Maid, 1966

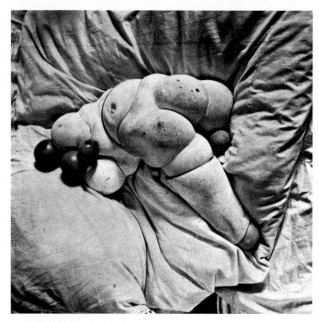

67 Bellmer, 1937

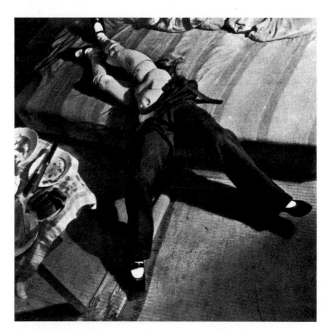

68 Bellmer, 1937

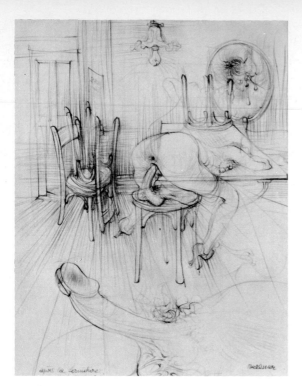

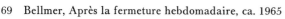

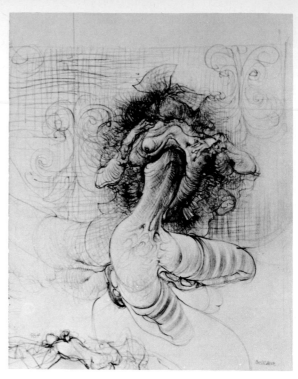

69 Bellmer, Après la fermeture hebdomadaire, ca. 1965 70 Bellmer, 1964

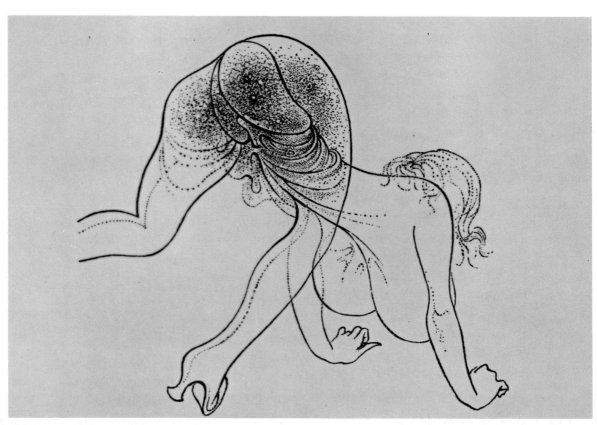

71 Bellmer, 1963

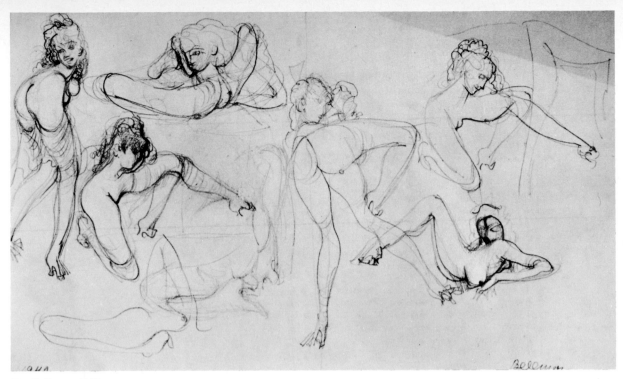

72 Bellmer, 1942

73 Brauner, Je et moi, 1949

74 Antes, Figur Schwarz-weiß, 1967

75 Bellmer, La Poupée, 1936

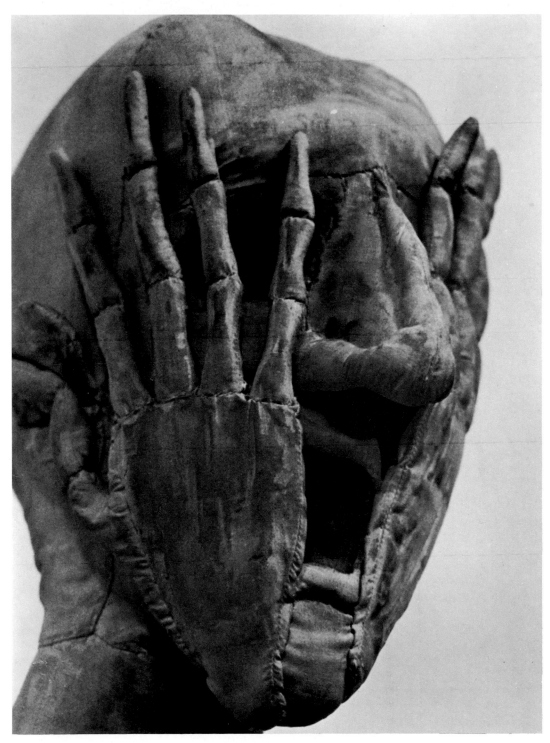

76 Aeppli, ca. 1965

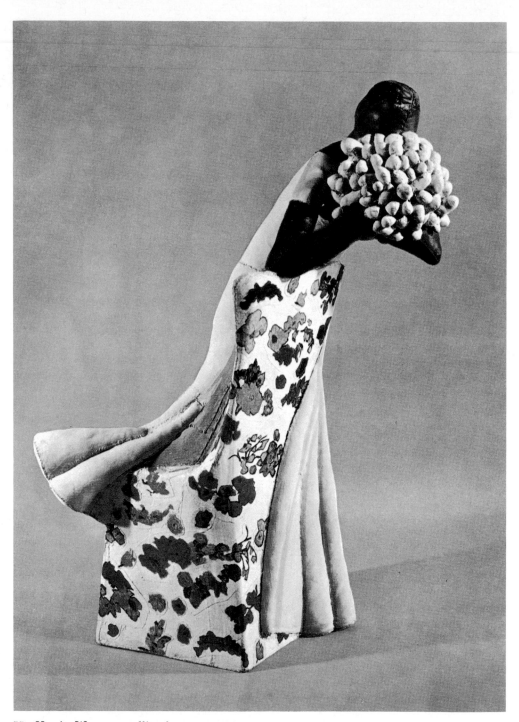

77 Harris, Woman smelling her roses, 1966

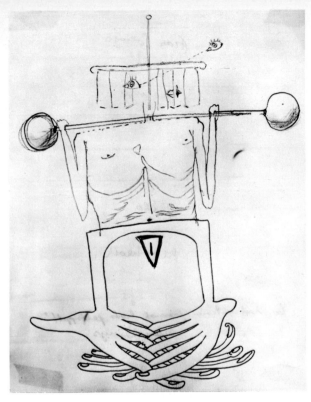

78 Beuys/Klapheck, Cadavre exquis, 1961

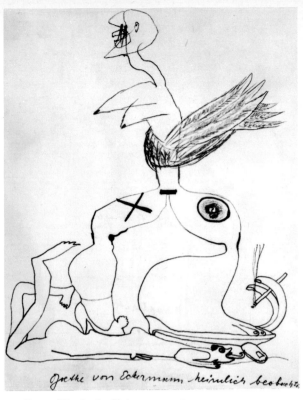

79 Beuys/Klapheck, Cadavre exquis, 1961

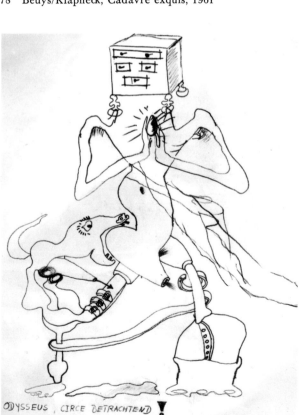

80 Beuys/Klapheck, Cadavre exquis, 1961

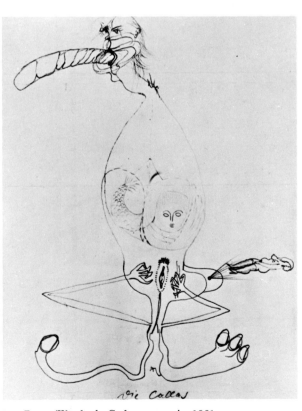

81 Beuys/Klapheck, Cadavre exquis, 1961

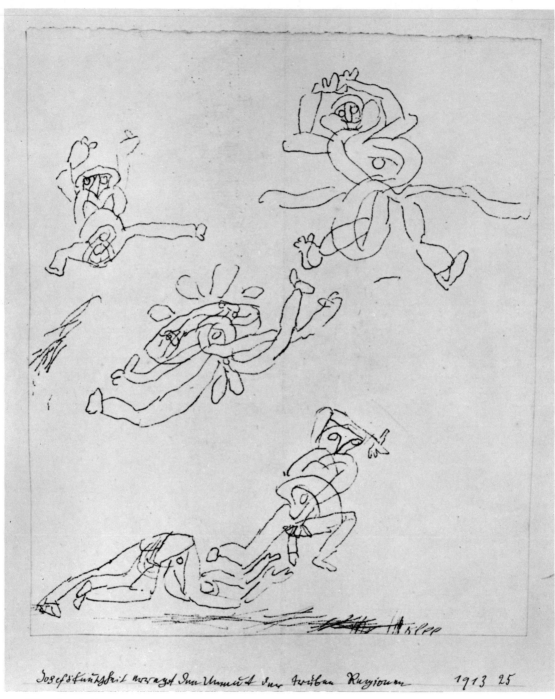

82　Klee, Josefs Keuschheit erregt den Unmut der trüben Regionen, 1913

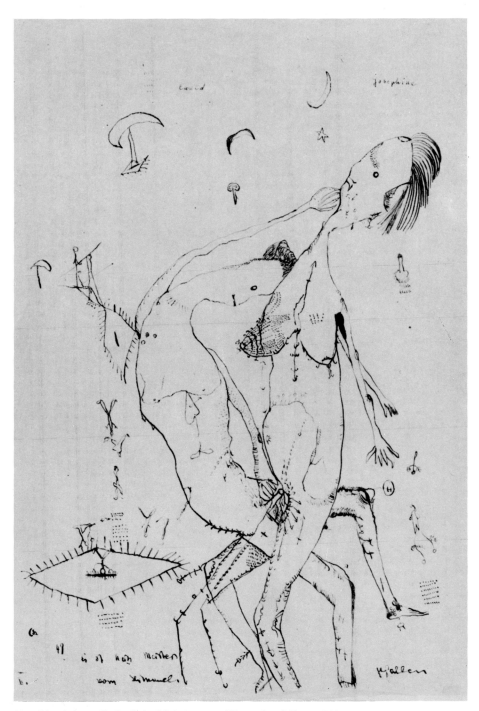

83 Altenbourg, Es ist kein Meister vom Himmel gefallen, 1949

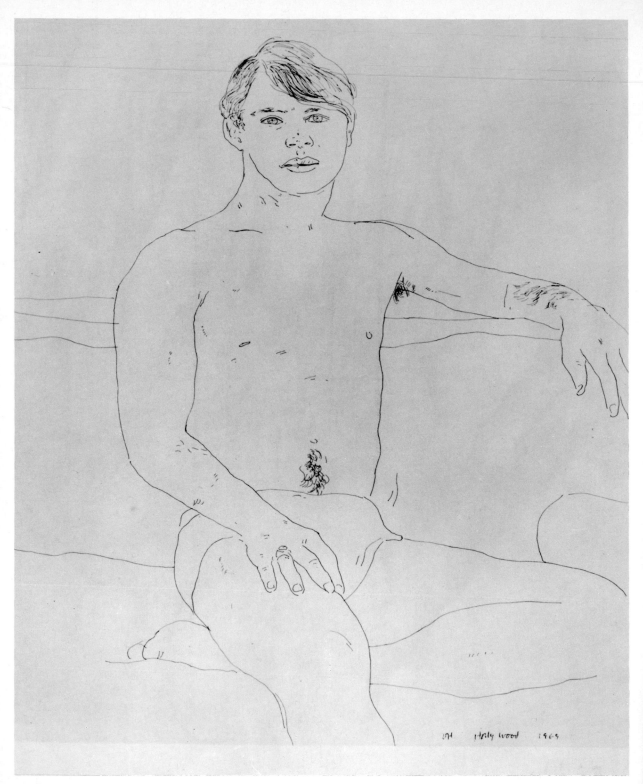

84 Hockney, 1969

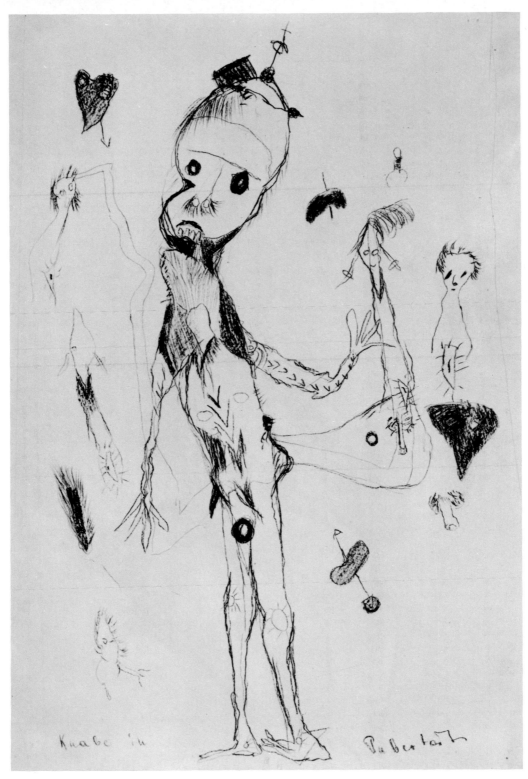

85 Altenbourg, Knabe in Pubertät, 1949

86 Meyer-Amden, Nackter Jüngling im Tannenwald, 1912/14

87 Schlemmer, 1929/30

88 Schlemmer, 1928

Schlemmer, Eingang zum Stadion, 1930

89 Hockney, 1966

90 Schlemmer, 1928

91 Schlemmer, 1928

92 Laurens, 1948

93 Laurens, 1948

94 Laurens, L'eveil, 1952

95 Dodeigne, Torse, 1962

96 Magritte, 1948

97 Goller, 1959

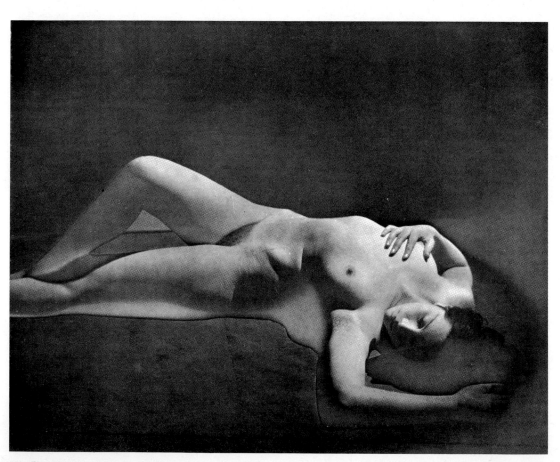

98 Ray, Primat de la matière sur la pensée, 1931

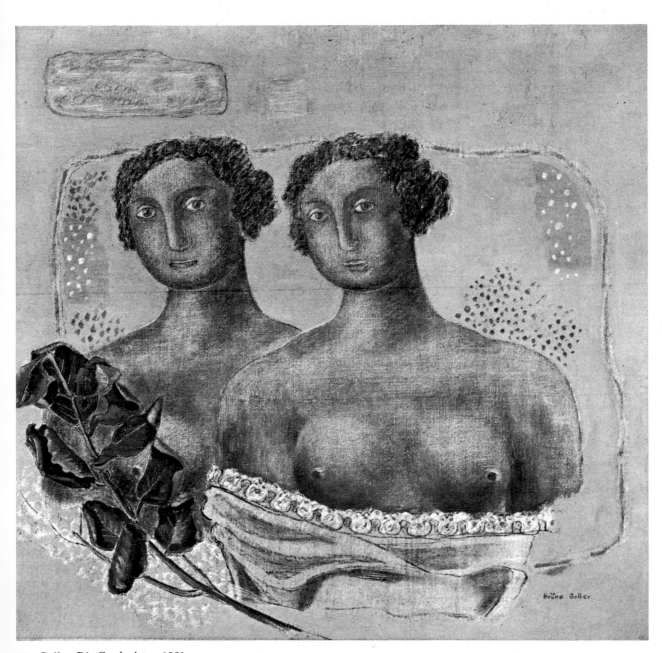

99 Goller, Die Geschwister, 1931

100 Baj, Nu couché, 1960

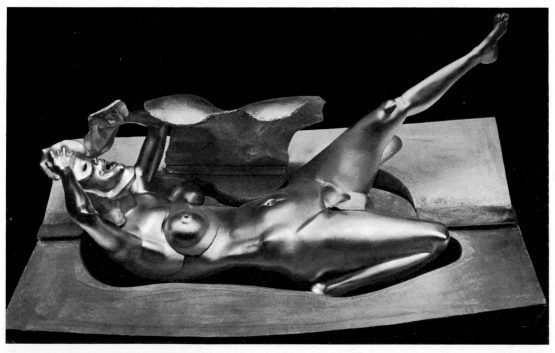

101 Ipoustéguy, La femme au bain, 1966

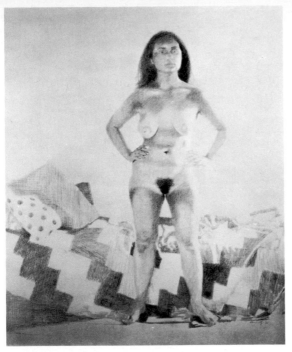

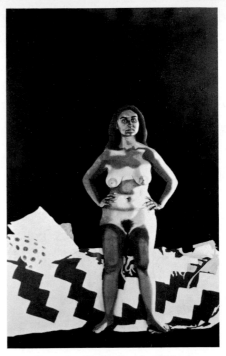

102 Kanovitz, Nude Greek, 1965

103 Kanovitz, Nude Greek, 1965

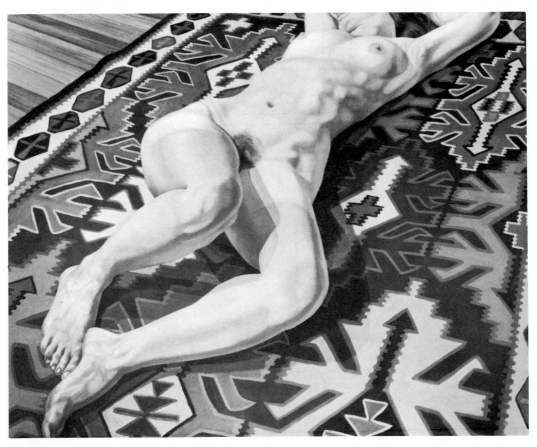

104 Pearlstein, Nude on Kilim Rug, 1969

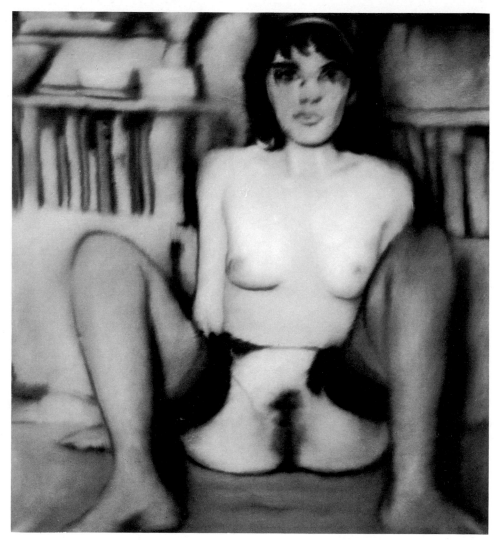

105 Richter, Studentin, 1967

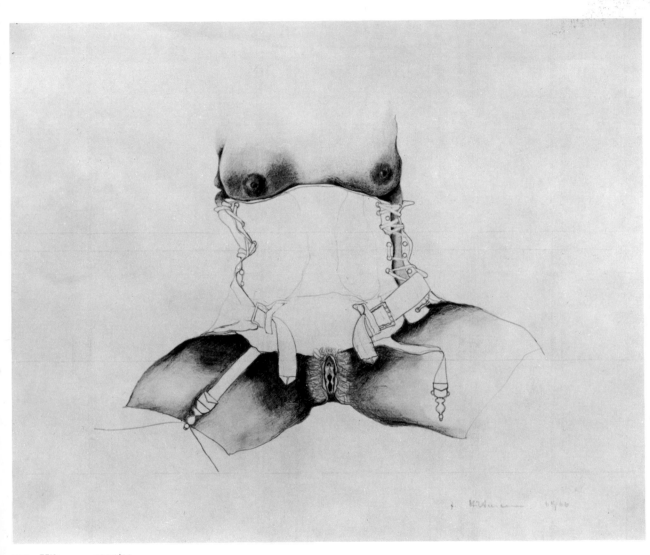

106 Hiltmann, 1965/66

107 Stein, 1969

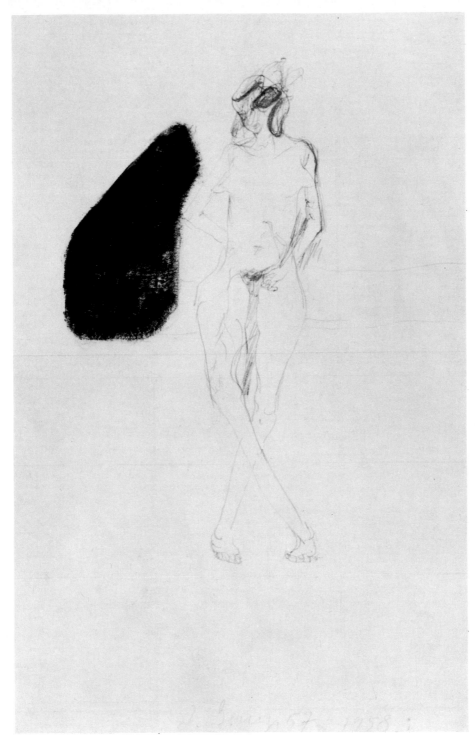

108 Beuys, 1957/58

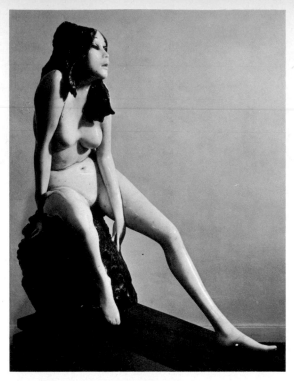

109 Gallo, Quiet nude, 1966

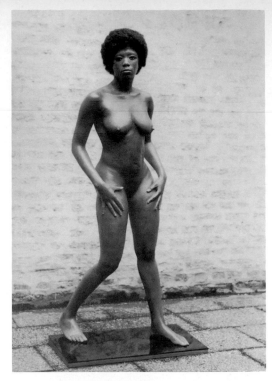

110 de Andrea, Woman No 2 (black), 1969/70

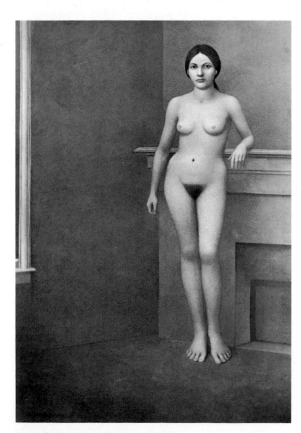

111 Bailey, French room, 1967

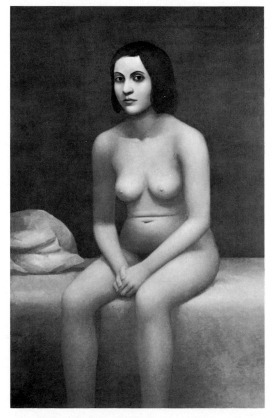

112 Bailey, Italian, 1966–68

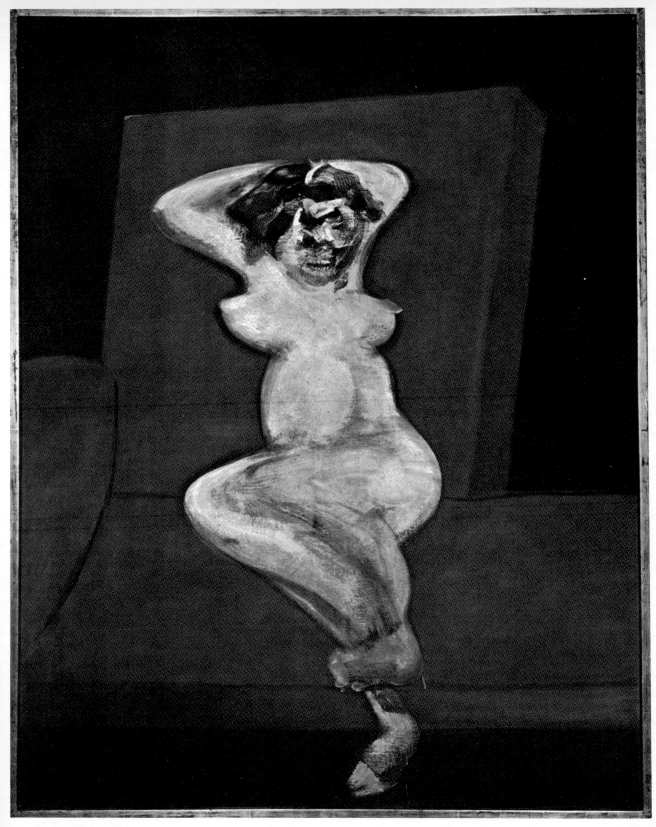

113 Bacon, Nude, 1960

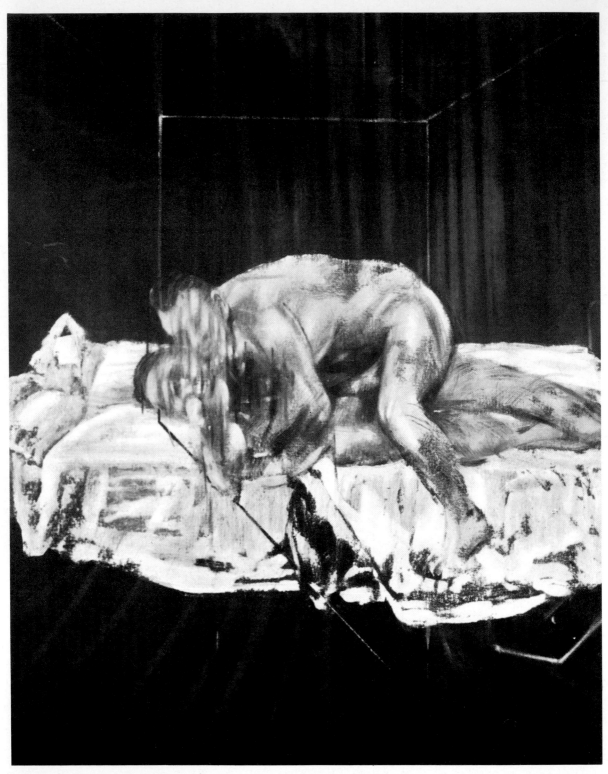

114 Bacon, Two figures, 1953

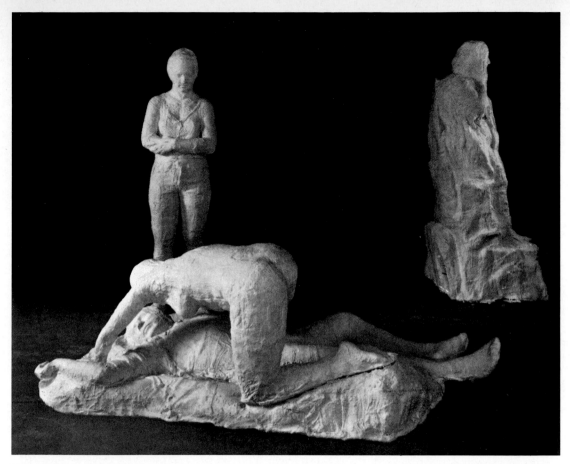

115 Segal, Legend of Lot, 1966

116 Dodeigne, Le couple, 1963

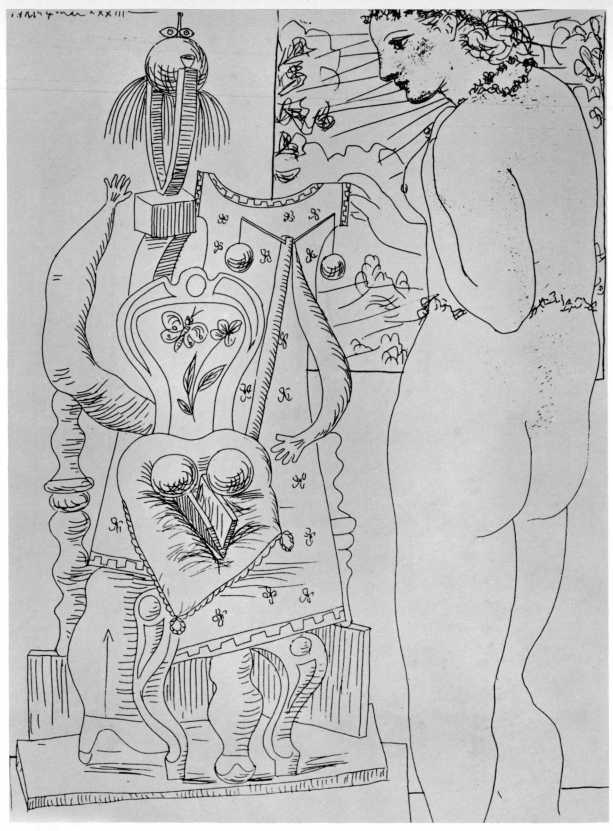

117 Picasso, 1933

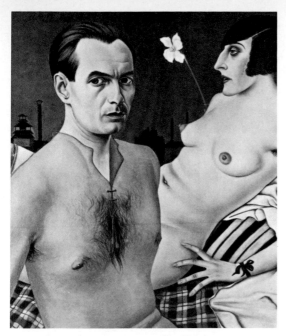

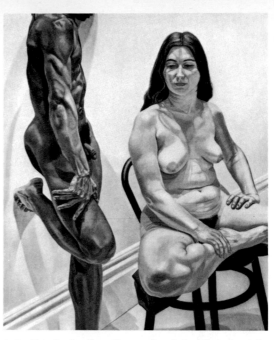

118 Schad, Selbstbildnis mit Modell, 1927

119 Pearlstein, Standing male, sitting female nudes, 1969

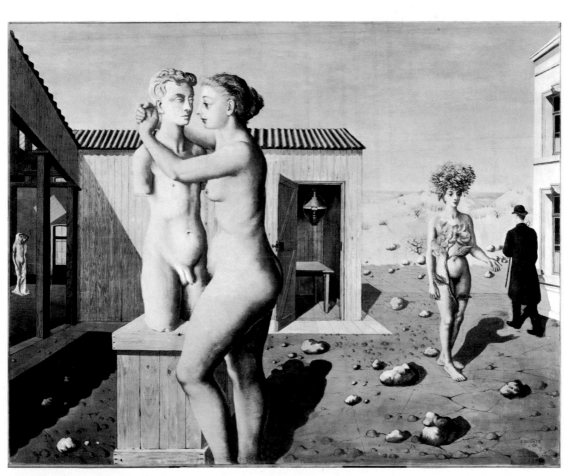

120 Delvaux, Pygmalion, 1939

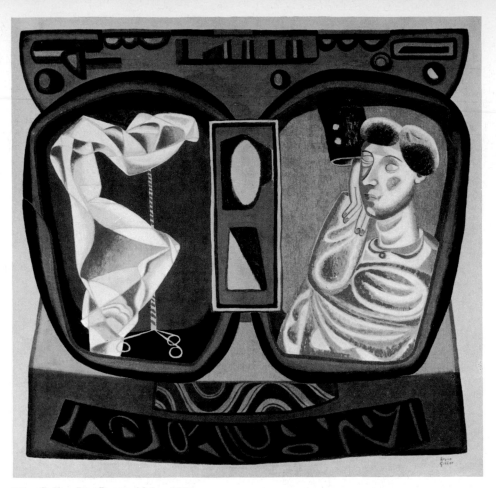

121 Goller, Der Brautschleier, 1952

122 Berrocal, Alfa et Romeo, 1964–68

123 Raysse, Tableau simple et doux, 1965

124 Marisol, Double date, 1963

125 Warhol, The kiss, 1965

126 Peverelli, Les paradisiers, 1962/63

127 Dodeigne, Les deux, 1965

128 Kienholz, The backseat Dodge '38, 1964

129 Matta, 1945

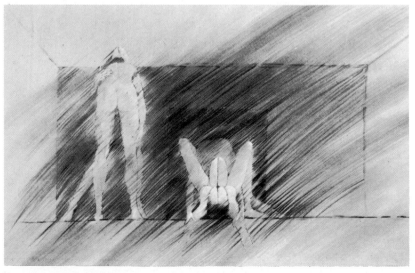

130 Peverelli, 1962/63

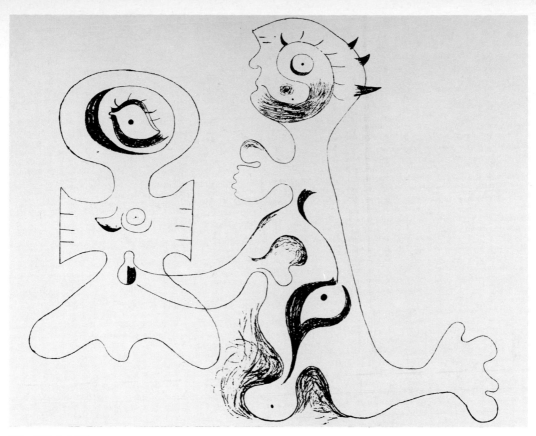

131 Miró, 1929

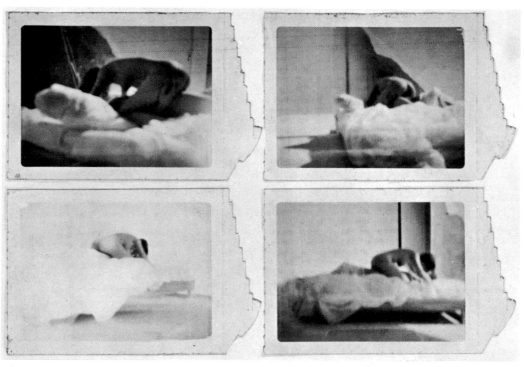

132 Graham, 1969

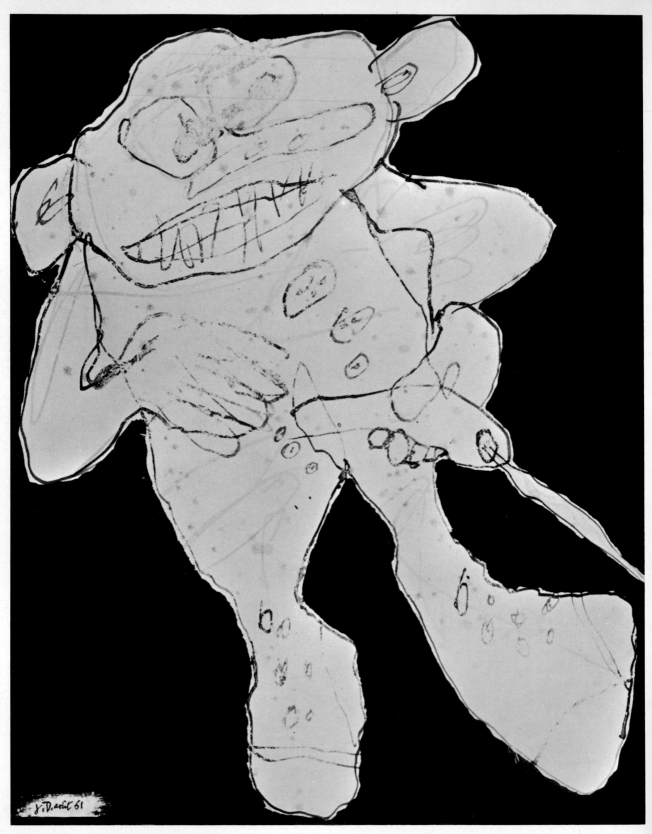

133 Dubuffet, Pisseur à droite IV, 1961

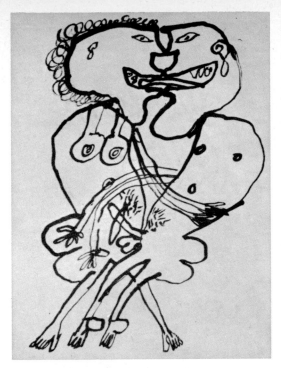

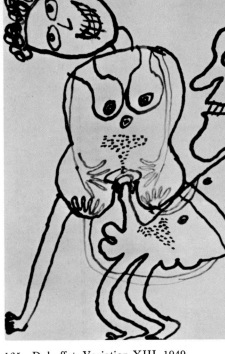

134 Dubuffet, 1950 135 Dubuffet, Variation XIII, 1949

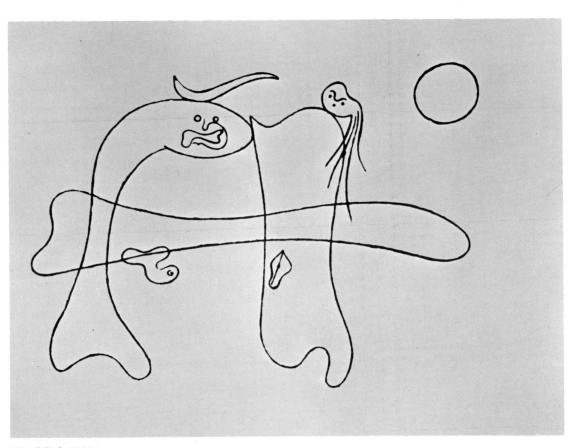

136 Miró, 1933

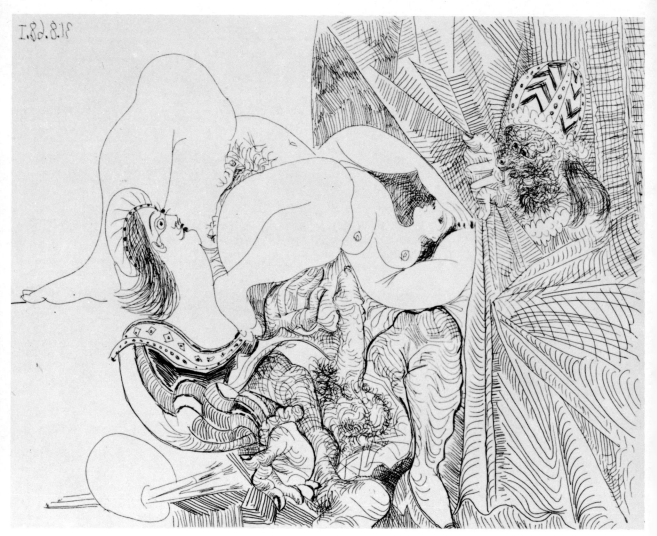

137 Picasso, 31. 8. 1968

138 Picasso, 3. 9. 1968

139 Picasso, 7. 9. 1968

140 Wesley, Captives, 1962

141 Wesley, Six maidens, 1962

Goller, Weiblicher Akt, 1962

142 Ceroli, Venere, 1965

143 Ceroli, Il Mister, 1965

144 Hamilton, Adonis in Y fronts, 1963

145 Rivers, Parts of the body, 1962

146 Raysse, Elaine Sturtevant, 1968/69

147　Wesselmann, 1968

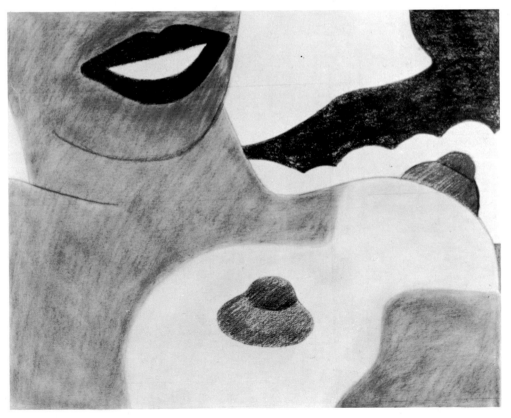

148　Wesselmann, 1968

149 Ramos, Chic, 1965

150 Ramos, Catsup Queen, 1965

151 Ramos, Lucky Strike, 1965

152 Ramos, The great red kangaroo, 1968

153 Wesselmann, 1963

154 Hamilton, Just what is it that makes today's homes so different, so appealing? 1956

155 Kitaj, The Ohio Gang, 1964

156 Lindner, *Disneyland*, 1965

157 Janssen, Geile Milli, 1968

158 Fuchs, Der Tod und das Mädchen. 1967

159 Dado, HRouv, 1968

160 Wunderlich, Frau, 1968

161 Fuchs, Pan, 1969

162 Jones, The table, 1969

163 Janssen, Souvenir, 1965

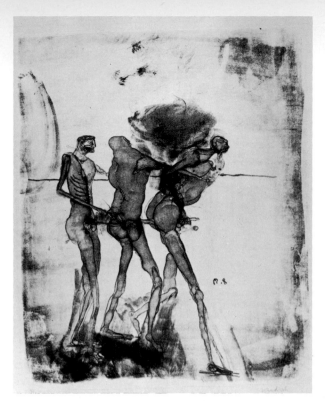

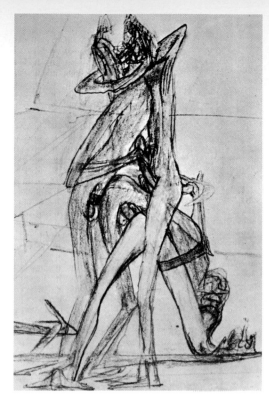

164 Wunderlich, Qui s'explique, 1959

165 Matta, ca. 1945

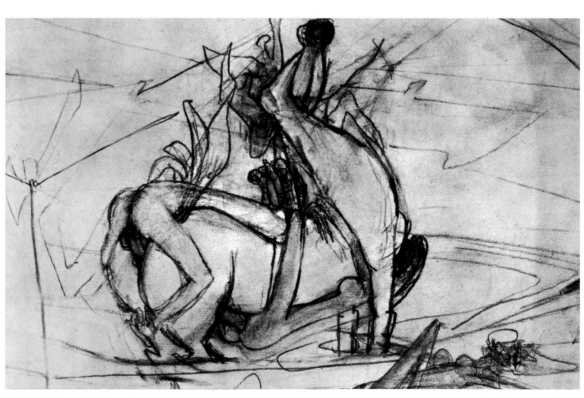

166 Matta, ca. 1945

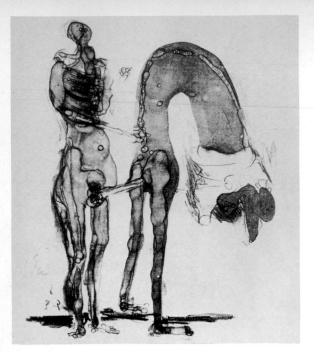

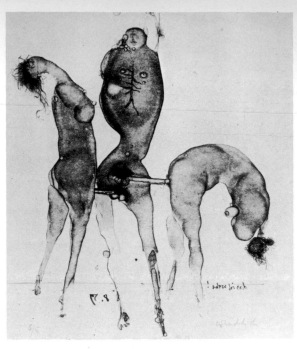

167 Wunderlich, Qui s'explique, 1959

168 Wunderlich, Qui s'explique, 1959

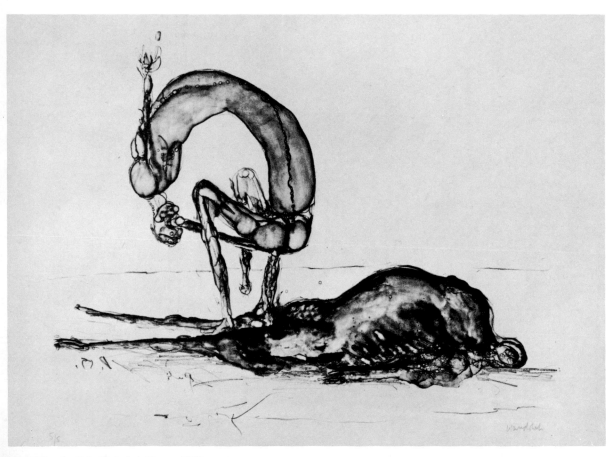

169 Wunderlich, Qui s'explique, 1959

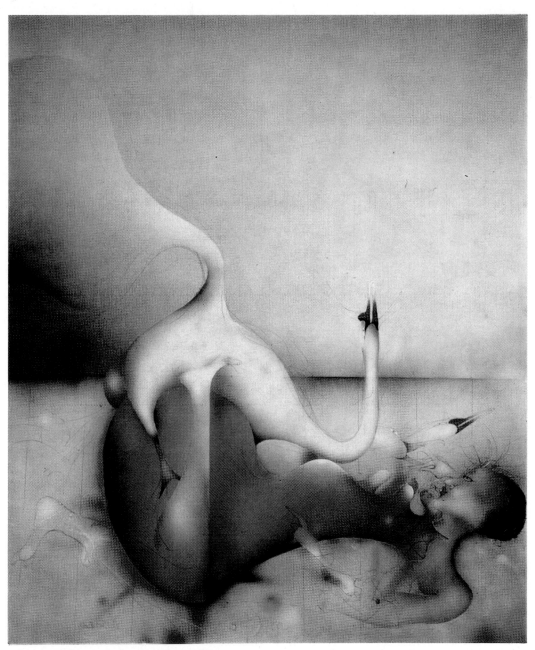

Wunderlich, Leda und der Schwan, 1966

ASSOCIATIONS

In the introduction I defined association, which is a familiar stylistic device and a very common way of expressing eroticism in art. It is largely based on feelings and impressions shared by the artist and the spectator, and it can sometimes involve certain social references.

Form as a means of expressing erotic associations

Gertrude Stein described the period of 1924 to 1935 in Picasso's work in the following analysis: 'During this time his consolation was cubism, the harlequins big and little, and his struggle was in the large pictures where the forms in spite of being fantastic forms were forms like everybody sees them, were, if you wish, pornographic forms ...'[78]

Forms, which are the building materials of a work of art, can contain erotic allusions. Their particular function is to convey artistic sensuality – so that the spectator is unconsciously drawn into their power. Then the spectator understands not only the objects in the picture, but also the associations. The formal elements are generally familiar and always premeditated. However the artist still has to cope with the creative task of the original visual synthesis, of the unique formulation: the discovery of what has not yet existed. For this is a prerequisite for any work of art which is to survive. Thus the creative artist is concerned first with the availability and then with the adaptability of the formal expressive means with which he proposes to realize his intentions pictorially. The danger here is that this kind of preoccupation can degenerate only too easily into aesthetic formalism, and indeed since the war the work of a considerable number of artists has suffered in this way: as soon as they find some new gimmick they publicize it and exploit it at its current market value, until everybody is heartily sick of it.

There is no form which can be limited to its character as a sign. A form always has a further connotation – as an association. It is the position of a form which gives

it significance. Thus the spectator will not react independently, but his associations will follow the laws which the artist himself obeyed.

Associations in Picasso's work – 'pornographic forms'

Gertrude Stein spoke of Picasso's 'pornographic forms' she was obviously referring to forms such as those in a charcoal drawing dated 1932 (ill. 170) and in two sculptures of the same year (ill. 171 and 172). The large-scale drawing (ill. 170) is a study for a sculpture and it shows a woman's head, composed of rounded sausage-like structures and spherical shapes. The eyes and lips are small expressive spheres which contrast with the large cheeks and the phallic bulges of the nose and hair. Various shapes are laid side by side round the head and this is what gives it its primitive, monumental quality. The *Bust of a woman (Buste de femme)* 1932 (ill. 171) appears innocuous in comparison, for the individual shapes are more firmly incorporated into the physical appearance of the woman. Only the bulge of the nose stands out, and this is joined to the skull cap of the hair. The phallic character of the nose destroys the quiet harmony of the face. The *Woman's head (Tête de femme)* 1932 (ill. 172) makes very clear use of association. These works by Picasso can help us to understand how artists use association. The features of the face cannot be clearly distinguished; the shapes are accumulated on the base of the neck but the woman's head is still recognizable. What Gertrude Stein means by 'pornographic forms' is swelling phallic forms such as these spheres. However organic forms are even more evocative for they can suggest erotic moods such as ripeness and decay.

Organic forms

Henri Laurens's *The great farewell (Le grand adieu)* 1941 (ill. 173) is a woman's body that has collapsed in a heap – a pile of organic masses embedded in the swelling contours of the female nude. This farewell would mean disintegration, were it not for the seeds of hope germinating in the toe of the right foot and the budding tips of the breasts. Or is this merely a last movement before the body dissolves into nothing?

In *Human mass on a bowl (Concrétion humaine sur coupe)* 1947 (ill. 174) Jean Arp shows the reverse process: a human organism poised on a bowl is coming into being. No part of the body is yet recognizable but we can see that organic masses are in the process of taking shape. The living form is clearly distinguished from the surface of the bowl: it is pressing with all its force on the edges of the bowl, fighting with the forces of gravity as it tries to raise itself up.

The concrete details incorporated in the three-dimensional organism determine the essential character of Ingeborg Maier-Buss's work, as in *Black Venus (Schwarze Venus)* 1963 (ill. 175) where coloured polyester materials are contrasted with the forms. The forms are organic for many of the details in this sculpture have been modelled on the natural world – the notches, excrescences, attachments, transitions, the masses, contours, surface structures, the colours which become lighter where they are transparent. In *Xylei* 1969–70 (ill. 176) the way the head is joined to the shoulder shape of the bottle's handle should be noted: the flesh-coloured bloom then grows from the head and is balanced on the bulging belly of the bottle. A sketch for a sculpture, by Maier-Buss, dated 1966, (ill. 180) which has a heavily emphasized phallus swinging on a spotted stem, shows how any organic form can awaken erotic associations. For this was obviously not modelled on a phallus but on a seed-vessel which was just breaking into flower. Another drawing dated 1969 (ill. 178) shows a prehistoric landscape. This detail isolates a complex of forms, and the monster lying there comfortably seems to be raising its left paw.

Jochen Hiltmann's wormlike structures also offer associations with primeval forms of life, and this is emphasized by the title in *Laocoon after the catastrophe (Laokoon nach der Katastrophe)* 1966–8 (ill. 177). Here snakes with puffed-up bodies lie around indolently, digesting their food. The fact that two of the snakes have realistic little feet protruding from their skins reminds us of the story of Laocoon. However the sinister feeling in this work comes from the way each body gradually swells into a tube shape – or alternatively we could see this as a progressive shrinking. These bodies jerk along the ground, like oversized limbs that have been torn from a body, and then finally they die. The reptile in the background is called 'Elephant's appendix' 1968, for its opening is closed with a mechanical screw cap. In a drawing dated 1967 (ill. 179) Hiltmann turns his attention to the way technology encroaches on organic form. Amputated limbs have been replaced by an artificial armpipe and a nipple-ring. We can compare this with Westermann's *Rotting jet wing* 1967 (ill. 181) in which the idea of amputation seems to have been transferred to a tree trunk: a phallic nose shape is mounted with nails on the right side of the tree trunk while there is a clean little hole in the left side of the trunk.

In Edward Kienholz's *The illegal operation* 1962 (ill. 182) the association is quite clear, for he gives us a shocking rendering of an abortion. A cheap carpet, an old – fashioned lamp with a naked bulb, a red lacquered footstool, a tin bucket filled with refuse, surgical instruments in white bowls, a pair of gloves – these are the props for the improvised operation theatre. Then there is the trolley itself bearing what is left of the body: an organic lump spread out between dirty cloths, with its stuffing coming out of a hole. This organic relic in these pseudo-clinical surround-

ings makes more impression on us than the most detailed description could do. For it is left to our power of association to do the work.

How trivial in comparison seem the clumps of head which Tetsumi Kudo has placed on two chairs, in *Love (L'amour)* 1964 (ill. 183). Their lips are pressed together in a kiss. However the dark impenetrable refuse heap by Robert Morris (ill. 184) attracts our attention in a completely different way. For these are the remains of that illegal operation on organic substance, mixed here with other rubbish and spread out for the forensic pathologist to see.

Procreation (Zeugung) 1960 (ill. 190) is the title of a picture by Konrad Klapheck. Organic substance is gushing from the technical apparatus of a sewing machine onto a huge rectangular plate. The process has only just begun, for living energy is being engendered in the body and neck of the machine – and this encourages us to wait expectantly to see what will gush out of the machine onto the plate. The same theme is given a more playful treatment in a sculpture by Phillip King called *Tra-la-la* 1963 (ill. 193). A pipe, made of two smaller pipes bound together, is ejecting matter from its lower end; this matter then gathers on the floor and turns into a pile of skittles.

Male and female genitals are shown in *Orch* 1959 (ill. 194) by Bernard Schultze; these three-dimensional genitals grow in profusion from the pictorial background, like plants. This corpse-like landscape cannot fail to terrify us, for a menacing breath of decay and resignation is emitted from it: we sense that it is impotent to perform any kind of copulation. *Green Migof (Grüner Migof)* 1963 (ill. 195) is in fact nothing but the blossoming skeleton of a corpse, which is still glittering. Ursula's *Lirads labyrinth* 1963 (ill. 197) is a more positive drawing. Rows of cells have been drawn in minute detail, close together. These cells proliferate in every cranny and corner. They even introduce extraneous beings into the picture which incite ideas of perversion and excess. While *Armchair* 1962 (ill. 196) by Kusama is a luxuriant growth, a phallic growth: it is only from the fringe round the bottom that we can recognize that this is an armchair. However this chair is not macabre or threatening but simply humorous.

Spherical shapes and circular shapes

The sphere and the circle are generally accepted as symbols of female sexuality, and this is obvious in Emile Gilioli's *Celebration of the sphere (Célébration de la boule)* 1968 (ill. 185) which has a dry, classical style. We immediately associate the sculpture with a female torso – a powerful sphere with two spheres as breasts.

But the pregnant body must open and burst its shell so that it can give birth: in

Split helmet (Casque fendu) 1958 (ill. 186) Jean Ipoustéguy smashes the smooth surface of the helmet with a blow from outside, while in *Death in the egg (La mort dans l'oeuf)* 1968 (ill. 187) the white marble egg is burst by a movement which comes from inside it, a movement that we can sense in the darkness. In *Spatial concept – nature (Concetto spaziale – natura)* 1965 (ill. 189) Lucio Fontana has opened up the kernel of a fruit: there is a large split, as though a powerful crustacean were opening up the two halves of its shell, so as to get some air. In Jochen Hiltmann's *Burst Ele-K (Geplatzter Ele-K)* 1963 (ill. 188) the outer shell has burst and there are a lot of inquisitive toadstools peering out through the split. In *Molten egg (Coulée à l'oeuf)* 1966 (ill. 192) César goes even further and shows an egg which is larger than lifesize, spilling its contents from its shell. While Lucio Fontana (ill. 191) shows an empty shell case, which does not even seem to have the strength or the modesty to close up its hole.

Fertility

The furrow ploughed into the meadow by Michael Heizer (ill. 198) is an immediate reference to fertility, for the earth has been broken open, ready to receive the seed. Lucio Fontana was playing on the same association when he slit open his canvas for the first time in 1959. He called this work *Spatial concept – expectations (Concetto spaziale – attese)* c. 1965 (ill. 200). This cut in Fontana's canvas was a great innovation and it had a tremendous influence on other artists.

Piero Manzoni's *Achrome* 1959 (ill. 199) appeared in the same year. It did not have a slit, but instead the sort of gap which appears when two halves are joined together without being fused together. The reinforcement round the gap merely emphasizes the gaping aperture. In Manzoni's *Achrome* sensuality is expressed more tangibly than in Fontana's decorative cut. Gorsen described these slits as follows: 'The entire artistic intention, which is not immediately apparent in a picture during the process of creation, has formed a kind of cyst which is invisible to the public. It leaves its traces behind in the picture as cyphers, insoluble puzzles which keep our curiosity in check.'[79]

Totems

Hofmann has drawn attention to the totem character of the 'extended jerky' *Three upright motives* 1965–6 (ill. 201) by Henry Moore. 'They are almost all based on basic, single cylinder shapes – trunks or bones; the elements they have drawn from

the natural world are now more closely integrated than previously, when there were many analogies and allusions'.[80] Phallic shapes absorb the 'Glenkiln Cross': the stakes are pulsating organisms with budding joints which give a figurative life to the swelling bodies. Some sketches for sculptures by Joannis Avramidis dated 1965 (ill. 202) show how strongly the three-dimensional forms of the erect human body resemble an articulated column. The volume of the rings round the different sections indicates the degree of their swelling. The same is true of Christo's work. In *5450 m cubic package* 1967–8 (ill. 222) the irregular knots and loops of string emphasize the organic consistency of his gigantic phallic package.

Line used to emphasize form

Yves Tanguy contrives to portray three-dimensional objects with clear contours. In a pen and ink drawing of 1935 (ill. 204) the shapes evoke plant seedlings, but at the same time their fullness suggests phallic connotations. Similarly, in a drawing of the same year (ill. 203) light shadings round the edges enhance the sensual surface tension of the constituents; a sculpture seems to be taking shape – a physical being with an erotic expression.

In one of his drawings Konrad Klapheck shows two forms next to each other (ill. 205). It looks as though a lump of meat had been sliced in two, and the ornate, flowing outline contrasts very strangely with the plastic clarity of the drawing. The horizontal straight line at the back of the picture moves these mysterious masses towards the spectator, making them more sensual and more tangible. Although our curiosity will set to work on this drawing and try to discover organic analogies, we will never find a satisfactory final solution – and this is what makes the picture attractive.

Torsos

It is immediately apparent that a well-stuffed coloured cushion in *Coloured body on a silver-grey background (Farbleib auf silbergrauem Grund)* 1964–5 (ill. 206) by Gotthard Graubner can only signify a human torso – in fact a female torso. The aluminium foil displays the body for our sensual enjoyment, as though it were on a precious tray.

The package (L'empaquetage) 1963 (ill. 207) by Christo is another torso, but here the body is concealed, for it is wrapped up in string and wrapping paper. And Paul van Hoeydonck is playing on the same idea in the trivial stucco-illusionism of his

150

Spatial triptych (Triptieck van de Ruimte) 1964 (ill. 208). Here the spheres are a feminine symbol, although their decorative arrangement has made them deteriorate into insignificant playthings.

A gouache by Gotthard Graubner dated 1965 (ill. 209) shows two of these amoeba-like torsos copulating. The upper torso is the male and it appears to be gathering together its strength in its nucleus so that it can inject it into the torso beneath it.

Sexual intercourse

Max Ernst has caught the moment of fertilization in *Love-song (Liebeslied)* 1934 (ill. 211). A naked female body without a head stands in a garden of luxuriant plants at the bottom of the sea. All the shapes in the picture are bursting with fertility. The woman is carefully holding a precious receptacle shaped like a testicle – whilst a snake is trying to penetrate her vagina.

Arman is saying the same thing more prosaically in *The colour of my love (La couleur de mon amour)* 1966 (ill. 210). He has filled the stomach of a female torso made of transparent polyester with paint tubes, which are emptying their contents into the belly.

In Alberto's Giacometti's *Man and woman (Homme et femme)* 1928–9 (ill. 213) the sexual act has been reduced to a dynamic gesture. The visual intensity of this sculpture is almost unequalled. The male spike first pierces a curved band on the right-hand side of the sculpture which represents the man's body. Then the point of the spike aggressively approaches the cringing outer shell of the woman's body, while the bends in the woman's neck reflect the force of his thrust.

Henry Moore's *Three points* 1939–40 (ill. 212) is also spiked, although it is a more formal, aesthetic work. The three points do not touch each other, and this sustains the tension.

Paul Klee drew his *Naked picture (Nacktes Bild)* 1938 (ill. 214) on jute, using a few economical strokes, which probably represent male and female forms. He economically concentrates the action, limiting it to the middle group, where copulation takes place. A particular magic emanates from the picture, a magic which is not easily dispelled. His economy of style brings out the nakedness but manages to avoid over-simplicity.

In *César's thumb (Le pouce de César)* 1965 (ill. 215) César has made a monumental cast of his own thumb. He is playing on the familiar association of fingers, especially the thumb, with the penis. Putting a finger to one's lips indicates a concealed secret, a gesture of silence, but it also refers by association to sexual union. Joe Tilson is

playing on the same association in *Secret* 1963 (ill. 216). In this picture the lips suggest the female sexual organ. And Martial Raysse expresses the same idea very clearly in a *Collage* 1962 (ill. 217), where the pointed pencil connects the girl's closed lips with the impression they make when they are open.

The erect thumb is also an important element in Roy Lichtenstein's *Couple* 1963 (ill. 218). Here the association suggested by the thumb is repeated by the tie and also by the woman's large, half-open mouth which looks as if it is waiting for something, while in a drawing called *Two seascapes* 1966 (ill. 219) Lichtenstein suggests sexual intercourse by recording two stages of an event. In the first seascape the sun is setting. Then in the second seascape the round ball of the sun is trying to force its way down into the gap between the rounded cloud masses and the smooth surface of the sea – and this makes us think of sexual intercourse. Lichtenstein uses the same idea in *Bread in bag* 1961 (ill. 220), which is also divided into two pictures. In the first picture the bread is being dropped into the bag. Then in the second picture the bread has disappeared into the bag and this is emphasized by the precise position of the fingers.

Towers

Towering shapes are usually associated with the penis. Bernhard and Hilla Becher's water towers (ill. 221 and 223 and 224) illustrate this very clearly, for the spherical shape of the water tank rests on a draped supporting structure. One of these towers has been jokingly called 'the penis of Badenberg' (ill. 221) – the inhabitants of Badenberg obviously had no difficulty in recognizing the association.

In Christo's *Column made from 5 barrels (Colonne de 5 tonneaux)* 1962 (ill. 225) the column towering up into the sky reminds us of a phallus. The top barrel, which is lying across the others, hints at the open penis tip. Günter Uecker obtains the same effect with his *New York dancer* 1966 (ill. 226), especially when it moves. For then the nails which are flying in rotation are lifted up off the pillar by the force of gravity, so that they outline the pillar like live hair. Similarly, the rising rod of *The sundial (La meridiana)* 1968 (ill. 258) by Pino Pascali is again a naked symbol for the phallus – here the shadow reminds us of its function. We can compare this work with Pascali's *Nest (Nido)* 1968 (ill. 257) where the erotic association is again very obvious; here the nest has the female role and the thorns have the male role.

Light and movement used to evoke erotic associations

In Gotthard Graubner's *Stylit I* 1968 (ill. 229) the bulge beneath the nylon fabric reminds us of a penis in a pair of tight trousers for the light subtly moulds the swellings of the material.

In Takis' *Electromagnetic (Electro-magnétique)* 1964 (ill. 228) three elements sway like the seed-heads of grasses in the wind – but the living, erotic element is severely reduced in this work. In Barnett Newman's *Here I* 1950 (ill. 227) the only reference to living things is in the development from a rough band to a smooth band, and this is underlined by the way they both grow from the same band.

In Donald Judd's work dated 1965 (ill. 232) the dividing sections grow bigger towards the top of the rod, whilst the immobile parts are diminished accordingly – which creates the visual effect of rockets taking off. In Soto's *Black and white relationship (Relation blanc et noir)* 1965 (ill. 234) the attraction is shifted to the level of visual illusion. The white band with the black square stands out, in front of the foremost plane of the picture, while the black band with the white square appears to be projected onto a background layer – although they are in fact standing next to one another. Dan Flavin's luminous tubes entitled *(to Shirley)* 1965–9 (ill. 230) exploit the contrast of coloured light, so that coloured zones appear.

But this kind of art soon degenerates into decorative aestheticism for it is scarcely capable of any further development. Larry Bell's *Cube no. 2* 1967 (ill. 235) needs a clear substructure for the dark glass cube in order to evoke the phallus, even vaguely, in such an aestheticized atmosphere, while the two chromium-plated steel pistons in Eduardo Paolozzi's *Twefx* 1967 (ill. 231) no longer have associations with living things. They are elegant pestles which are only capable of creating formal tension, like poor printing doublets. However *Gexhi* 1967 (ill. 233) which Paolozzi made in the same year is another matter. Here the structure comes to life in the windings of the aluminium tube: a controlled force flows from left to right, through the mechanized body of the snake, and then stops abruptly.

Play with gravity

In a work dated 1965 (ill. 236) Ronald Bladen has put three cubic elements side by side, so that they hover between standing and collapsing. The attraction comes from the play with gravity, which is intensified by the threefold arrangement. At the same time there is a vague association with the erection of the penis.

Alberto Giacometti's *The nose (Le nez)* 1947 (ill. 238) is clearly meant to represent the penis. The play with gravity is also an important feature in this work: a small

head with a huge elongated spike of a nose is suspended in a casing, with a counter-weight where the neck joins the shoulders, which keeps the nose suspended in a horizontal position. In Giacometti's *Spear pointed at the eye (Pointe à l'oeil)* 1931 (ill. 237) the elongated form is pointing at the eye, so that the formal composition – and hence the association – of *The nose* is repeated. In Giacometti's *Suspended sphere (Boule suspendue)* 1930 (ill. 239) the sphere hangs in its casing over a banana-shaped form, so that the cleft in the sphere slides along the ridge of the banana form as soon as the slightest movement begins. The movement is induced because of the way the objects are suspended, and so a kinetic association is added to the initial association of forms.

We find the same association in Victor Pisani's *Study of Marcel Duchamp (Studi su Marcel Duchamp)* 1965–70 (ill. 241). There is no sense of horror in this work although it is clearly inspired by Poe's story *The pit and the pendulum.*

In Robert Müller's *Archangel (L'archange)* 1963 (ill. 240) the archangel has become a dynamic force. In spite of the weight of the material he has retained his ability to hover, and it is this that gives the phallic piston its horizontal balance. The piston has a twisted wire like a fuse which acts as a buttress, while the curved indentation of its support makes it seem less heavy, but increases the thrusting effect from left to right: the archangel has been transformed into a phallic rocket.

In *Marcus* 1968 (ill. 242) by Mario Ceroli a pointed beam in a wooden casing is hinged so that the beam could become erect if only it had enough strength – though we can estimate its potential power. Erwin Heerich, in a cardboard sculpture dated 1960 (ill. 245), replaces the hinge with a disc-joint, so that friction then holds the phallic pivot firmly in any position into which we put it.

Pol Bury actually introduces movement into his work. In *Rods (Les bâtons)* 1964 (ill. 244) the rods jerk themselves upright, one after another, in slow motion, and then fall down again. The nylon strings in *Punctuation (Ponctuation)* 1961 (ill. 243) work on the same principle, moving like living hair.

Mario Ceroli's *Subliminal cock* 1968 (ill. 247) is a hanging phallus made up of layers of wooden discs. The association is perfectly clear, even without the hand in the photograph holding up the phallus. A drawing by Jochen Hiltmann dated 1967 (ill. 246) shows organic forms which are joined in symbiosis by a suspender. By contrasting soft and hard textures the artist defines a sphere of action, while both the form and the texture of the objects allude to the sexual organ.

154

Contrasting textures

Throughout his work Claes Oldenburg exploits a contrast in consistencies – soft substances appear hard and hard substances appear soft – for example in *Four soft Dormeyer mixers* 1965 (ill. 248) where the fourfold arrangement conceals and embellishes the phallic character of the individual suspended elements. The *Giant soft Swedish light switch* 1966 (ill. 252) has female associations: a round belly and two hanging breasts. While in his *Study for giant soft drum set 2* 1967 (ill. 249) round female forms also lie spread out over each other, as though a huge body were lying there, with two protruding breasts. Another drawing by Oldenburg entitled *Colossal fagend, dream state* 1967 (ill. 251) portrays the erotic dream of a woman in ecstasy. She stands there stretching out her arms admiringly before the tip of a colossal phallic cigarette – which eventually ends up exhausted in her arms.

Phallic forms

Robert Israel's *Peach progress* 1966 (ill. 250) appears to be a three-dimensional realization of a girl's dream fantasies. Mark Brusse's *Strange fruits VI* 1965 (ill. 253) requires no interpretation, for the clean precise execution of these strange fruits makes them into a kind of aesthetic toy. It is interesting to compare this with *The temptation of St Antony (Die Versuchung des Hl. Antonius)* 1964 (ill. 255) by Jochen Hiltmann, for here a dynamic power makes the polished spherical head protrude from the neck ruffle between the mighty thighs. Rudolf Hoflehner also uses this dynamic power to make the three-dimensional spike shoot up out of *Figure (Figur)* 1961 (ill. 254). In Erwin Heerich's *Cylindrical doll (Walzenpuppe)* 1963 (ill. 256) the cylindrical forms have come to rest. For as the sub-title tells us John XIII rests on his death bed. But the doll's hands and feet are piercing the walls of the cardboard box in which it is embedded.

The erotic associations suggested by Pino Pascali's two works *Nest (Nido)* 1968 (ill. 257) and *The sundial (La meridiana)* 1968 (ill. 258) are in fact complementary, for the sundial suggests the penis while the nest suggests the female sex organ.

While in Barry Flanagan's *Two rsb* 1967 (ill. 262) the male and female organs are laid side by side, the male rearing up tightly while the female has withdrawn into itself. An extended arrangement by Flanagan which he has called *rsbtworahsbbsharowtbsr* 1967 (ill. 267) shows two phallic shapes on either side of a sack-cum-torso. They stand on a ring drawn on the ground, which is a female sex symbol.

A work by Palermo dated 1968 (ill. 261) uses the same two shapes, but here they are much closer to each other. The sellotape covering enlivens the rod and the ring

to a certain extent. While in Gilberto Zoria's work the membrane appears to have been mutilated and there are only a few fragments of the membrane left to form a ring round the dark hole: *Fluorescent sponge (Spugna fluorescente)* 1968 (ill. 266).

Lee Bontecou, in a work dated 1964 (ill. 265), shows the female genital zone as a hole with a grid over it set in a mechanical contraption which reminds us of car radiators – but the resulting figure is only the outer casing and there may well be a vital nerve concealed behind it. César's *The two of us (On est deux)* 1961 (ill. 269) compresses and exploits technical material – sheet iron – and the moulding process makes the cell structures look like organic tissues. In John Chamberlain's *Funburn* 1967 (ill. 268) the thick padded cleft of the female genital looks like a distended vulva made of sponge rubber. And if we assume that the stone pedestal belongs to the sculpture, we can regard it as a male symbol.

Plants

Plants also suggest associations with the female sex organ. The flower that blossoms in Heinz Mack's *Fata morgana* 1968 (ill. 263) has been stylized although it has a living cell structure, and it has become a lustrous but sterile plant formation.

The rose is well-known as a female genital symbol. In *Space rose* 1959 (ill. 264) by Marc Tobey the title emphasizes the association with the flower. The same symbol is concealed in Günther Uecker's *Nail-object (Nagelobjekt)* 1962 (ill. 260) for the nails form a rose. This symbol appears as a grass-covered mons Veneris in Hans Haacke's *Grass grows* 1969 (ill. 272), while in Mario Merz's work (ill. 273) it appears as a triangular wax gusset in the fork of a tree. In Kenneth Noland's *Night green* 1964 (ill. 270) the symbol is reduced to a capacious triangular gusset. While in *Gate* 1959 (ill. 271) by Ellsworth Kelly the title emphasizes the association.

Fur, felt and leather used to evoke eroticism

Often a preference for fur reveals fetishistic tendencies. This material has sexual overtones: it is a partial image which evokes the total image of the fetish.

Meret Oppenheim's *Fur-covered cup, saucer and spoon* 1936 (ill. 259) evokes erotic associations, partly because of the cup's shape which alludes to the female sex organ, but primarily because of the hairy fur cover. The brushlike spoon is a male symbol which has been added as a contrast. Ursula covers her little wooden boxes with fur and also lines them with fur. These boxes can be opened and they sometimes reveal glittering precious objects – they are jewel cases with symbolic fur trimming. In

156

her *Fur bird jewel case (Pelzvogelkasten)* 1968 (ill. 275) she decorates the lid of a tall jewel case with a bird made of feathers and fur, which has a long fur tail hanging down.

For Beuys it is felt which has a fetishistic character, as we can see in *How to explain pictures to a dead hare (Wie man einem toten Hasen die Bilder erklärt)* 1964 (ill. 274). For Kalinowski it is leather – indeed leather is essential to his work: it covers his shapes like a precious skin and in some cases it actually determines the dimensions of the work. There is nothing perverse about these works (ill. 277 and 278 and 279): they are rather humdrum objects which could furnish the elegant boudoir of an aesthete. Honest works, made with great care and technical accuracy: which distinguishes them from gimmicky, modernistic works with only a super-ficial, dazzling elegance. *Rose thorn (Épine de rose)* 1968 (ill. 278) and *Torso for ab-lutions (Torse pour les ablutions)* 1968 (ill. 279) are complementary: male and female. *The prey (La proie)* 1970 (ill. 277) shows a metal spike violently piercing a leather sack. This association is taken up in Jim Dine's *Black hand saw* 1962 (ill. 276) where the saw is cutting through a wooden slat.

A lead relief by Robert Morris, dated 1964 (ill. 280), has leather folds which emphasize the power with which a sphere moves along a groove, and above there are two window openings with knotted strings in them. Bruce Nauman uses a knotted rope to evoke locked arms (ill. 281) and the way the different strands touch one another is very sensual. And in *Granny's knot* 1968 (ill. 282) by Shinkuchi Tajiri we find a similar knot with similar associations. While in *Double figure (Doppelfigur)* *c*.1960 (ill. 283) Joseph Beuys has bound two bronze figures together with an elastic band and then coated them with wax, so as to emphasize the unity he has created.

Sensual tension created through the arrangement of forms

The forms of a work of art can be arranged in a number of different ways in order to produce sensual tension. They do not even have to touch. In Claes Oldenburg's *Model giant drainpipe* 1966–7 (ill. 285) a tap is hanging over a waste pipe, but the angle-joint which should correspond to it has shifted slightly to the left. If water were to run out of the pipe, the waste pipe could only catch a very small part of it. This discrepancy creates tension, for our eye tries to perfect the arrangement so that the machine will function smoothly.

In his *Construction with a spherical hoop (Construction par un cerceau sphérique)* 1965–6 (ill. 284) Max Bill has balanced two spherical segments unsteadily on top of one another, so that the axis of the sphere has in fact been displaced. The surfaces of

the two spheres only have a tiny area of contact and this disturbs the eye, which tries to compensate by imagining the segments as a complete sphere.

In a work dated 1965 (ill. 289) by Bruce Nauman two rod elements move towards each other. Each rod has been bisected and they are differentiated by their colours, but they are trying to join together and form a new rod. The ends of the rods have already achieved this and they are leaning against each other in an erect position. While in Anthony Caro's work entitled *LX1* 1968 (ill. 288) a similar tube has been made out of various tin elements. This work is an organism which culminates in an erect tube.

In *Khmer* 1962 (ill. 287) Isamu Noguchi has placed a tubular bronze shape inside another tubular shape which encircles it safely and tenderly. The two elements are closely related, for they are made of the same material and they have the same volume – they are fused together but at the same time carefully separated. Bruce Nauman is playing on the same idea, with an elastic strip which is cut into three strands but still joined at the top (ill. 286).

Eduardo Chillida's block of iron is broken up by a complicated series of notches in *Field, space of peace (Champ, espace de paix)* 1965 (ill. 292). The different elements which make up this work snuggle up to one another tenderly, but avoid the final contact. In George Sugarman's *Ritual place* 1964–5 (ill. 293) related elements made of painted wood flow down from a pedestal. He manages to defy the consistency of wood, for it is only when they reach the floor that they form into firm lumps of wood again. Tony Smith's *Playground* 1966 (ill. 290) uses the simplest possible formal relationship. Sheets of wood are arranged in a shape that reminds us of a fallen human figure. The most important elements in this work are the direction from left to right, which is clearly indicated, and the hollowed-out hole, which is like a gateway offering a means of escape from the encroaching human figure.

Walter de Maria has also left an opening shaped like a gate in his *Death wall* 1965 (ill. 291). But the inexorable hardness of the steel is not softened by this hole – in fact it is the hole which enables us to grasp the monumental structure of the wall. Sol Lewitt's *C 369* 1968 (ill. 295) shows three different stages in the building of a cubic structure, which stands on a floor marked off in squares. He gradually adjusts the geometrical elements in the total construction. The workshop drawing for *C 369* (ill. 296) clarifies the design of this work; if we look from right to left the whole system can be reversed. And Richard Serra's *Object* 1968 (ill. 294) can also be reversed. He has wrapped a lead cylinder loosely around an iron rod, but alternatively we could say that the cylinder is the first element, which is then pierced by the rod. In another work by Serra, dated 1968, (ill. 300) a square panel of lead is held up against a wall by a rod. This arrangement is unstable and this somehow connects the two elements, almost as if they had been intimidated into standing to attention.

158

In his *Dumb record-player (Stummer Plattenspieler)* 1961 (ill. 299) Joseph Beuys has juxtaposed a square and a circle. An arm made of bone reaches over to the record turntable, and there are two little crosses nailing it down. The record is also nailed down by the crosses, but in any case it will never move again, for the rectangle superimposed on it prevents it from moving. Thus the record rests silently on the turntable.

In *Segments of a circle (Kreissegmente)* 1921 (ill. 297) Moholy-Nagy fuses the two forms very aggressively. The narrow black segment penetrates vertically into the plump, placid white segment. However in Theo van Doesburg's *Arithmetical composition (Composition arithmétique)* 1930 (ill. 298) the movement is more violent. He has placed a series of diminishing black squares diagonally across the picture, and the distance between them becomes smaller as the objects themselves grow smaller – it is almost as if the squares were hurrying faster and faster across the page. In Josef Albers' drawings entitled *Structural constellation (Strukturale Konstellation)* 1953–8 (ill. 301 and 302) the lines are drawn round a symmetrical axis; each surface and each body formed by the lines has its counterpart. The adaptability of these identical forms is attractive visually, and there is a transparent vibrant quality in this structure of white lines running across one another and next to one another, against a black background. In *Bora III*, dated 1958–62 (ill. 303), Victor Vasarely exploits all the possibilities of optical illusion, confining himself to experimenting with white strips against a black background. The principle behind his composition is to lay three square surfaces inside one another, and all we notice in this picture is a fluctuating backwards and forwards movement. But although optical illusion is the outstanding feature, the different elements in the picture contrive to form a living organism.

Another kind of movement can be seen in the linear arrangement of an element in Jim Dine's *4 designs for a fountain of the painter Balla* 1961 (ill.305). There are three identical forms and then one form which is slightly different. On the fourth form there is no dividing stripe between the upper and the lower zone, but instead there is a hole. On this fourth form the dangling end of the thread is attached lower down on the form and the top foil of the upper part is disarranged. But the same idea is expressed in all four forms: in the upper part there is the opening for the water to gush out, as suggested in the title, while in the lower part there is the dangling end of the thread which seems to anticipate the direction of the jet of water. The principle of arranging things in sequence is paramount in all Günther Uecker's work. His *Nail-object (Nagelobjekt)* 1958 (ill. 304) shows this: the nails grow out of the flat lower plane and attempt to push their heads inquisitively through the rows of holes in the concave upper level – and in the middle of the picture they have succeeded in doing this.

When Carl André puts thirty-six iron plates together to form a square (ill. 308) his intention is very like that of a builder who has to tile the floor of a terrace. The material and the dimensions may be attractive, but when we see this theme continually repeated with varying numbers of plates our only reaction is to recognize the artist straightaway. In *Bread (Pane)* 1962 (ill. 307) Piero Manzoni humorously arranged twenty-five bread rolls in the same way. And in 1960 he used the same technique to convert fleecy squares into a kind of quilt, in *Squares which change colour (Quadri che cambiano colore)* 1960 (ill. 320). We find this theme again in Lalanne's *Sheep (Les moutons)* 1966 (ill. 306) although the arrangement is much more disordered here. From the four black heads we can see that the group is in fact a herd of sheep.

In *Alphabet of passion (Alphabet der Leidenschaft)* 1961 (colour ill. VII) Konrad Klapheck painted 'twenty bicycle bells in a regular row, which were partly meant to suggest a landscape'. In his monograph on Klapheck, José Pierre wrote of this picture: 'Are we not being offered a catalogue of love positions here? ... The propeller shape represents the male element and the lever shape represents the female element. The cogwheel, the symbol of physical union, could represent the orgasm – or alternatively it could stand for the child, the visible result of the embrace.'[81] This interpretation would seem to be justified by the title, especially as each single bell has its own individual character.

A button which binds two halves together by penetrating a hole has sexual significance, even if it is not fastening up the flies of the trousers, as in Domenico Gnoli's *Waist line* 1969 (ill. 311). In Claes Oldenburg's *Soft typewriter* 1964 (ill. 312) the hard buttons of the typewriter keys are embedded in the soft trough of the instrument. In Arman's picture *Accumulation* 1963 (ill. 309) a fetishistic collection of buttons is covered with a sticky substance which keeps them together – and at the same time this collection is very pleasing to the eye. In *White lights* 1959 (ill. 310) Marc Tobey carries this idea a stage further: two elements, a dot and a dash, fill the space and the two different kinds of tension create an aesthetic texture which may, by association of ideas, suggest a night sky filled with stars.

In *The sea (Il mare)* c. 1914 (ill. 315) Piet Mondrian creates sensual tension within a large oval form by juxtaposing horizontal and vertical elements, while relating each of these elements to the oval which surrounds them. Here the detail of the sea is extended to include the water, in the lower half of the oval bowl, and the sky in the upper half of the oval bowl. The streak on the horizon has the most important function, for it marks the beginning and the end of the two bowls. Similarly, in *Achrome* 1959 (ill. 314) Piero Manzoni relates the play of the folds to a horizontal symmetrical axis, but in this case the halves only open after suction from above or from below, for the zone shows a detail and the points of tension lie outside the

160

picture. Mondrian later introduced a kind of rhythm into the arrangement which we saw in *The sea* (ill. 315): in a charcoal drawing which is also called *The sea (Il mare)* 1914 (ill. 313) he joined the verticals and horizontals in such a way that the horizontal parallel elements determine the appearance of the drawing. The water moves horizontally, but the tension arises from the vertical stress of the crests of the waves. Thus we have the feeling that the oval encloses a living organism. If a pier penetrates into the ocean, as in *Pier and ocean* 1914 (ill. 316), the wave rhythm becomes disorderly – only when the line of movement has reached the horizon line does it try to compensate by smoothing the mirror of the sea.

Giuseppe Capogrossi creates his pictures from a single shape which resembles a rake with four prongs. But in a drawing dated 1964 (ill. 317) we can see how much sensual tension is contained in the prongs of this shape. The ones at the bottom of the picture are posed like a row of pin men, but each shape seems to be waiting for its complementary half. The missing half resists the idea of joining up and tries instead to achieve symbiosis with the shapes in the upper half of the picture. It is not certain which connections will be stable, for everything is in a state of fluctuation and tension.

Dieter Stein's use of colour gives his work a visual sensuality – indeed the organic quality of his pictures comes from their colour composition. We can contrast this with an early work by Gotthard Graubner dated 1960 (ill. 319), which is almost monochrome and in which we can distinguish nothing but overlapping, cloud-like zones. Richard Oelze obtained the same effect in a drawing c. 1935 (ill. 318), expanding the surface of the picture into a sensual, vibrating area of colour. Dieter Stein builds up spots of colour, layered on top of one another, which create a whole series of different spatial relationships. In a work of 1967 (colour. ill. VIII) he combines strongly coloured elements inside a conical gusset. It looks almost as if the colours are being swallowed up and reduced, so that when they have been purified and reduced they can trickle through the lower cleft between the wide, protruding thighs.

Erotic associations emphasized by the title

If the title of a work expressly indicates its erotic character, we have only to follow the association indicated by the artist in order to understand it. Jean Ipoustéguy's *Sexual sandwich (Sandwich sexuel)* 1968 (ill. 323) is made of marble and it stands on a black tray. The tray stands on a pedestal composed of two marble slabs, and there are soft breast shapes and angular lumps clamped in between these two marble slabs. The sandwich is made up of rough splinters and smooth organic shapes, all in marble.

But the title is only really justified when we see the slender beaker, which seems to be waiting for something to fill it, and the well-rounded marble phial that goes with the beaker. The marble phial has the male role, for it will empty its fluid into the beaker.

In Valerio Adami's work the environment is transformed by erotic elements. In *The homosexuals* 1966 (ill. 321) the artist combines a public lavatory, a private shower-room and also a public urinal (which has different compartments which seem to grow from a finger). It is left to the spectator to make the erotic associations, for the different elements of the picture are interlocked in a very complex way and we can only vaguely distinguish the action of the picture – from a hat, a cigarette, a mouth and the remains of a face. Altogether, the atmosphere is rather sterile, but the large scale of the picture is responsible for this. The same elements are transferred to the female sex in *Pink pornographic tale (Racconto pornografico rosa)* 1966 (ill. 322), which has one woman – or perhaps several women – in an erotic position.

In Edward Kienholz's *Night of nights* 1961 (ill. 325) the title also points to the erotic connotations. Woman is the subject of the night of nights and the shapes in the steel wool mattress suggest sexual intercourse. A picture by Joan Miró is called *Love (Amour)* 1926 (ill. 326). Above a large cloudy shape are cross wires and there is a bar at the end with four hairs fluttering from it – the man is lying over the woman. As though to explain the picture a woman composed of spheres and pin-legs appears on the right-hand side of the picture. Her sexual organ is shown as a star. The word *Amour* is inscribed, in capital letters, around the base of the large, cloudy, female shape. In Robert Motherwell's *I love you IV (Je t'aime IV)* 1955–7 (ill. 327) the handwriting is the most important element, although the shapes stress erotic experience. In Motherwell's *Elegy to the Spanish republic, no. 70* 1961 (ill. 328) the violent action underlines the erotic associations suggested by the shapes. In Robert Indiana's *Love* 1966 (ill. 324) erotic associations have been reduced to the word *love*, printed in a typographic arrangement worthy of a publicity designer.

Concealed erotic stimulus producing works which do not seem erotic

An artist can be motivated by a concealed erotic stimulus, even if the resulting work shows hardly any evidence of this. This is true of Yves Klein, and an example of his work is *Positive static multiple blue imprint (Empreinte positive statique multiple bleue)* 1960 (ill. 329). He dipped naked human models into blue paint, so that he could paint pictures with these living rubber stamps. He wrote: 'The form of the human body, its lines, its colour which is somewhere between life and death – none of these things interest me, for I am concerned exclusively with the climate of feelings: that

is what counts. As for the flesh …! Certainly, the whole body is made of flesh – but the real bulk of the body is the rump and the thighs. For there lies truly universal creation, concealed creation. When human flesh was present in my studio, it helped me to preserve in my monochrome works the freshness of my initial impression.'[82]

In a picture by Jean Fautrier entitled *Reclining nude (Nu couché)* c. 1945 (ill. 330) the female nude appears as a transparent silhouette against a light background with wavy contours, with a dark outer background. The association suggested by this nude needs no explanation. Similarly, in a watercolour by Henri Michaux dated 1961 (ill. 333) the same association is expressed in a sequence which reminds us of writing, and the shape of the nude can only be vaguely sensed. In Jackson Pollock's painting of 1951 (ill. 334) all we can see are impulsive gestures, charged with vitality. But at times living embryos emerge from an informal gesture – like the phallic gnomes in Wols's *Monstrum horrendum* 1945 (ill. 332). There is a threatening upward movement in this painting, which is aiming at a cleft – a cleft such as the greedy, gaping cleft in a coloured body entitled *Nude – 15F (Nu – 15F)* 1956 (ill. 331) by Jean Fautrier: nothing is left of the nude but an immense gap, and the picture reminds us of a hungry face. A similar half-moon shape made from sack-cloth is encircled with moving coloured lines in a picture by Lucio Fontana (ill. 337), but one of the lines has already given vent to its aggression and punched a line of holes right through the body. Antonio Tàpies also spreads out a body as a collage in a work dated 1961 (ill. 335). Its shape is marked with chalk-like streaks and it is centred around a hole that has been torn in the collage. Traces of scratches suggest aggression which has now died away, leaving a violated torso. In *Black bag (Sacco nero)* 1956 (ill. 336) Alberto Burri shows what looks like a close-up of the violation Tàpies was hinting at.

Scribbling, the purest form of drawing, is the main element in Cy Twombly's pictorial world. Peter Gorsen has defined the obscene character of such drawings as 'an obsession with scatology expressed in a polymorphous form'. 'We are right to look on the walls of urinals for the drawings which inspired Twombly's drawings, for it is there that frustrated sexuality can give vent to its indecent desires in secret. These drawings are not a copy of some previously discovered morphology, for they have dissociated themselves from all primitive needs. But this does not make them any less harmful, in fact it increases the nature of their indecency. If we compare them with the fantasies of urinal grafitti, their strength lies in their detail. The sexuality in Twombly's drawings is to be found in the detail: it is much less important in the symbolic silhouettes in which anyone can recognize whatever he wants, for it is concentrated in the cryptic scrawl which is overpowered by its own desire. From these ciphers we can see how pure sexuality can be tolerated: as a naked vacuum of masturbation, a shadow cast on the ground by sexual symbols

bursting with strength.'[83] A drawing by Twombly dated 1959 (ill. 339) clarifies this quotation, for the largely aesthetic character of its writing has a spontaneity which reveals its obscene impulse quite openly. An earlier drawing, dated 1957, (ill. 338) has disintegrated into a series of illegible characters: a recumbent nude, very loosely outlined, is stretched out in a meadow covered with grafitti. In a drawing called *Mars and Venus* 1962 (ill. 341) the obscene erotic reference is obvious, and this is not only because of the title. Coloured traces of filth have been caught in the net of the scribbling. However the title and the signature raise them to a conscious, intellectual level, for they reveal that they are part of an artistic composition.

In *Rose tip (Bout de rose)* 1960 (ill. 340) Antonio Tàpies exploits the physical tension of empty surfaces. A few, apparently accidental streaks bring life to the female genital knot, which is the target of the male organ as it thrusts its way through the streaked horizon. Robert Rauschenberg's *Collage with white* 1956 (ill. 342) has a similar centre. Different surfaces are superimposed on each other, and the layers of dirty white tones form a kind of patched carpet, with violent dirty traces in the centre. We can also see that an aggressive hand has intervened, daubing colour.

In a picture by Arshile Gorky dated 1944 (ill. 344) shapes are driven playfully through an indecipherable labyrinth. Erotic ideas are involuntarily stimulated by these associations, although we cannot pin down anything concrete – male and female elements seem to be whirling around in confusion. In Alan Davie's *Rub the lamp* 1961 (ill. 346) and *Pomo* 1962 (ill. 343) the action is no less violent, but it is more clearly organized. Dieter Rot's drawing *Extended embryo (Gedehntes Embryo)* 1964 (ill. 345) takes up one of the elements in Alan Davie's work and isolates it: the egg has just burst and it is striving to leave its centre, but it wants at the same time to stay in contact. The character of the picture is definitely phallic, in spite of the symmetrical, decorative nature of its forms.

The arrows indicate the direction of the action in a watercolour drawing by Shusaku Arakawa dated 1963 (ill. 347), which has been arranged in unhurried stages. The circle indicates a fertilizing impulse, which then moves downwards in stages until it reaches the receptive U-shaped container. On the other hand the apparatus in a drawing by Joseph Beuys dated 1961 (ill. 348) tirelessly pumps life into the circulation, through an organism whose functions attempt to remain active while the signposts point up and down. In this drawing foodstuffs are being processed – probably fat, for according to Gorsen 'the artist who works with fat finds, just as the spectator does, that this material can be experienced as an entity before it is absorbed into the body – just as faeces can be experienced as an entity after they leave the body, as the "aesthetic" end product'.[84] This is the reason for 'the aesthetic fascination of the "fat-corners" and "fat-spaces" in Beuys's work' which Gorsen

164

rightly pointed out. Thus fat has a hyperaesthetic quality, for it can create a magical effect by the aesthetic manipulation of alienated foodstuffs, by flirting with unsavoury associations. If the tension were to slacken – and indeed the shock is sharply reduced at each encounter – Beuys's drawing would turn out to be nothing but a heap of aesthetic trash. And then even Beuys's *The intelligence of swans (Intelligenz der Schwäne)* 1955 (ill. 349) will not help us: for the penises are wilting, their phallic strength broken, and they are thrusting themselves into a vacuum.

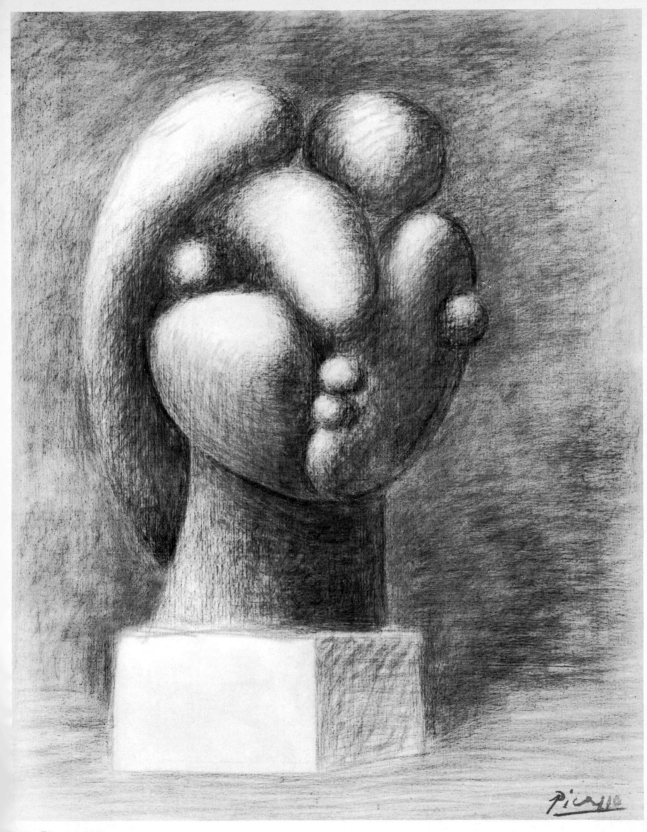

170 Picasso, 1932

171 Picasso, Buste de femme, 1932

172 Picasso, Tête de femme, 1932

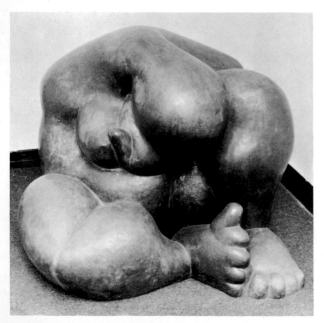

173 Laurens, Le grand adieu, 1941

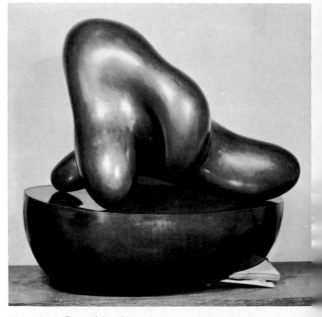

174 Arp, Concrétion humaine sur coupe, 1947

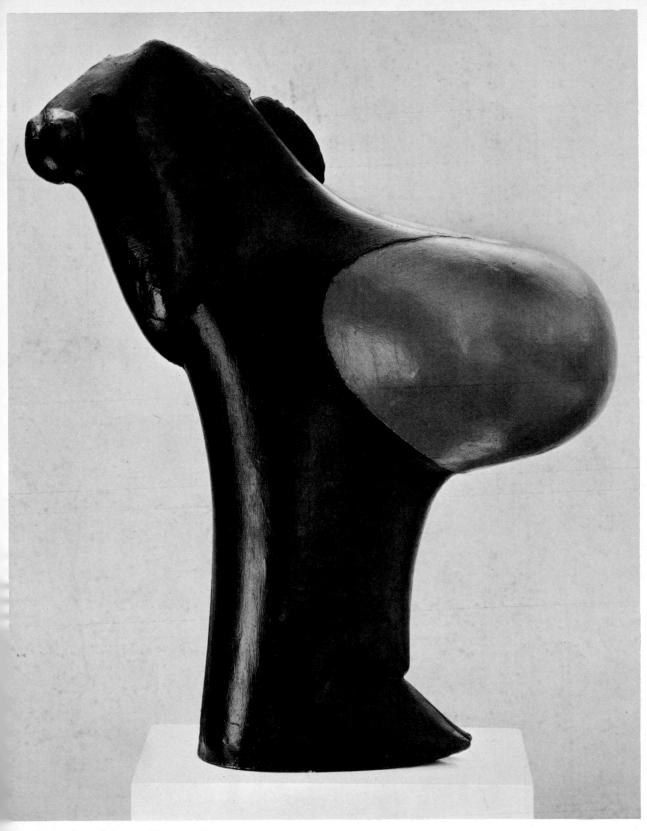

75 Maier-Buss, Schwarze Venus, 1963

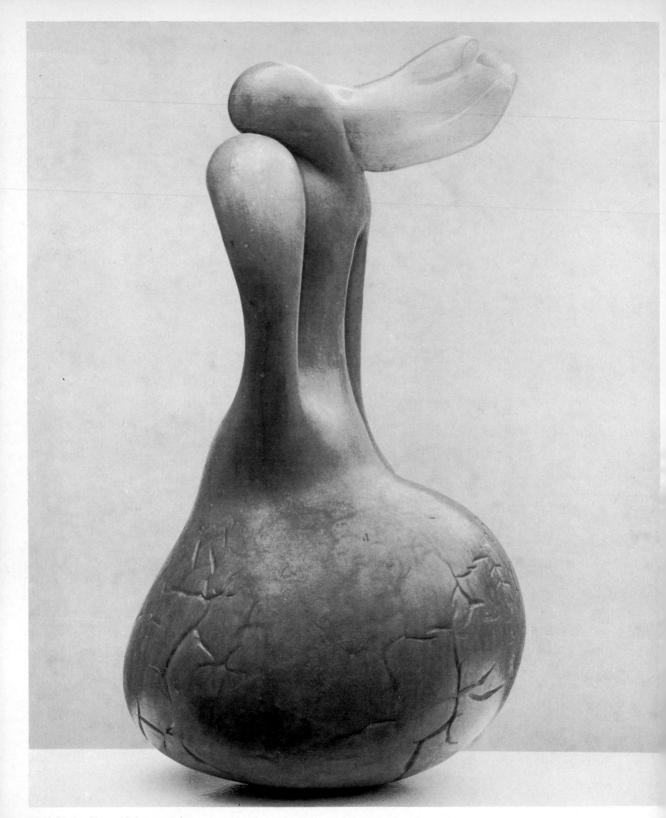

176 Maier-Buss, Xylei, 1969/70

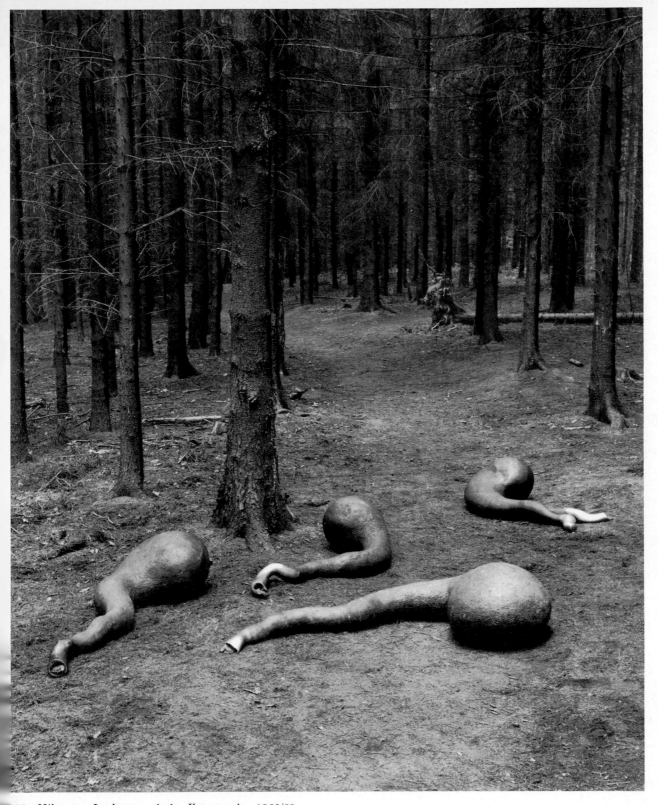

177 Hiltmann, Laokoon nach der Katastrophe, 1966/68

178 Maier-Buss, 1969

179 Hiltmann, 1967

180 Maier-Buss, 1966

181 Westermann, Rotting Jet Wing, 1967

182 Kienholz, The illegal operation, 1962

183 Kudo, L'amour, 1964

184 Morris, 1968

185 Gilioli, Célébration de la boule, 1968

186 Ipoustéguy, Casque fendu, 1958

187 Ipoustéguy, La mort dans l'œuf, 1968

188 Hiltmann, Geplatzter Ele-K, 1963

189 Fontana, Concetto spaziale – Natura, 1965

190 Klapheck, Zeugung, 1960

191 Fontana, ca. 1965

192 César, Coulée à l'œuf, 1966

193 King, Tra – la – la, 1963

194 Schultze, Orch, 1959

195 Schultze, Grüner Migof, 1963

196 Kusama, Armchair, 1962

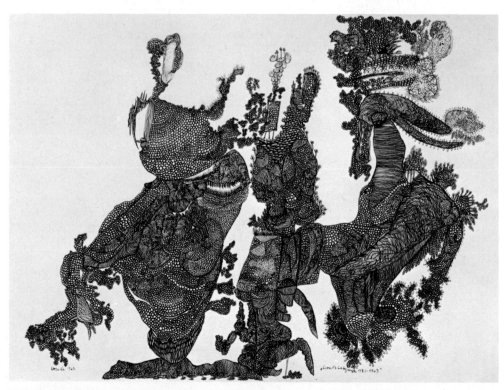

197 Ursula, Lirads Labyrinth, 1963

198 Heizer, 1969

199 Manzoni, Achrome, 1959

00 Fontana, Concetto spaziale Attese, ca. 1965

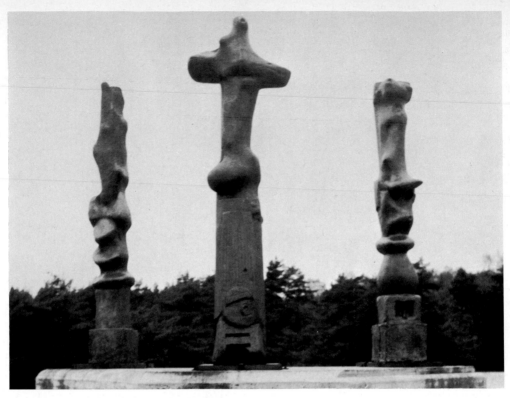

201 Moore, Three upright motives, 1965/66

202 Avramidis, 1965

203 Tanguy, 1935

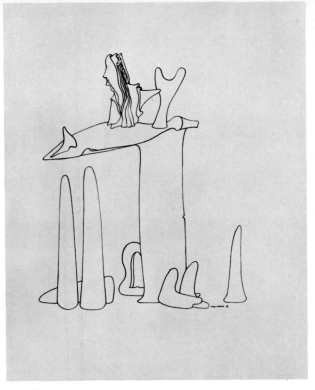

204 Tanguy, 1935

205 Klapheck, ca. 1960

206 Graubner, Farbleib auf silbergrauem Grund, 1964/65

207 Christo, L'empaquetage, 1963

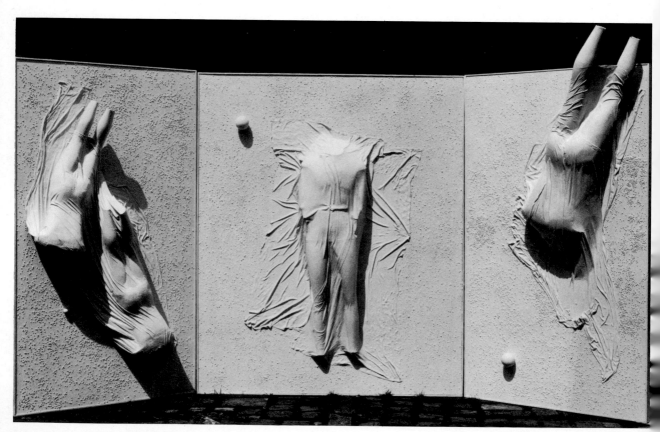

208 van Hoeydonck, Triptiek van de Ruimte, 1964

209 Graubner, 1965

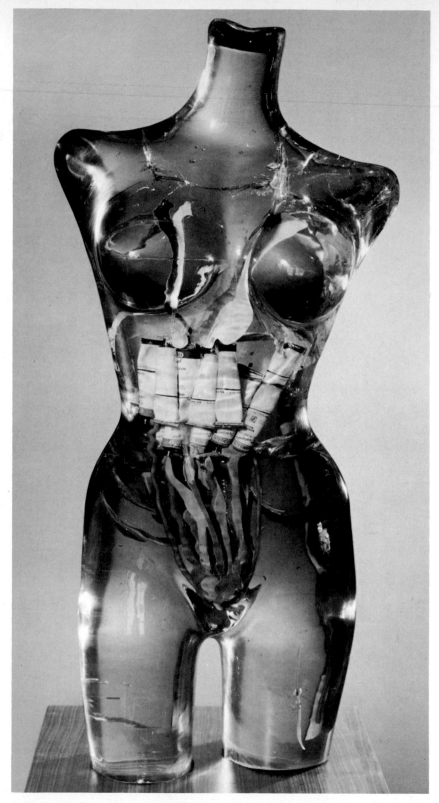

210 Arman, La couleur de Mon Amour, 1966

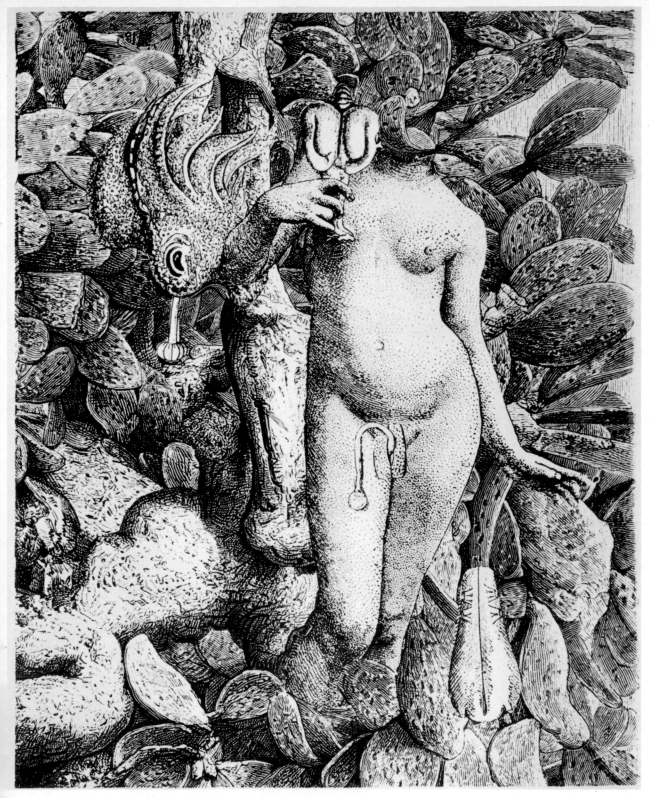

211 Ernst, Liebeslied, 1934

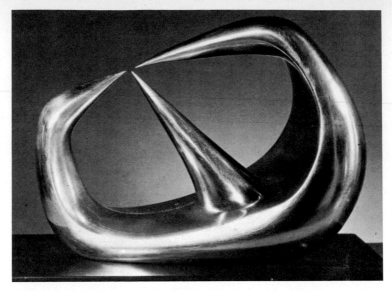

212 Moore, Three points, 1939/40

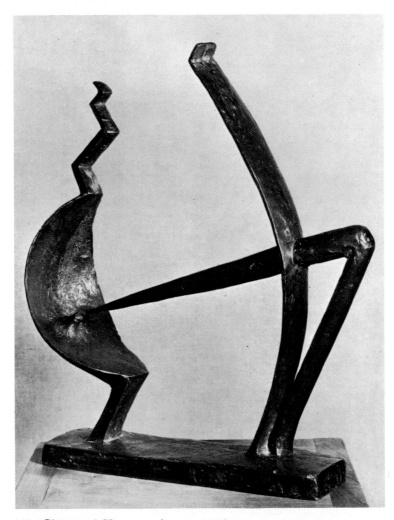

213 Giacometti, Homme et femme, 1928/29

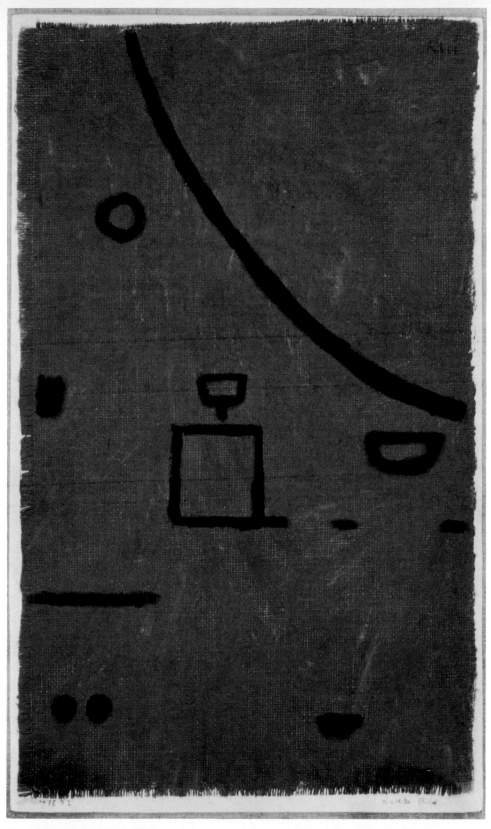

214 Klee, Nacktes Bild, 1938

215 César, Le pouce de César, 1965

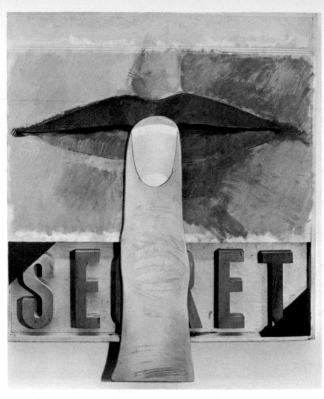

216 Tilson, Secret, 1963

217 Raysse, Collage, 1962

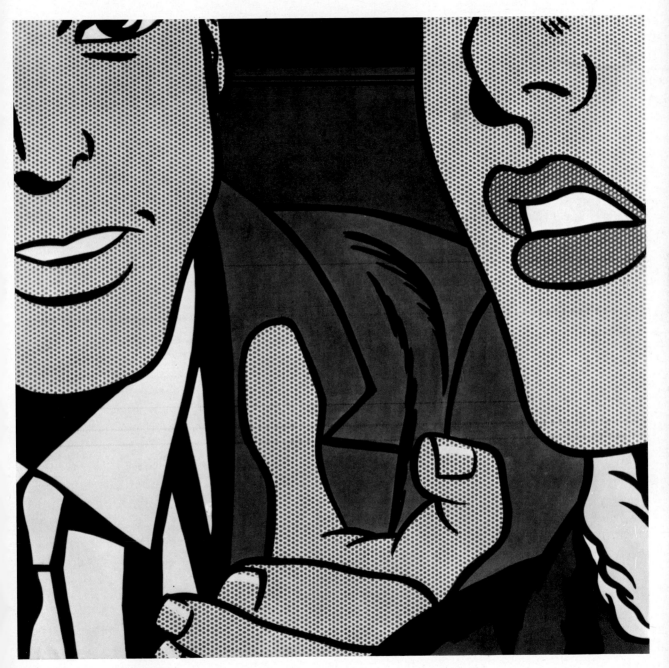

218 Lichtenstein, Couple, 1963

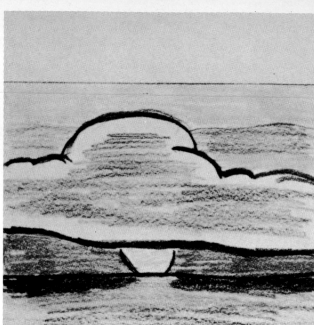

219 Lichtenstein, Two seascapes, 1966

220 Lichtenstein, Bread in bag, 1961

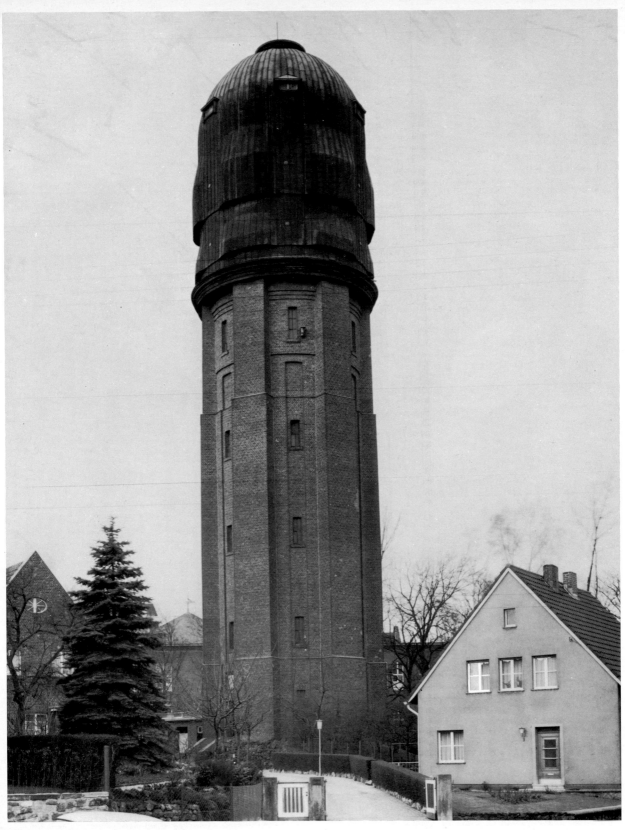

221 Becher, Wasserturm, Badenberg

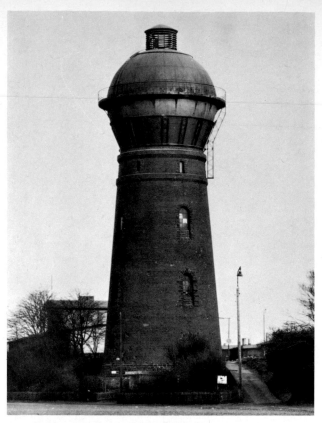

222 Christo, 5450 m cubic package, 1967/68

223 Becher, Wasserturm, Duisburg

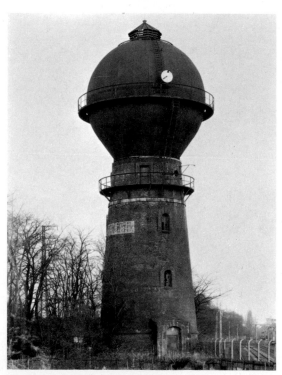

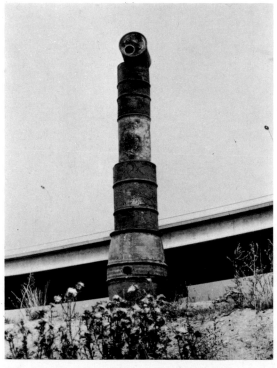

224 Becher, Wasserturm, Köln

225 Christo, Colonne de 5 tonneaux, 1962

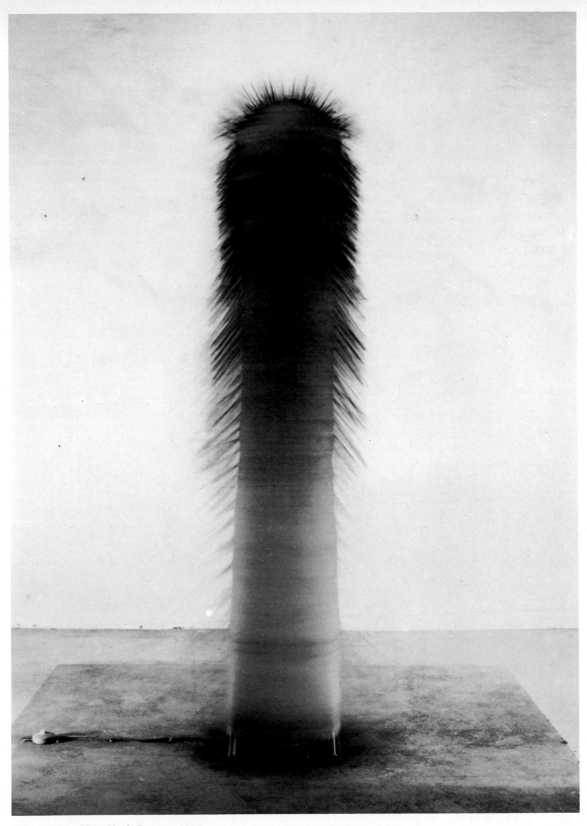

226 Uecker, New York Dancer, 1966

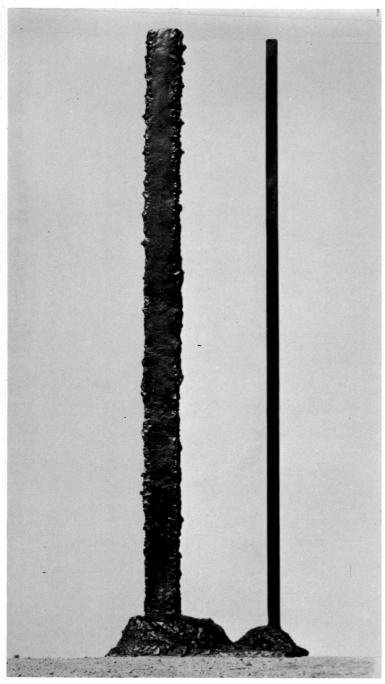

227 Newman, Here I, 1950

228 Takis, Electro-magnétique, 1964

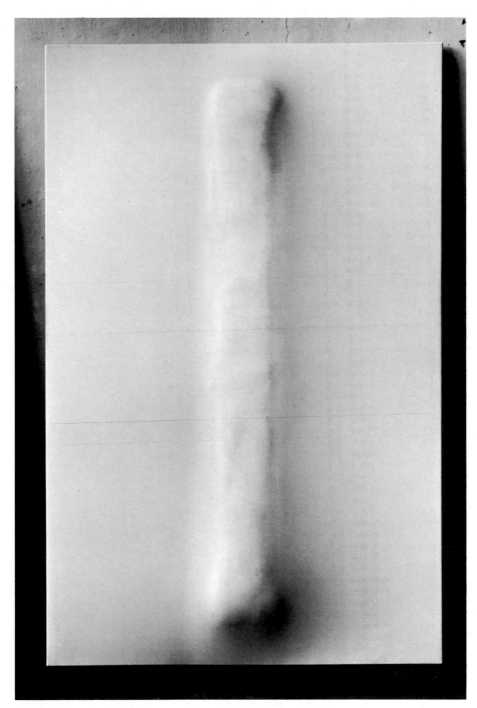

229 Graubner, Stylit I, 1968

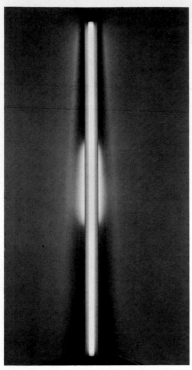

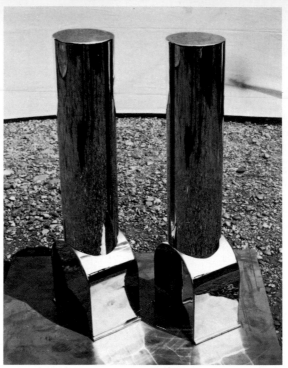

230 Flavin (to Shirley), 1965–69 231 Paolozzi, Twefx, 1967 232 Judd, 1965

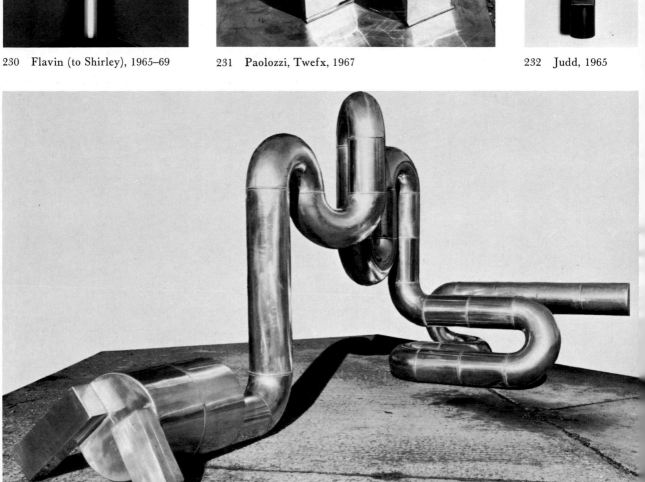

233 Paolozzi, Gexhi, 1967

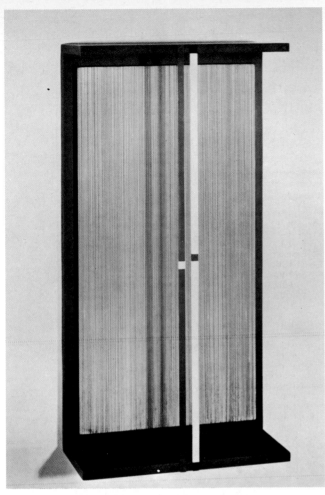

234 Soto, Relation blanc et noir, 1965

235 Bell, Cube No 2, 1967

236 Bladen, 1965

237 Giacometti, Pointe à l'œil, 1931

238 Giacometti, Le nez, 1947

239 Giacometti, Boule suspendue, 1930

240 Müller, L'archange, 1963

241 Pisani, Studi su Marcel Duchamp, 1965/70

242 Ceroli, Marcus, 1968

243 Bury, Ponctuation, 1961

244 Bury, Les batons, 1964

245 Heerich, 1960

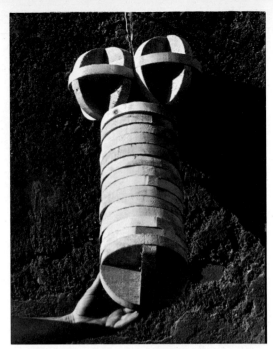

246 Hiltmann, 1967

247 Ceroli, Subliminal cock, 1968

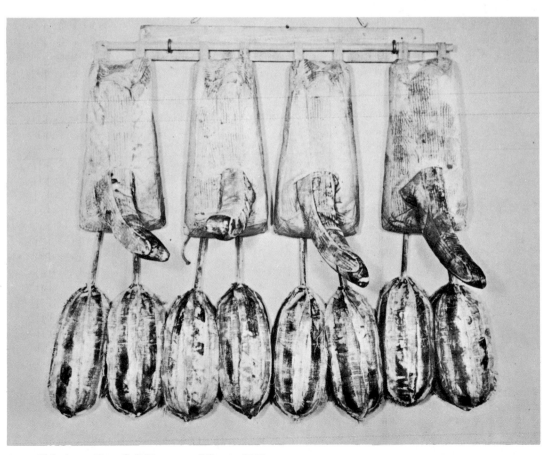

248 Oldenburg, Four Soft Dormeyer Mixers, 1965

249 Oldenburg, Study for Giant Soft Drum Set 2, 1967

250 Israel, Peach Progress, 1966

251 Oldenburg, Colossal Fagend, Dream State, 1967

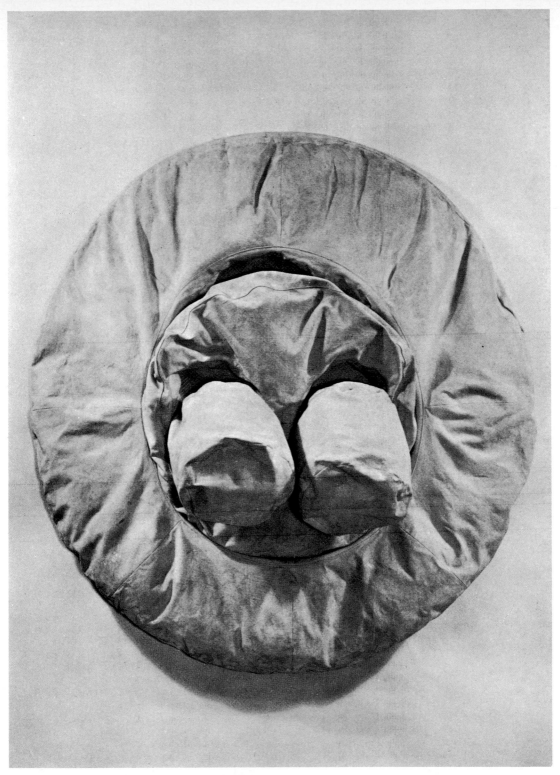

252 Oldenburg, Giant Soft Swedish Light Switch, 1966

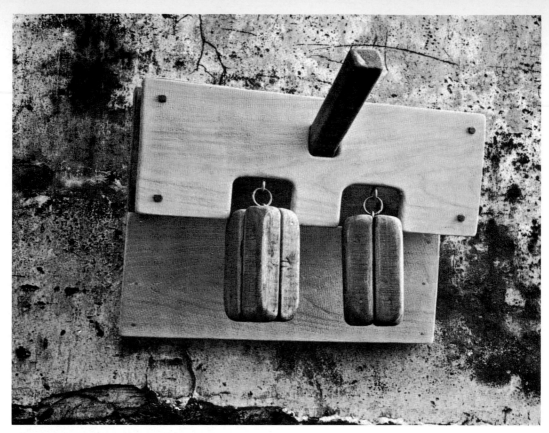

253 Brusse, Strange fruits **VI**, 1965

254 Hoflehner, Figur, 1961 255 Hiltmann, Die Versuchung des Hl. Antonius, 1964

256 Heerich, Walzenpuppe, 1963

257 Pascali, Nido, 1968

258 Pascali, La meridiana, 1968

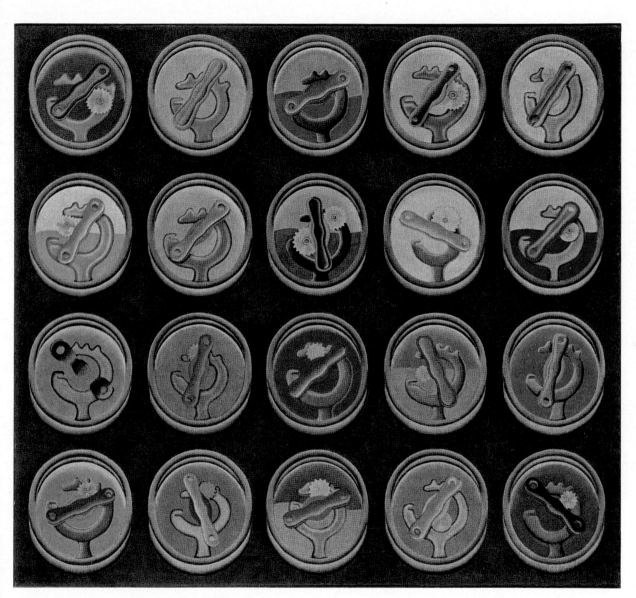

Klapheck, Alphabet der Leidenschaft, 1961

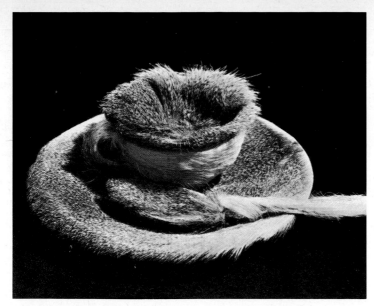

259 Oppenheim, Fur-covered cup, saucer and spoon, 1936

260 Uecker, Nagelobjekt, 1962

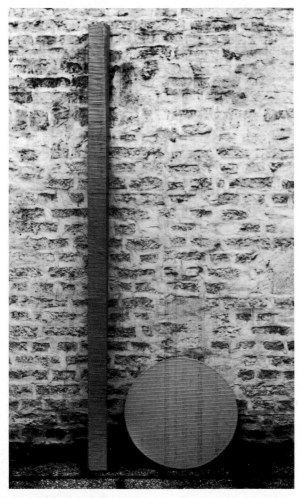

261 Palermo, 1968

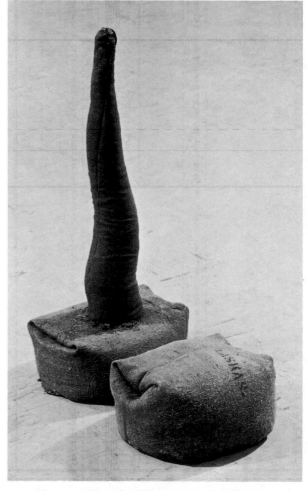

262 Flanagan, Two rsb, 1967

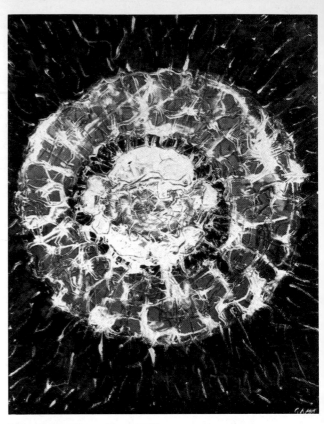

263 Mack, Fata Morgana, 1968

264 Tobey, Space Rose, 1959

265 Bontecou, 1964

266 Zorio, Spugna fluorescente, 1968

267 Flanagan, rsbtworahsbbsharowtbsr, 1967

268 Chamberlain, Funburn, 1967

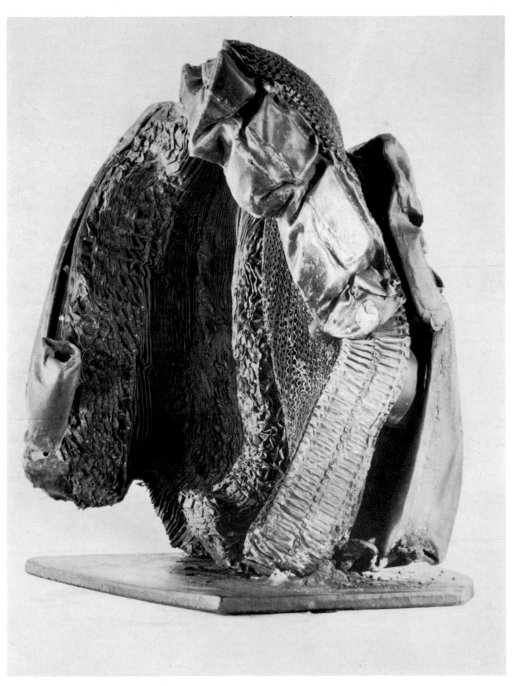

269 César, On est deux, 1961

270 Noland, Night green, 1964

271 Kelly, Gate, 1959

272 Haacke, Grass grows, 1969

273 Merz, 1967

274 Beuys, Wie man einem toten Hasen die Bilder erklärt, 1964

275 Ursula, Pelzvogelkasten, 1968

276 Dine, Black Hand Saw, 1962

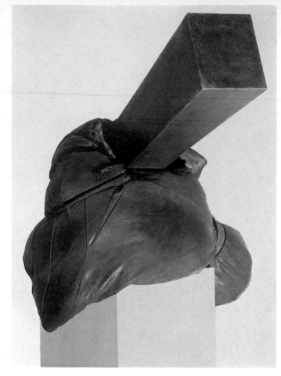

277 Kalinowski, La Proie, 1970

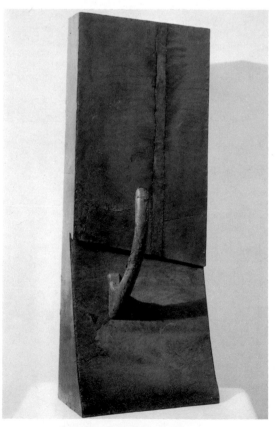

278 Kalinowski, Épine de Rose, 1968

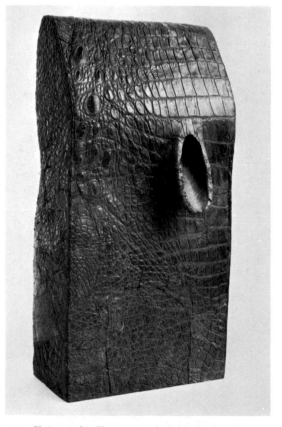

279 Kalinowski, Torse pour les ablutions, 1968

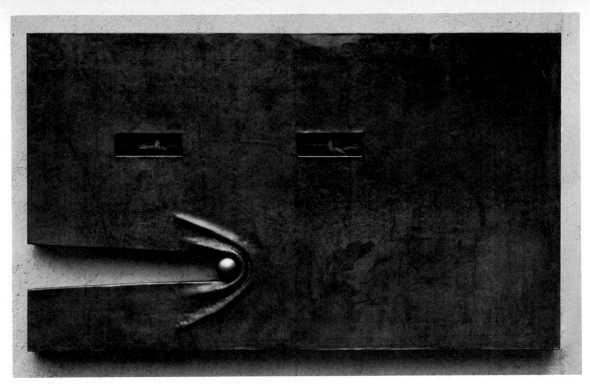

280 Morris, 1964

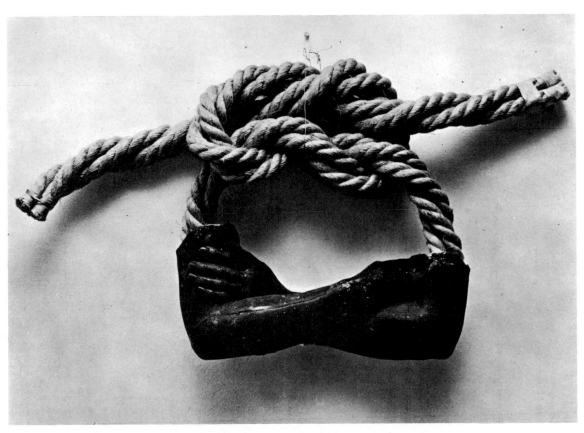

281 Nauman, 1967

282 Tajiri, Granny's knot, 1968

283 Beuys, Doppelfigur, ca. 1960

284 Bill, Construction par un cerceau sphérique, 1965/66

285 Oldenburg, Model Giant Drainpipe, 1966/67

286 Nauman, 1965

287 Noguchi, Khmer, 1962

288 Caro, LXI, 1968

289 Nauman, 1965

290 Smith, Playground, 1966

291 de Maria, Death Wall, 1965

292 Chillida, Champ espace de Paix, 1965

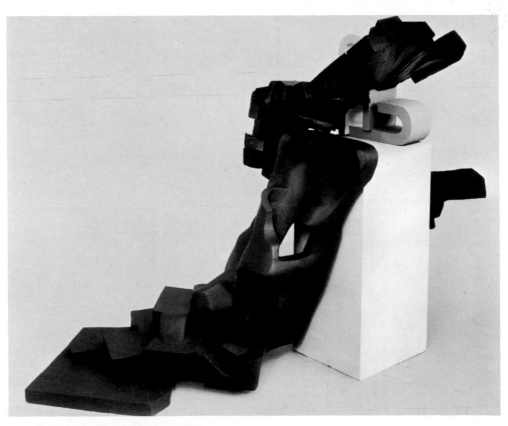

293 Sugarman, Ritual Place, 1964/65

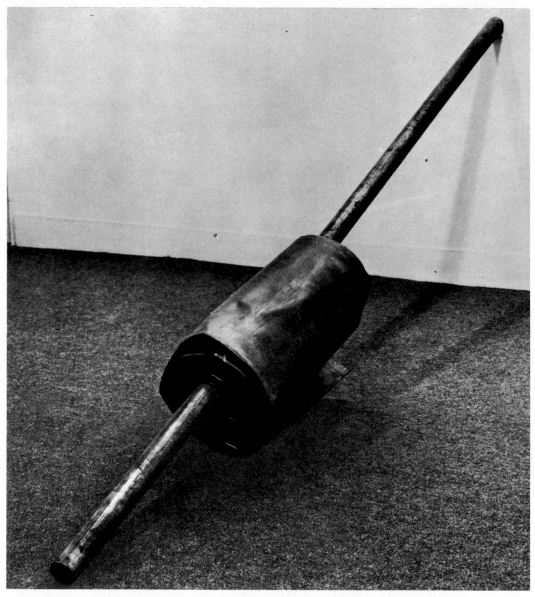

294 Serra, Object, 1968

295 Lewitt, C 369, 1968

296 Lewitt, 1968

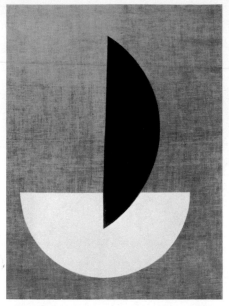

297 Moholy-Nagy, Kreissegmente, 1921 298 van Doesburg, Composition arithmétique, 1930

299 Beuys, Stummer Plattenspieler, 1961

300 Serra, 1968

301 Albers, Strukturale Konstellation, 1953–58

302 Albers, Strukturale Konstellation, 1953–58

303 Vasarely, Bora III, 1958–62

304 Uecker, Nagelobjekt, 1958

305 Dine, 4 Designs for a Fountain of the Painter Balla, 1961

306 Lalanne, Les moutons, 1966

307 Manzoni, Pane, 1962

308 Andre, 1968

309 Arman, Accumulation, 1963

310 Tobey, White lights, 1959

311 Gnoli, Waist line, 1969

312 Oldenburg, Soft Typewriter, 1964

313 Mondrian, Il mare, 1914

314 Manzoni, Achrome, 1959

315 Mondrian, Il mare, ca. 1914

316 Mondrian, Pier and Ocean, 1914

317 Capogrossi, 1964

Stein, 1967

318 Oelze, ca. 1935

319 Graubner, 1960

320 Manzoni, Quadri che cambiano colore, 1960

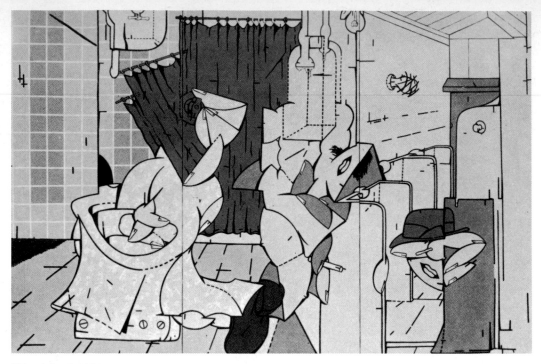

321 Adami, 1966

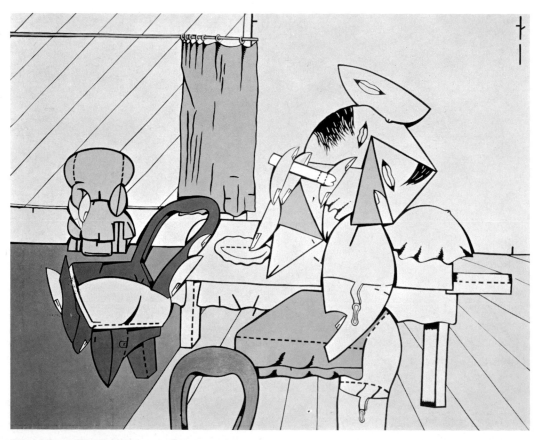

322 Adami, Racconto pornografico rosa, 1966

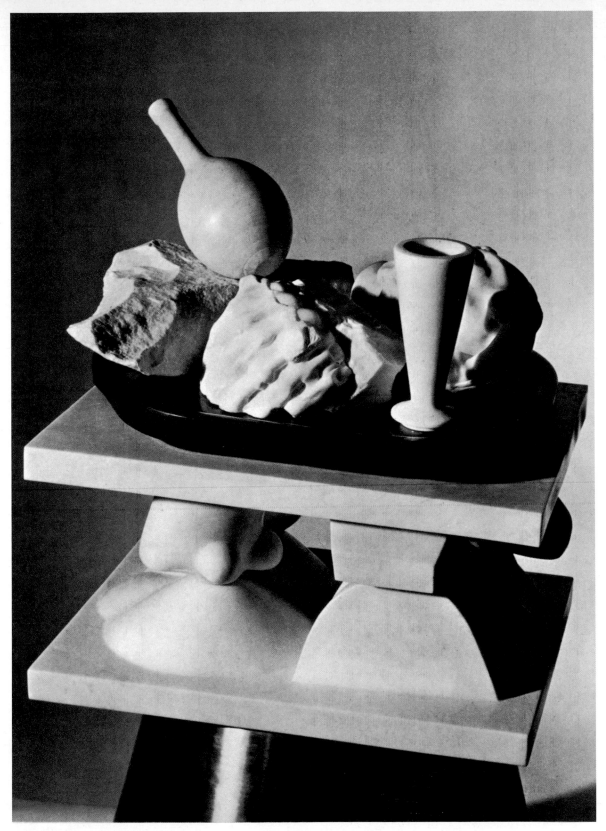

323 Ipoustéguy, Sandwich sexuel, 1968

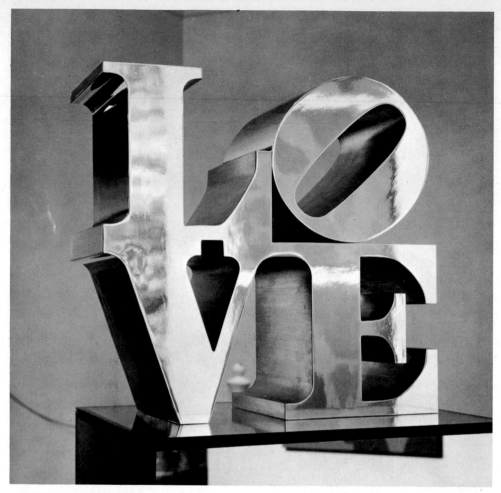

324 Indiana, Love, 1966

325 Kienholz, Night of nights, 1961

326 Miró, Amour, 1926

327 Motherwell, Je t'aime IV, 1955–57

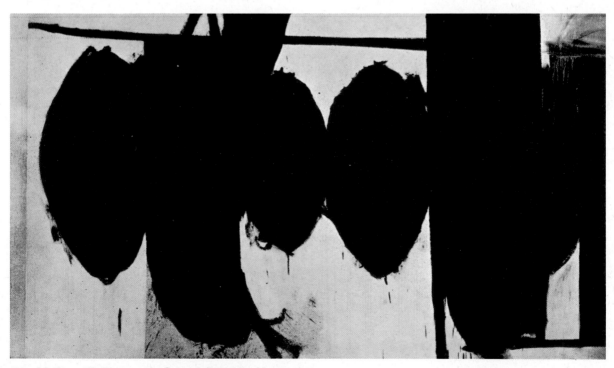

328 Motherwell, Elegy to the Spanish Republic, No 70, 1961

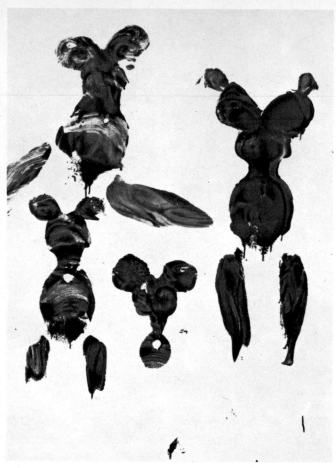

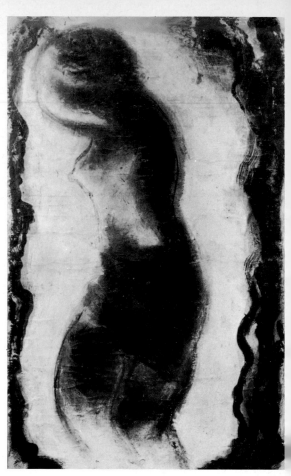

329 Klein, Empreinte positive statique multiple bleue, 1960

330 Fautrier, Nu couché, ca. 1945

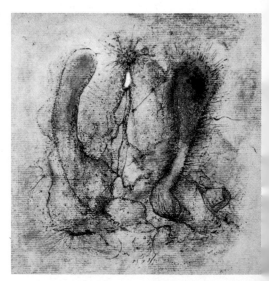

331 Fautrier, Nu – 15 F – 1956

332 Wols, Monstrum horrendum, 1945

333 Michaux, 1961

334 Pollock, 1951

335 Tàpies, Collage, 1961

336 Burri, Sacco nero, 1956

337 Fontana, 1955

338 Twombly, 1957

339 Twombly, 1959

340 Tàpies, Bout de rose, 1960

341 Twombly, Mars and Venus, 1962

342 Rauschenberg, Collage with white, 1956

343 Davie, Pomo, 1962

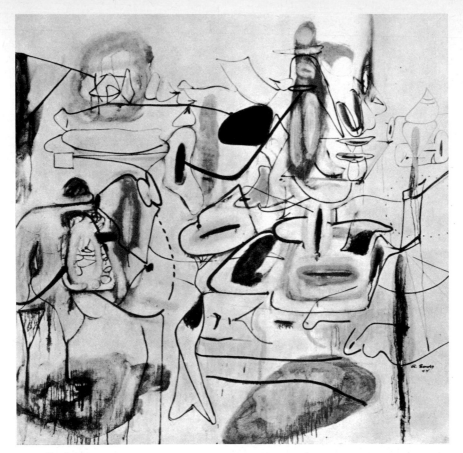

344 Gorky, 1944

345 Rot, Gedehntes Embryo, 1964

346 Davie, Rub the lamp, 1961

347 Arakawa, 1963

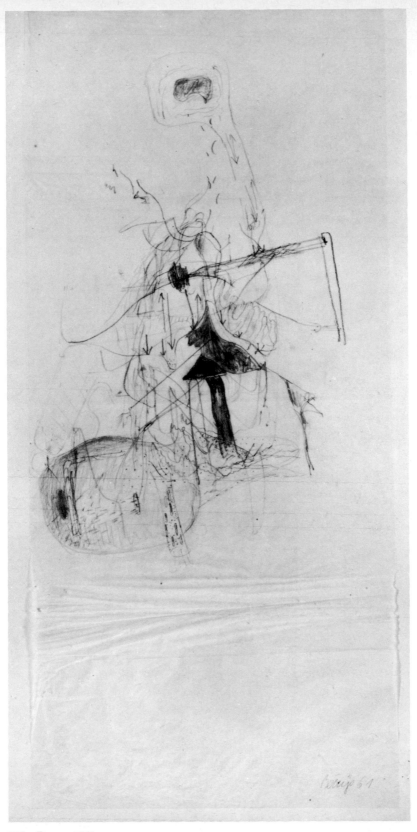

348 Beuys, 1961

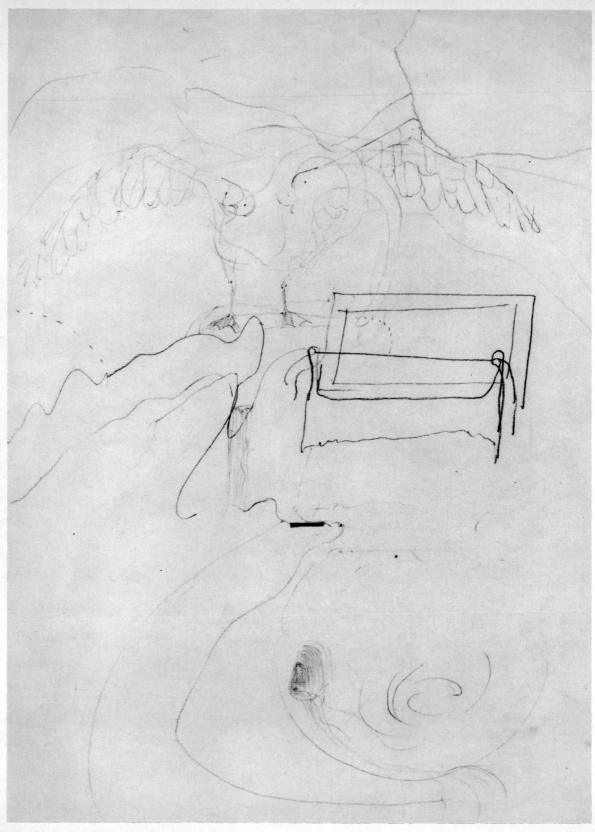

349 Beuys, Intelligenz der Schwäne, 1955

Notes

1 Armand Mergen *Sexualforschung* (Hamburg 1963) p.235
2 Eberhard and Phyllis Kronhausen *The first international Exhibition of Erotic Art* (Lund 1968) p.18
3 ibid. p.20
4 Mergen, op. cit. p.455
5 Eduard Fuchs *Geschichte der erotischen Kunst* (Berlin 1908) p.15
6 ibid. p.61
7 ibid. p.64
8 ibid. p.68
9 Peter Gorsen *Das Bild Pygmalions, Kunstsoziologische Essays* (Hamburg 1969) pp.18–9
10 ibid. p.11
11 Sigmund Freud *Introductory lectures on psycho-analysis* (eleventh impression, London 1968) ch.10 'Symbolism in Dreams' p.125
12 ibid. p.126
13 ibid. pp.127–8
14 ibid. p.139
15 ibid. p.140
16 ibid. p.139
17 Patrick Waldberg *Surrealism* (London 1965) p.11
18 Freud, loc. cit. p.129
19 Fuchs, op. cit. p.286, plate 253
20 Freud, loc. cit. p.129
21 ibid. p.128
22 ibid. p.131
23 ibid. p.133
24 *Bilder-Lexikon der Erotik* vol.2, *Literatur und Kunst* (Vienna and Leipzig 1929) p.828
25 Pierre Demarne *René Magritte, Rhétorique, No 3* (September 1961) p.21 (plate)
26 Freud, loc. cit. p.133
27 ibid. p.130
28 *René Magritte, Katalog der Kestner-Gesellschaft* (Hanover 1969) pp.6–7 (plate)
29 *Fernand Léger, Katalog der Kunsthalle* (Baden-Baden 1967) plate 7
30 Freud, loc. cit. p.131
31 *Bilder-Lexikon der Erotik* vol.1, *Kulturgeschichte* (Vienna and Leipzig 1928) p.770
32 Freud, loc. cit. p.132
33 Marcel Jean *Geschichte des Surrealismus* (Cologne 1959) p.33 (plate)
34 Freud, loc. cit. p.133
35 ibid. p.129
36 ibid. p.130
37 ibid. p.131
38 There is another version of this: the bottle is closed with a cork, which gives a male accent

to the picture. *René Magritte, Katalog des Museums Boymans van Beuningen* (Rotterdam 1967) p.221, plate 94

39 Freud, loc. cit. p.134

40 ibid. p.132

41 *Rembrandt, Das graphische Werk* (Vienna 1968, second edition) plate 201

42 Freud, loc. cit. p.132

43 *Bilder-Lexikon der Erotik* vol.1, p.639

44 *Bilder-Lexikon der Erotik* vol.2, p.828

45 Gorsen *Das Bild Pygmalions, Kunstsoziologische Essays* (Hamburg 1969) pp.114–41

46 ibid. p.128

47 Freud, loc. cit. p.130

48 ibid. p.130

49 ibid. p.131

50 ibid. p.131

51 ibid. p.131

52 *Bilder-Lexikon der Erotik* vol.2, p.828

53 Fleur Cowles *The case of Salvador Dali* (London 1959) p.84

54 Salvador Dali *Diary of a genius* (London 1966) p.36

55 Cowles, op. cit. p.79–80

56 ibid. p.79

57 Dali, op. cit. p.22

58 ibid. p.22

59 Hans Bellmer *Die Puppe* (Berlin 1962) p.13

60 ibid. pp.14–5

61 ibid. p.17

62 ibid. p.18

63 ibid. p.18–9

64 ibid. pp.145–6

65 ibid. p.59

66 ibid. p.130

67 Mergen, op. cit. p.510

68 Waldberg, op. cit. pp.93, 95

69 Oskar Schlemmer *Briefe und Tagebücher* (Munich 1958) p.59

70 Pierre Brassai *Conversations with Picasso* (London 1967) pp.163–4

71 Peter Gorsen *Das Prinzip Obszön* (Hamburg 1969) p.128

72 *Evergreen No.58 September 1968* p.79

73 ibid. p.79

74 *Time April 1970* p.58–9

75 Mergen, op. cit. p.504

76 Gorsen *Das Prinzip Obszön* (Hamburg 1969) p.40

77 ibid. p.89

78 Gertrude Stein *Picasso* (London 1938) p.41

79 Mergen, op. cit. p.483

80 Werner Hofmann *Henry Moore, Schriften und Skulpturen* (Frankfurt 1959) p.96

81 José Pierre *Konrad Klapheck* (Cologne 1970) p.16

82 *Zero 3, 1961* Yves Klein 'Das Wahre wird Realität'

83 Mergen, op. cit. p.476

84 Gorsen *Das Bild Pygmalions, Kunstsoziologische Essays* (Hamburg 1969) p.104

List of artists and works

I should like to thank all the galleries and private owners who kindly put their works at my disposal. They are all named below. I should particularly like to thank Georg Heusch who photographed 76 works especially for this book.

Adami, Valerio
born 1935 Bologna, Italy; lives Arona, Italy
(321) *The homosexuals* 1966, acrylic on canvas, 200×300 cm. *Collection Arroyo, Milan, Italy*
(322) *Pink pornographic tale*
(Racconto pornografico rosa) 1966, acrylic on canvas

Aeppli, Eva
born 1925 Zofingen, Switzerland; lives Paris
(76) *Head c.* 1965, fabric, lifesize.
Galerie Schmela, Düsseldorf, Germany

Albers, Josef
born 1888 Bottrop, Germany; lives New Haven, Connecticut, USA
(301) *Structural constellation*
(Strukturale Konstellation) 1953–8,
engraved in resopal (plastic), 45×66 cm
(302) *Structural constellation*
(Strukturale Konstellation) 1953–8,
engraved in resopal (plastic) 45×66 cm

Altenbourg, Gerhard
born 1926 Rödichen bei Friedrichsroda, Germany
lives Altenburg, Germany
(83) *No man is born a master of his craft*
(Es ist kein Meister vom Himmel gefallen) 1949,
Indian ink, 37.4×24.8 cm
Galerie Brusberg, Hannover, Germany
(85) *Boy at puberty (Knabe in Pubertät)*
1949, chalk lithograph, 51×33.5 cm.
Galerie Brusberg, Hannover, Germany

André, Carl
born 1935 Quincy, Massachusetts, USA;
lives New York
(308) Untitled 1968, thirty-six iron plates.
Galerie Zwirner, Cologne, Germany

Andrea, John de
born 1941 Denver, Colorado, USA;
lives Denver, USA
(110) *Woman no. 2 (black)* 1969–70, latex,
162 cm. high.
Galerie Zwirner, Cologne, Germany

Antes, Horst
born 1936 Heppenheim/Bergstrasse, Germany;
lives Wolfartsweier bei Karlsruhe, Germany
(74) *Black-and-white figure (Figur Schwarz-weiss)*
1967, aquatint on canvas, 150×120 cm.
*Kunstsammlung Nordrhein-Westfalen, Düsseldorf,
Germany*

Arakawa, Shusaku
born 1936 Nagoya, Japan; lives New York
(347) untitled 1963, watercolour and gouache,
76×56 cm. *Collection Graubner, Düsseldorf,
Germany*

Arman, Fernandez
born 1928 Nice, France; lives New York
(210) *The colour of my love (La couleur de mon amour)*
1966, polyester *Sidney Janis Gallery, New York,
USA*
(309) *Accumulation* 1963, buttons on wood,
60×20.5 cm. *Collection Graubner, Düsseldorf,
Germany*

Arp, Jean
born 1887 Strasbourg, France; died 1966 Locarno,
Switzerland

265

(174) *Human mass on a bowl (Concrétion humaine sur coupe)* 1947, bronze, 60×44×60 cm. *Galerie Zwirner, Cologne, Germany*

Avramidis, Joannis
born 1922 Batum, USSR; lives in Vienna, Austria
(202) sketches for sculptures (dating from 1957) 1965, pencil, 28×36.5 cm. *Collection Graubner, Düsseldorf, Germany*

Bacon, Francis
born 1909 Dublin, Eire; lives London
(113) *Nude* 1960, oil and tempera on canvas, 152.5×119 cm. *Collection Ströher, Darmstadt, Germany*
(114) *Two figures* 1953, based on a photograph by Muybridge of two wrestlers, oil on canvas, 152.5×117 cm.

Bailey, William
born USA; lives New York
(111) *French room* 1967, oil on canvas, 160×112 cm. *Private collection, USA*
(112) *Italian* 1966–8, oil on canvas, 115.5×72.5 cm. *Schoelkopf Gallery, New York*

Baj, Enrico
born 1924 Milan, Italy; lives Milan, Italy
(100) *Reclining nude (Nu couché)* 1960, collage and oil-based chalk on canvas, 81×130 cm. *Collection Baroness Oppenheim, Cologne, Germany*

Becher, Bernhard
born 1931 Siegen, Germany; has worked with Hilla Becher since 1959; lives Düsseldorf, Germany
(54) photograph of wind-heater at Gutehoffnungshütte, Oberhausen, Germany
(221) photograph of water tower at Badenberg, Germany
(223) photograph of water tower at Duisburg, Germany
(224) photograph of water tower at Cologne, Germany

Bell, Larry
born 1939 Chicago, USA; lives Los Angeles, USA
(235) *Cube no. 2* 1967, coloured glass, 31×31×31 cm. *Galerie Zwirner, Cologne, Germany*

Bellmer, Hans
born 1902 Kattowitz, Germany; lives Paris
(16) *Young man (self-portrait) with two female nudes* 1923, pencil and watercolour, 44×32 cm. *Doris Hahn, Berlin*
(67) *The doll's games XI* 1937, colour photograph
(68) *The doll's games XII* 1937, colour photograph
(69) *After the weekly early closing (Après la fermeture hebdomadaire)* c. 1965, pencil, 21.5×16 cm. *Collection Ursula Zwirner, Cologne, Germany*
(70) drawing dated 1964, pencil, 21×16.5 cm. *Collection Ursula Zwirner, Cologne, Germany*
(71) *The doll* 1963, pen and ink drawing, 10×14 cm.
(72) drawing dated 1942, pencil, 14×21.5 cm. *Galerie Gmurzynska, Cologne, Germany*
(75) *The doll (La poupée)* 1936, hand-coloured photo-montage, 65×64 cm. *Galerie Petit, Paris*

Berrocal, Miguel
born 1933 Villanueva de Algaidas, Malaga, Spain; lives Negrar, Verona, Italy
(122) *Alfa and Romeo* 1964–8, bronze; this work is composed of eleven separate pieces and it can be taken apart; 50×100×11 cm. *Collection Ludwig, Cologne, Germany*

Beuys, Joseph
born 1921 Kleve, Germany; lives Düsseldorf, Germany
(78) *Exquisite corpse (Cadavre exquis)* 1961 (by Eva Beuys, Joseph Beuys, Lilo Klapheck and Konrad Klapheck), pencil and ink, 28×21.7 cm. *Collection Lilo and Konrad Klapheck, Düsseldorf, Germany*
(79) *Goethe secretly observed by Eckermann* 1961 (*Exquisite corpse* by Joseph Beuys, Lilo Klapheck, Eva Beuys, Konrad Klapheck; title by Joseph Beuys) pencil and ink, 28×21.7 cm. *Collection Lilo and Konrad Klapheck, Düsseldorf, Germany*
(80) *Odysseus observing Circe* 1961 (*Exquisite corpse* by Lilo Klapheck, Joseph Beuys, Konrad Klapheck, Eva Beuys; title by Lilo Klapheck) pencil and ink, 28×21.7 cm. *Collection Lilo and Konrad Klapheck, Düsseldorf, Germany*
(81) *Callas* 1961 (*Exquisite corpse* by Joseph Beuys, Eva Beuys, Konrad Klapheck, Lilo Klapheck;

title by Joseph Beuys) pencil and ink, 28 x 21.7 cm. *Collection Lilo and Konrad Klapheck, Düsseldorf, Germany*
(108) drawing dated 1957–8, pencil, 26.9 x 17.9 cm. *Lilo and Konrad Klapheck, Düsseldorf, Germany*
(274) *How to explain pictures to a dead hare (Wie man einem toten Hasen die Bilder erklärt)* 1964, detail. *Collection Ströher, Darmstadt, Germany*
(283) *Double figure (Doppelfigur)* c. 1960, bronze figures bound together with an elastic band and coated with wax, 20 x 6 cm.
Collection Graubner, Düsseldorf, Germany
(299) *Dumb record-player (Stummer Plattenspieler)* 1961, 25 x 32 x 25 cm. *Collection Graubner, Düsseldorf, Germany*
(348) drawing dated 1961, pencil, *Galerie Borgmann, Cologne, Germany*
(349) *The intelligence of swans (Intelligenz der Schwäne)* 1955, pencil, 30 x 21 cm. *Galerie Borgmann, Cologne, Germany*

Bill, Max
born 1908 Winterthur, Switzerland; lives Zürich, Switzerland
(284) *Construction with a spherical hoop (Construction par un cerceau sphérique)* 1965–6, white Carborundum, 32 x 32 cm.
Carborundum Company Niagara Falls, New York

Bladen, Ronald
born 1918 Vancouver, Canada; lives New York
(236) untitled 1965, aluminium and wood (painted), each element in this work measures 275 x 122 x 305 cm. *Fischbach Gallery, New York*

Bontecou, Lee
born 1931 Providence, Rhode Island, USA; lives New York
(265) untitled 1964, steel and canvas, 53.3 x 43.2 x 15.2 cm.
Leo Castelli Gallery, New York

Brauner, Victor
born 1903 Piatra Neamt, Carpathian Mountains, Romania; died 1966 Paris
(73) *I and me (Je et moi)* 1949, oil on canvas, 46 x 55 cm.

Brusse, Mark
born 1937 Alkmaar, Holland; lives Paris

(253) *Strange fruits VI* 1965, wood and iron, 60 x 80 x 25 cm.

Burri, Alberto
born 1915 Città di Castello, Perugia, Italy; lives Rome, Italy
(336) *Black bag (Sacco nero)* 1956, fabric, 50 x 86 cm. *Galerie Zwirner, Cologne, Germany*

Bury, Pol
born 1922 Haine-St Pierre, Belgium; lives Fontenay-aux-Roses, France
(243) *Punctuation (Ponctuation)* 1961, wood, nylon and electric motor, 62 x 45 cm. *Collection Christian Stein, Turin, Italy*
(244) *Rods (Les bâtons)* 1964, wood. *Galerie Schmela, Düsseldorf, Germany*

Capogrossi, Giuseppe
born 1900 Rome; lives Rome
(317) *Surface (Superficie)* 1964, felt pen on paper, 26 x 21.5 cm. *Private collection*

Caro, Anthony
born 1924 London; lives London
(288) *LXI* 1968, steel painted brown, 58.4 x 115.6 x 55.6 cm. *Hayward Gallery, London*

Ceroli, Mario
born 1938 Castelfrentano, Italy; lives Rome
(142) *Venus (Venere)* 1965, wood, lifesize. *Galeria Bonino, New York*
(143) *The he-man (Il mister)* 1965, wood, lifesize. *Galeria Bonino, New York*
(242) *Marcus* 1968, wood, 24.5 x 18 x 7 cm. *Galerie Schmela, Düsseldorf, Germany*
(247) *Subliminal cock* 1968, wood. *Galerie Schmela, Düsseldorf, Germany*

César, Baldaccini
born 1921 Marseilles, France; lives Paris
(192) *Molten egg (Coulée à l'oeuf)* 1966, polyester, 75 cm. long
(215) *César's thumb (Le pouce de César)* 1965, bronze, 41 x 17 cm. *Galerie Claude Bernard, Paris*
(269) *The two of us (On est deux)* 1961, 40 x 29 cm. *Galerie Zwirner, Cologne, Germany*

Chamberlain, John
born 1927 Rochester, Indiana, USA; lives New York

(268) *Funburn* 1967,
pieces of foam rubber bound together with a cord,
102x162x137cm.
Collection Ströher, Darmstadt, Germany

Chillida, Eduardo
born 1924 San Sebastian, Spain;
lives in Hernani, Pays Basque, France
(292) *Field, space of peace (Champ, espace de paix)*
1965, iron, 21x35x20cm.

Chirico, Giorgio de
born 1888 Volos, Thessaly, Greece; lives Rome
(24) *The poet's disquiet (L'inquiétude du poète)* 1913,
oil on canvas. *Collection Roland Penrose, London*
(25) *The philosopher's conquest*
(La conquista del filosofo) 1914, oil on canvas,
126x100cm. *The Art Institute of Chicago, USA*

Christo (Christo Javacheff)
born 1935 Gabrovo, Bulgaria; lives New York
(207) *The package (L'empaquetage)* 1963,
Perlon (nylon) foil, 35x30cm.
Collection Graubner, Düsseldorf, Germany
(222) 5450 m. cubic package 1967–8,
made from polyethylene, rope, metal cable, air,
air balloons, helium, paint;
85 m. high, 9.75 m. in diameter.
Fourth Documenta exhibition Kassel, Germany 1968
(225) *Column made from 5 barrels*
(Colonne de 5 tonneaux) 1962, 5 barrels.
Galerie Schmela, Düsseldorf, Germany

Copley, William N.
born 1919 New York; lives New York
(39) *Casey strikes out* 1966, oil on canvas,
116x89cm. *Galerie Iolas, Paris*

Cornell, Joseph
born 1903 Nyack, New York;
lives Flushing, New York
(46) *Ocean Hotel (Hôtel de l'Océan)* 1959–60,
wooden box, 21.5x36x10.2cm.
Galerie Borgmann, Cologne, Germany

Dado, Miodrag Djuric
born 1933 Cetinje, Montenegro, Yugoslavia;
lives in France
(159) *HRouv* 1968,
pen and ink drawing using Indian ink, 28x37cm.
Galerie Zwirner, Cologne, Germany

Dali, Salvador
born 1904 Figueras, Spain; lives Cadaquès, Spain
(63a) drawing dated 1933, reverse side of (63b),
pencil, 26x19.5cm. *Private collection*
(63b) *The Fall of Icarus (Sturz des Ikarus)* 1933,
pencil and ink, 26x19.5cm. *Private collection*
(64) drawing dated *c.* 1935, pencil, 24x15cm.
Galerie Borgmann, Cologne, Germany
(65) drawing dated *c.* 1932, pencil and ink,
28.5x22cm. *Galerie Petit, Paris*

Davie, Alan
born 1920 Grangemouth, Scotland; lives London
(343) *Pomo* 1962, oil and canvas, 122x152cm.
Galerie Zwirner, Cologne, Germany
(346) *Rub the lamp* 1961, oil on canvas.
Galerie Zwirner, Cologne, Germany

Delvaux, Paul
born 1897, Anthée, Belgium; lives Brussels
(1) *The girls at the water's edge*
(Les filles au bord de l'eau) 1966, oil on canvas,
140x180cm. *Galerie Zwirner, Cologne, Germany*
(120) *Pygmalion* 1939, oil on wood, 117x147.5cm.
Musées Royaux des Beaux-Arts de Belgique, Brussels

Dine, Jim
born 1935 Cincinnati, Ohio; lives London
(38) *Angels for Lorca* 1966, fibreglass, aluminium,
185x61cm. (each element).
Collection Ludwig, Cologne, Germany
(41) silk screen print dated 1965, 60x50cm.
Galerie Zwirner, Cologne, Germany
(276) *Black hand saw* 1962, collage and oil on
canvas, 183x79cm. *Galerie Sonnabend, Paris*
(305) *4 designs for a fountain of the painter Balla* 1961,
oil and rope on canvas, four panels each
138x67.5cm.
Galerie Schmela, Düsseldorf, Germany

Dodeigne, Eugene
born 1923 Rouvreux, Belgium;
lives Bois Blancs, Lille, France
(95) *Torso (Torse)* 1962, granite, 79x33x38cm.
(height including wooden base).
Wilhelm Lehmbruck-Museum, Duisburg, Germany
(116) *The couple (Le couple)* 1963, granite.
Galerie Jeanne Bucher, Paris
(127) *The couple (Les deux)* 1965, bronze,
70cm. high. *Galerie Zwirner, Cologne, Germany*

268

Doesburg, Theo van
born 1883 Utrecht; died 1931 Davos, Switzerland
(298) *Arithmetical composition*
(Composition arithmétique) 1930, oil on canvas,
101 x 101 cm. *Private collection, Switzerland*

Dubuffet, Jean
born 1901 Le Havre, France; lives Vence, France
(133) *Man pissing on the right IV*
(Pisseur à droite IV) 1961, gouache, 43 x 33.5 cm.
Collection Ursula Zwirner, Cologne, Germany
(134) illustration for *La Bonne Femme à Beber* 1950,
lithograph. *Collection Kronhausen*
(135) *Variation XIII* 1949, Indian ink.
Private collection, Rome

Ernst, Max
born 1891 Brühl, Cologne, Germany;
lives Seillans, Var, France
(20) *Daylight robbery or: when you are in need any
port will do (Öffentliche Entladung oder: in der not ist
jeder hafen recht)* from *Femme 100 têtes* 1929,
9 x 17 cm.
(26) collage on a postcard, Cologne 1919–20,
13.5 x 8.5 cm.
Collection Ursula Zwirner, Cologne, Germany
(211) *Love – song (Liebeslied)* from
Une semaine de bonté 1934, 19 x 15 cm.

Fautrier, Jean
born 1898 Paris; died 1964 Chatenay-Malabry,
near Paris
(330) *Reclining nude (Nu couché) c.* 1945,
oil on canvas, 130 x 81 cm.
Galerie Schmela, Düsseldorf, Germany
(331) *Nude 15F (Nu – 15F)* 1956, oil on canvas.
Galerie Schmela, Düsseldorf, Germany

Flanagan, Barry
born 1941 England; lives London
(262) *Two rsb 3'67 khite* 1967,
made from a sack, plastic and sand, 84 x 36 x 66 cm.
Galerie Schmela, Düsseldorf, Germany
(267) *rsbtworahsbbsharowtbsr 5' 67*
1967, made from a sack, plastic and sand,
127 x 63.5 cm. (radius)
Galerie Schmela, Düsseldorf, Germany

Flavin, Dan
born 1933 New York; lives New York

(230) *(to Shirley)* 1965–9,
pink and blue neon lighting tubes, 240 x 20 cm.
Galerie Zwirner, Cologne, Germany

Fontana, Lucio
born 1899 Rosario di Santa Fé, Argentina;
died 1968 Milan, Italy
(189) *Spatial concept – nature*
(Concetto spaziale – natura) 1965, bronze,
90 cm. in diameter.
Collection C. M. J. de Groot, Otterlo, Holland
(191) ceramic with polychrome glazing c. 1965,
30 cm. high. *Galerie Zwirner, Cologne, Germany*
(200) *Spatial concept – expectations*
(Concetto spaziale – attese) c. 1965, canvas,
55 x 46 cm.
Collection A. O. Müller, Cologne, Germany
(337) oil on canvas, 1955, 97 x 80 cm.
Collection Heinz Simon, Würzburg, Germany

Fuchs, Ernst
born 1930 Vienna; lives Vienna
(158) *Death and the girl*
(Der Tod und das Mädchen) 1967, etching,
14.5 x 8.5 cm. *Galerie Ketterer, Munich, Germany*
(161) *Pan* 1969, coloured poster, 84 x 119 cm.
Galerie Ketterer, Munich, Germany

Gallo, Frank
born 1933 Toledo, Ohio, USA;
lives Urbana, Illinois, USA
(109) *Quiet nude* 1966, plastic, 76 cm. high.
Felix Landau Gallery, Los Angeles, USA

Giacometti, Alberto
born 1901 Stampa, Switzerland;
died 1965 Chur, Switzerland
(213) *Man and woman (Homme et femme)* 1928–9,
bronze, 46 x 40 cm.
Collection Henriette Gomès, Paris
(237) *Spear pointed at the eye (Pointe à l'oeil)* 1931,
plaster of Paris, 59 cm. long.
(238) *The nose (Le nez)* 1947, painted plaster
of Paris, 82.5 cm. high.
Kunsthaus Zürich, Switzerland
(239) *Suspended sphere (Boule suspendue)* 1930,
plaster of Paris and metal, 61 cm. high.
Galerie Beyeler, Basle, Switzerland

Gilardi, Piero
born 1942 Turin, Italy; lives Turin, Italy

(27) *Water-melons (Pastèques)* 1966, foam rubber, 150×150 cm. *Galerie Zwirner, Cologne, Germany*

Gilioli, Emile
born 1911 Paris; lives Paris
(185) *Celebration of the sphere*
(Célébration de la boule) 1968, painted stone, 45 cm. high

Gnoli, Domenico
born 1933 Rome; died 1970 Rome
(43) *Man: back and front view*
(Homme double-face) 1964, oil and sand on canvas, two sections each measuring 149×72 cm.
Collection Ludwig, Cologne, Germany
(311) *Waist line* 1969, oil on canvas, 100×130 cm.
Collection Ursula Küppers, Mülheim/Ruhr, Germany

Goller, Bruno
born 1901 Gummersbach, Germany;
lives Düsseldorf, Germany
(V) *Female nude (Weiblicher Akt)* 1962, oil on canvas, 150×80 cm. *Private collection*
(6) *Girl with a rose (Mädchen mit Rose)* 1970, oil on canvas, 170×190 cm. *Artist's collection*
(97) *Large female head (Grosser Frauenkopf)* 1959, pencil on cardboard, 29.5×20.5 cm.
Private collection
(99) *Brother and sister (Die Geschwister)* 1931, oil on canvas, 66×66 cm.
Collection Klaus Gebhard, Munich, Germany
(121) *The bridal veil (Der Brautschleier)* 1952, oil on canvas, 100×100 cm. *Artist's collection*

Gorky, Arshile
born 1905 Armenia; died 1948 Sherman, Connecticut, USA
(344) *Painting* 1944, oil on canvas, 177×167 cm.
Peggy Guggenheim Foundation, Venice, Italy

Graham, Robert
born 1938 Mexico City; lives London
(132) four polaroid photographs of 14 cm. high wax figures, taken by the artist, 1969

Graubner, Gotthard
born 1930 Erlbach, Germany;
lives Düsseldorf, Germany
(206) *Coloured body on a silver-grey background*

(Farbleib auf silbergrauem Grund) 1964–5, painted foam rubber cushion on aluminium background, 40×40 cm.
Collection Baroness Oppenheim, Cologne, Germany
(209) gouache dated 1965, 34.5×25 cm.
Artist's collection
(229) *Stylit I* 1968, painted foam rubber cushion on polyester fabric covered with Perlon (nylon), 200×130 cm. *Artist's collection*
(319) watercolour dated 1960, 15.5×14.5 cm.
Private collection

Grosz, George
born 1893 Berlin; died 1959 Berlin
(30) *The 4 Avo c.* 1916,
pen and ink drawing using Indian ink, 38×32 cm.
Galerie Borgmann, Cologne, Germany

Haacke, Hans
born 1936 Cologne, Germany; lives New York
(272) *Grass grows* 1969,
Cornell University Collection, Ithaca, USA

Hamilton, Richard
born 1922 London; lives London
(59) *The critic laughs* 1968, offset litho, 59.5×46.5 cm. *Petersburg Press, London*
(144) *Adonis in Y fronts* 1963, silk screen print, 68.5×84 cm.
(154) *Just what is it that makes today's homes so different, so appealing?* 1956, collage, 26×25 cm.
Collection Edwin Janss Jr, Thousand Oaks, California, USA

Harris, Paul
born 1925 Orlando, Florida, USA;
lives Bolinas, California, USA
(77) *Woman smelling her roses* 1966, acrylic paint, material, wood, dye, 150×60×104 cm.
Collection Ludwig, Aachen, Germany

Haworth, Jann
born 1942 Hollywood, California, USA;
lives London
(66) *Maid* 1966, nylon and kapok, 168×51 cm.
Robert Fraser Gallery, London

Heerich, Erwin
born 1922 Kassel, Germany;
lives Düsseldorf, Germany

(245) *Cardboard sculpture* 1960, cardboard,
22x57x22cm.
Galerie Borgmann, Cologne, Germany
(256) *Cylindrical doll – John XXIII on his death bed
(Walzenpuppe – Johannes XXIII auf dem Totenbett)*
1963, cardboard, 77x51x17cm.
Galerie Borgmann, Cologne, Germany

Heizer, Michael
born 1944 Berkeley, California, USA;
lives New York
(198) Furrow 1969, cement and earth, *c.* 8m. long.
Berne

Hiltmann, Jochen
born 1935 Hamburg, Germany;
lives Krahforst bei Rheinbach, Eifel, Germany
(106) drawing dated 1965–6, pencil, 40x45cm.
Private collection
(177) *Laocoon after the catastrophe
(Laokoon nach der Katastrophe)* 1966–8, bronze
and steel, three sections each 250cm. long.
*Collection Professor Stein, Cologne, Germany
Elephant's appendix II
(Intestino cieco d'elefante II)* 1968,
bronze and steel, 160cm. long.
(179) drawing dated 1967, pencil, 27x22cm.
Private collection
(188) *Burst Ele-K (Geplatzter Ele-K)* 1963,
bronze and steel, 36cm. in diameter.
Collection Klinker, Bochum, Germany
(246) drawing dated 1967, pencil, 27x18cm.
Private collection
(255) *The temptation of St Antony
(Die Versuchung des Hl. Antonius)* 1964, steel,
64cm. in diameter. *Galleria l'Attico, Rome*

Hockney, David
born 1937 Bradford, England;
lives London and Los Angeles, USA
(84) pen and ink drawing, Hollywood 1969,
Indian ink. *Galerie Zwirner, Cologne, Germany*
(89) pen and ink drawing dated 1966, Indian ink,
25.5x31.5cm.
Galerie Borgmann, Cologne, Germany

Hoeydonck, Paul von
born 1925 Antwerp, Belgium;
lives Antwerp, Belgium
(208) *Spatial triptych (Triptieck van de ruimte)* 1964,
wood, synthetic dye, relief, 235x428cm.

Hoflehner, Rudolf
born 1916 Linz, Austria; lives Vienna
(254) *Figure (Figur)* 1961, iron, 53cm. high.

Indiana, Robert Clark
born 1928 New Castle, Indiana, USA;
lives New York
(324) *Love* 1966, aluminium, 30.5x30.5x15cm.
Galerie Schmela, Düsseldorf, Germany

Ipoustéguy, Jean
born 1920 Dun-sur-Meuse, France;
lives Choisy-le-Roi, France
(101) *Woman bathing (La femme au bain)* 1966,
bronze, 10x200x150cm.
Galerie Claude Bernard, Paris
(186) *Split helmet (Casque fendu)* 1958, bronze
(187) *Death in the egg (La mort dans l'oeuf)* 1968,
marble, 40x40cm.
(323) *Sexual sandwich (Sandwich sexuel)* 1968,
marble, 65x57x70cm.

Israel, Robert
born 1939 USA; lives New York
(250) *Peach progress* 1966, plastic.
Dayton's Gallery, Minneapolis, USA

Janssen, Horst
born 1929 Hamburg, Germany;
lives Hamburg, Germany
(157) *Geile Milli* 30.7.1968,
coloured pencil on paper, 38.5x28cm.
Galerie Brockstedt, Hamburg, Germany
(163) *Souvenir* 10.10.1965, pencil.
Galerie Zwirner, Cologne, Germany

Johns, Jasper
born 1930 Allendale, South Carolina, USA;
lives New York
(13) *Target with four faces* 1955.
Museum of Modern Art, New York
(61) *The critic smiles* 1959, metal, 20cm. long.
Artist's collection

Jones, Allen
born 1937 Southampton, England; lives London
(18) *La sheer* 1968, oil on canvas, 183x152cm.
with steps measuring 46x152cm.
Richard Feigen Gallery, New York
(19) *Figure falling* 1964, oil on canvas,
273x244cm. *Collection Ludwig, Cologne, Germany*

(21) silk screen print dated 1965, 60x50cm.
Galerie Zwirner, Cologne, Germany
(162) *The table* 1969, lifesize.
Collection Ludwig, Aachen, Germany

Judd, Donald
born 1928 Excelsior Springs, Missouri, USA;
lives New York
(232) untitled 1965, painted iron,
12.5 x 170 x 22 cm.
Galerie Zwirner, Cologne, Germany

Kalinowski, Horst Egon
born 1924 Düsseldorf; lives Paris
(277) *The prey (La proie)* 1970, aluminium,
200 x 23 x 20 cm. dark brown leather, rope,
52 x 90 x 72 cm.
(278) *Rose thorn (Épine de rose)* 1968,
caisson, red leather and wood, 120 x 44 x 12 cm.
(279) *Torso for ablutions (Torse pour les ablutions)*
1968, caisson, brown crocodile skin and wood,
43 x 23 x 91 cm.

Kanovitz, Howard
born 1929 Fall River, USA; lives New York
(102) *Nude Greek* 1965, pencil on paper,
74 x 61 cm.
(103) *Nude Greek* 1965, Liquitex on canvas,
157.5 x 96.5 cm.

Kelly, Ellsworth
born 1923 Newburgh, New York;
lives New York
(271) *Gate* 1959, painted aluminium, 169 x 138 cm.
*Collection Mr and Mrs Donald Factor,
Beverly Hills, USA*

Kienholz, Edward
born 1927 Fairfield, Washington;
lives Los Angeles, USA
(128) *The backseat dodge '38* 1964, dye, fibreglass,
pieces of wool, 1938 Dodge, wire-netting, beer
bottles, synthetic grass, plaster cast of figure,
165 x 600 x 360 cm.
Collection Mrs Kienholz, Los Angeles, USA
(182) *The illegal operation* 1962, trolley for
shopping, furniture, concrete, surgical
instruments, 147.7 x 120 x 135 cm.
*Collection Mr and Mrs Monte Factor,
Los Angeles, USA*

(325) *Night of nights* 1961, zinc, steel wool,
head made of plaster of Paris, 77 x 74 x 20 cm.
Collection Ludwig, Cologne, Germany

King, Phillip
born 1934 Tunis, Tunisia; lives London
(193) *Tra-la-la* 1963, polyester, 274 x 76 cm.
Galerie Schmela, Düsseldorf, Germany

Kitaj, Ronald B.
born 1932 Cleveland, Ohio, USA; lives London
(31) *Where the railroad leaves the sea 1964*
(first draft), oil and pencil on canvas,
122 x 152.5 cm.
(155) *The Ohio gang* 1964, oil and pencil on canvas,
183 x 183 cm. *Museum of Modern Art, New York*

Klapheck, Konrad
born 1935 Düsseldorf, Germany;
lives Düsseldorf, Germany
(VII) *Alphabet of passion
(Alphabet der Leidenschaft)* 1961, oil on canvas,
60 x 65 cm.
Collection Lilo Klapheck, Düsseldorf, Germany
(47) *Love-song (Liebeslied)* 1968, oil on canvas,
100 x 80 cm.
(48) *The sex-bomb and her escort
(Die Sexbombe und ihr Begleiter)* 1963,
oil on canvas, 89 x 69 cm.
Von der Heydt Museum, Wuppertal
(78, 79, 80 and 81) *Exquisite corpses
(Cadavres exquis)* 1961 produced by Lilo and
Konrad Klapheck and Eva and Joseph Beuys
(190) *Procreation (Zeugung)* 1960, oil on canvas,
70 x 75 cm. *Collection Enrico Baj, Milan, Italy*
(205) drawing dated *c.* 1960,
black and white chalk on grey paper, 10 x 17.5 cm.
Private collection

Klee, Paul
born 1879 Münchenbuchsee, Berne, Switzerland;
died 1940 Locarno-Muralto, Switzerland
(82) *Joseph's chastity arouses the displeasure of the
gloomy regions (Josefs Keuschheit erregt den Unmut
der trüben Regionen)* 1913, pen and ink drawing,
18.2 x 15 cm. *Kunstsammlung Nordrhein-Westfalen,
Düsseldorf, Germany*
(214) *Naked picture (Nacktes Bild)* 1938,
adhesive paint on jute, 66 x 38.5 cm.
Baukunst, Cologne, Germany

Klein, Yves
born 1928 Nice, France; died 1962 Paris
(329) *Positive static multiple blue imprint*
(Empreinte positive statique multiple bleue) 1960,
151 x 112.2 cm.
Galerie Bonnier, Lausanne, Switzerland

Kudo, Tetsumi
born 1935 Osaka, Japan; lives Paris
(7) *For your living-room (For nostalgic purpose)*
1965, polyester, fluorescent colour,
30 x 33 x 18 cm.
(183) *Love (L'amour)* 1964,
polyester, 90 x 120 x 45 cm.
Collection Becht, Hilversum, Holland

Kusama, Yayoi
born Matsumoto, Japan; lives New York
(196) Armchair 1962

Lalanne, Francois Xavier
born France; lives Ury, near Paris
(306) *Sheep (Les moutons)* 1966,
Galerie Iolas, Paris

Laurens, Henri
born 1885 Paris; died 1954 Paris
(92) *Striding female nude* 1948, black chalk,
33 x 20.4 cm. *Staatsgalerie, Stuttgart, Germany*
(93) *Striding female nude* 1948, pencil, 37 x 25 cm.
Private collection
(94) *The awakening (L'éveil)* 1952, bronze,
31 cm. high.
Collection Georg Meistermann, Cologne, Germany
(173) *The great farewell (Le grand adieu)* 1941,
bronze, 70 x 85 x 85 cm.
Galerie Zwirner, Cologne, Germany

Léger, Fernand
born 1881 Argentan, France;
died 1955 Gif-sur-Yvette, France
(8) *The Mona Lisa with keys*
(La Joconde aux clés) 1930, oil on canvas,
92 x 73 cm.
Musée National Fernand Léger, Biot, France
(53) *Big Julie (La grande Julie)* 1945, oil on canvas,
112 x 127 cm. *Museum of Modern Art, New York*

Lewitt, Sol
born 1928 Hartford, Connecticut, USA;
lives New York

(295) *C 369* 1968, enamel and aluminium,
50 x 80 x 200 cm.
Galerie Zwirner, Cologne, Germany
(296) workshop drawing for *C 369* dated 1968,
pencil and pen. *Galerie Zwirner, Cologne, Germany*

Lichtenstein, Roy
born 1923 New York; lives New York
(10) *The ring* 1962, oil on canvas, 121 x 178 cm.
Galerie Zwirner, Cologne, Germany
(218) *Couple* 1963, oil on canvas, 170 x 170 cm.
Collection Schniewind, Neviges
(219) *Two seascapes* 1966,
coloured pencil on paper,
each measuring 11.5 x 11.5 cm.
Collection Ströher, Darmstadt, Germany
(220) *Bread in bag* 1961, oil on canvas, 70 x 144 cm.
Galerie Schmela, Düsseldorf, Germany

Lindner, Richard
born 1901, Hamburg, Germany; lives New York
(14) *Target no. 1* 1962, oil on canvas,
152.4 x 101.5 cm.
Collection Ludwig, Cologne, Germany
(15) *Adults-only* 1967, watercolour,
101.6 x 52.7 cm.
Cordier and Ekstrom Gallery, New York
(156) *Disneyland* 1965, oil on canvas, 200 x 125 cm.
Galerie Zwirner, Cologne, Germany

Mack, Heinz
born 1931 Lollar;
lives Mönchengladbach, Germany
(263) *Fata morgana* 1968,
metal relief, 146 x 115 cm.
Galerie Schmela, Düsseldorf, Germany

Magritte, René
born 1898 Lessines, Belgium;
died 1967 Brussels
(I) *La folle du logis* 1948, gouache, 17 x 14 cm.
Private collection, Brussels
(III) *Rape (Le viol)* 1934, later copy of the picture
in *Collection George Melly*, London, oil on canvas,
25 x 18 cm. *Collection Isy Brachot, Brussels*
(2, 3, 4 and 5) drawings dated *c.* 1940,
pencil on paper, each measuring 15 x 10 cm.
Private collection
(36) *The lady (La dame)* 1943,
painted bottle, 30.5 cm. high.
Collection Georgette Magritte, Brussels

(44) sketch for *La contenue pictorale* 1947,
coloured pencil on paper, 22x21cm.
Private collection
(49) drawing *c.* 1940, pencil, 8x11.5cm.
Private collection
(57) drawing *c.* 1945, pencil, 12x13cm.
Private collection
(96) *Girl's head (Mädchenkopf)* 1948,
pencil on paper, 23x21.5cm.
Private collection

Maier, Ulf
born 1940 Heidenheim an der Brenz, Germany;
lives Munich, Germany
(56) drawing dated 1963, reed pen, 35x49.5cm.
Private collection

Maier-Buss, Ingeborg
born 1950 Mannheim, Germany; lives Münich,
Germany
(175) *Black Venus (Schwarze Venus)* 1963,
coloured polyester, 56x25x43 cm.
Private Collection
(176) *Xylei* 1969-70, coloured polyester,
44x24x29 cm. *Private Collection*
(178) *Landscape* 1969, charcoal drawing,
15x21 cm. *Private Collection*
(180) drawing dated 1966, oil-based chalks,
51x35 cm. *Private Collection*

Manzoni, Piero
born 1933 Soncino, Cremona, Italy;
died 1963 Milan, Italy
(199) *Achrome* 1959, clay, linen, jute, 100x80cm.
Collection A.O. Müller, Cologne, Germany
(307) *Bread (Pane)* 1962,
coloured bread rolls, wood, 39x39cm.
Collection Contessa Valeria Manzoni, Milan, Italy
(314) *Achrome* 1959, clay, linen, jute, 71x90cm.
Collection A.O. Müller, Cologne, Germany
(320) *Squares which change colour
(Quadri che cambiano colore)* 1960,
synthetic spun glass, 50x41cm.

Maria, Walter de
born 1935 Albany, California, USA;
lives New York
(291) *Death wall* 1965,
stainless steel, 13x52x2.5cm.
Collection Mr and Mrs Robert C. Scull

Marisol, Escobar
born 1930 Paris; lives New York
(35) *Love* 1962, stucco and Coca Cola bottle,
21x16x10cm.
Collection Mr and Mrs Tom Wesselmann
(124) *Double date* 1963, painted wood.
Galerie Schmela, Düsseldorf, Germany

Matta (Roberto Sebastian Matta Echaurren)
born 1912 Santiago, Chile; lives Paris
(129) *Violation during the night
(Nächtliche Vergewaltigung)* 1945,
chalk on paper, 126x100cm.
Galerie du Dragon, Paris
(165) drawing *c.* 1945, coloured pencil.
Collection Kronhausen
(166) drawing *c.* 1945, coloured pencil.
Collection Kronhausen

Mense, Carlo
born 1886 Rheine, Westfalen, Germany;
died 1965 Honnef am Rhein, Germany
(55) *Girl by the lake (Mädchen am See)* *c.* 1930,
oil on canvas

Merz, Mario
born 1924 Milan, Italy; lives Turin, Italy
(273) *The space between two branches which grow
from the same tree trunk is as big as this block of wax is
small and as finite as this block of wax* 1967, wax

Meyer-Amden, Otto
born 1885 Berne, Switzerland;
died 1933 Zürich, Switzerland
(86) *Nude youth in the pine forest
(Nackter Jüngling im Tannenwald)* 1912–4,
pencil, 27.6x21.8cm.
*Städelsches Kunstinstitut, Frankfurt am Main,
Germany*

Michaux, Henri
born 1899 Namur, Belgium; lives Paris
(333) *Watercolour* 1961, 56.5x76.5cm.

Miró, Joan
born 1893 Barcelona, Spain;
lives Palma de Mallorca
(131) pen and ink drawing using Indian ink, 1929
(136) pen and ink drawing using Indian ink, 1933,
from the series of pictures entitled *Légende du
Minotaure*

274

(326) *Love (Amour)* 1926,
oil on canvas, 146×114cm.
Wallraf-Richartz Museum, Cologne, Germany

Moholy-Nagy, Laszlo
born 1895 Borsod, Hungary;
died 1946 Chicago, USA
(297) *Segments of a circle (Kreissegmente)* 1921,
tempera on canvas, 78×60cm.
Galerie Zwirner, Cologne, Germany

Mondrian, Piet
born 1872 Amersfoort, Holland;
died 1944 New York
(313) *The sea (Il mare)* 1914,
charcoal on paper, 95×128cm.
Peggy Guggenheim Foundation, Venice, Italy
(315) *The sea (Il mare)* c. 1914,
pencil on paper, 10×17cm.
Collection Holtzman, New York
(316) *Pier and ocean* 1914,
charcoal and Indian ink on paper, 53.5×66cm.
Collection Holtzman, New York

Monory, Jacques
born France; lives New York
(22) *Stylistic exercise no. 1
(Exercise de style no. 1)* 1968, oil on canvas

Moore, Henry
born 1898 Castleford, England;
lives Much Hadham, England
(201) *Three upright motives* 1965–6,
bronze, 335cm. high. *Otterlo, Holland*
(212) *Three points* 1939–40, bronze, 15.3×19cm.
Collection Miss Mary Moore

Morandi, Giorgio
born 1890 Bologna, Italy;
died 1964 Bologna, Italy
(32) *Still life with nine objects
(Natura morta con nove oggetti)* 1954,
etching, 18×25cm.
(33) *Still life with large targets
(Natura morta a grandi segni)* 1931,
etching, 24.7×34.4cm.

Morris, Robert
born 1931 Kansas City, USA; lives New York
(184) untitled 1968, earthwork dated October
1968 composed of earth, peat, steel, aluminium,

copper, brass, zinc, felt, grease, bricks.
Dwan Gallery New York
(280) *Lead relief* 1954.
Galerie Schmela, Düsseldorf, Germany

Motherwell, Robert
born 1915 Aberdeen, Washington, USA;
lives New York
(327) *I love you IV (Je t'aime IV)* 1955–7,
oil on canvas, 178×254cm.
Collection Walter Bareiss, Munich, Germany
(328) *Elegy to the Spanish republic, no. 70* 1961,
oil on canvas, *Sidney Janis Gallery, New York*

Müller, Robert
born 1920 Zürich, Switzerland;
lives Villiers-le-Bel, France
(240) *Archangel (L'archange)* 1963,
iron, 80×160×80cm. *Galerie de France, Paris*

Nauman, Bruce
born 1941 Fort Wayne, Indiana, USA;
lives San Francisco, USA
(281) untitled 1967, rope, wax over plaster,
43×66×11.4cm.
(286) untitled 1965, rubber, 223.5×15×5cm.
*Collection Mr and Mrs John McCracken,
Los Angeles, USA*
(289) untitled 1965, fibre glass, 61×335×12.7cm.
Collection Mr and Mrs Melvin Hirsch, Beverly Hills

Nevelson, Louise
born 1900 Kiev, Russia; lives New York
(42) wooden case dated 1954, wood

Newman, Barnett
born 1905 New York; died 1970 New York
(227) *Here I (to Marcia)* 1950,
bronze, 243.8×68.6×71.1cm.
Collection Mr and Mrs Fred Weisman

Nicholson, Ben
born 1894 Denham, Buckinghamshire, England;
lives Ronco, Tessin, Switzerland
(34) *Pale grey bottle* 1965, oil-wash-drawing,
56×43cm. *Private collection*

Noguchi, Isamu
born 1904 Los Angeles, USA; lives New York
(287) *Khmer* 1962, bronze, 183cm. high.
Cordier and Ekstrom Gallery, New York

Noland, Kenneth
born 1924 Ashville, North Carolina, USA;
lives South Shaftsbury, Vermont, USA
(11) *Provence* 1960,
acrylic paint on canvas, 91x91cm.
Collection Ludwig, Cologne, Germany
(270) *Night green* 1964,
acrylic paint on canvas, 176.5x176.5cm.
Galerie Zwirner, Cologne, Germany

Oelze, Richard
born 1900 Magdeburg, Germany;
lives Posteholz bei Hameln, Germany
(37) *Expectation (Erwartung)* 1935–6,
oil on canvas, 81.5x100.5cm.
Museum of Modern Art, New York
(318) drawing *c.* 1935, pencil, 20.2x29.7cm.
*Collection Lilo and Konrad Klapheck,
Düsseldorf, Germany*

Oldenburg, Claes
born 1929 Stockholm, Sweden; lives New York
(248) *Four soft Dormeyer mixers – ghost version* 1965,
linen stuffed with kapok, wood, varnish,
107x91x61cm.
*Collection Mr and Mrs Eugene M. Schwartz,
New York*
(249) *Study for giant soft drum set 2: black and white*
1967, pencil on paper, 69x88.5cm.
Collection Ludwig, Cologne, Germany
(251) *Colossal fagend, dream state* 1967,
pencil on paper, 76.2x55.8cm.
Collection Alfred Ordover, New York
(252) *Giant soft Swedish light switch – ghost version*
1966, linen, kapok, dye, 130cm. in diameter.
Collection Ludwig, Cologne, Germany
(285) *Model giant drainpipe* 1966–7, 132x102cm.
Galerie Schmela, Düsseldorf, Germany
(312) *Soft typewriter* 1964,
painted fabric and stuffing, 72x77cm.
Collection Ströher, Darmstadt, Germany

Oppenheim, Meret
born 1913, Berlin; lives Berne, Switzerland
(259) *Fur-covered cup, saucer and spoon* 1936,
fur covering, cup: 11cm. in diameter, saucer:
23.8cm. diameter, spoon: 20.3cm. long.
Museum of Modern Art, New York

d'Orgeix, Christian
born 1927 Foix-Arièges, France; lives Paris
(62) *Assemblage c.* 1955, 19.2x14cm.

*Collection Lilo and Konrad Klapheck,
Düsseldorf, Germany*

Palermo
born 1943, Leipzig, Germany;
lives Düsseldorf, Germany
(261) untitled 1968, wood, 230x90cm.
Galerie Zwirner, Cologne, Germany

Paolozzi, Eduardo
born 1924 Edinburgh, Scotland; lives London
(231) *Twefx* 1967, chrome-plated steel,
89.2x33.7x25.4cm.
(233) *Gexhi* 1967,
polished aluminium, 182x375x171cm.
Galerie Zwirner, Cologne, Germany

Pascali, Pino
born 1935 Bari, Italy; died 1968 Rome
(23) *Arms (Armi)* 1966, wood and metal
(257) *Nest (Nido)* 1968, 45x120x120cm.
Galerie Iolas, Milan, Italy
(258) *The sundial (La meridiana)* 1968
220x120x120cm.
Galerie Iolas, Milan, Italy

Pearlstein, Philip
born 1924 Pittsburgh, USA; lives New York
(104) *Nude on Kilim rug* 1969,
oil on canvas, 119.4x152.4cm.
Collection Mr and Mrs Lauder, New York
(119) *Standing male, sitting female nudes* 1969,
oil on canvas, 188x157.5cm.
*Collection Mrs Gilbert Carpenter,
Greensboro, North Carolina, USA*

Peverelli, Cesare
born 1922 Milan, Italy;
lives Seillans, Var, France
(126) *Birds of paradise (Les paradisiers)* 1962–3,
oil on canvas, 195x97cm.
(130) drawing dated 1962–3, pencil.
Collection Kronhausen

Picasso, Pablo
born 1881 Malaga, Spain; lives South of France
(117) *Model and surrealistic sculpture*, etching from
his *Vollard* sequence of 1933, 26.8x19.2cm.
(137) etching of *31 August 1968*, 17x20.5cm.
Galerie Louise Leiris, Paris
(138) etching of *3 September 1968*, 15x20.5cm.

276

Galerie Louise Leiris, Paris
(139) etching of *7 September 1968*, 15 x 20.5 cm.
Galerie Louise Leiris, Paris
(170) study for a sculpture, dated 1932,
charcoal on canvas, 92 x 73 cm.
Private collection, Zurich, Switzerland
(171) *Bust of a woman (Buste de femme)*
1932, bronze, 78 x 46 x 48 cm.
(172) *Woman's head (Tête de femme)*
1932, bronze, 70 x 41 x 36 cm.

Pisani, Victor
(241) *Study of Marcel Duchamp*
(Studi su Marcel Duchamp) 1965–70, *Rome*

Pollock, Jackson
born 1912 Cody, Wyoming, USA;
died 1956, Springs, Long Island, USA
(334) drawing dated 1951, Devolac on paper,
56.5 x 67 cm.

Ramos, Mel
born 1935 Sacramento, California, USA;
lives Sacramento
(149) *Chic* 1965, silk screen print, 60 x 50 cm.
Galerie Zwirner, Cologne, Germany
(150) *Catsup Queen* 1965, oil on canvas,
(151) *Lucky strike* 1965, oil on canvas
Bianchini Gallery, New York
(152) *The great red kangaroo* 1968, oil on canvas.
Private collection, Lugano, Switzerland

Rauschenberg, Robert
born 1925 Port Arthur, Texas, USA;
lives New York
(9) *Exile* 1962, silk screen print and oil on canvas,
152 x 91 cm. *Private collection, Switzerland*
(12) *Combine painting c.* 1960,
Galerie Sonnabend, Paris
(342) *Collage with white* 1956,
collage and oil on canvas, 76 x 63 cm.
Galerie Zwirner, Cologne, Germany

Ray, Man
born 1890 Philadelphia, USA; lives Paris
(45) *What we all need (Ce qui nous manque à tous)*
1935
(98) *The primacy of matter over thought*
(Primat de la matiere sur la pensée) 1931,
solarized photograph

Raysse, Martial
born 1936 Golfe-Juan, France;
lives Paris and New York
(123) *Simple and gentle picture*
(Tableau simple et doux) 1965,
collage with neon lighting tubes.
Collection A. Mongues, Paris
(146) *Elaine Sturtevant* 1968–9, acrylic paint
on canvas, neon lighting tubes, 160 x 96 cm.
Galerie Zwirner, Cologne, Germany
(217) untitled 1962, collage.
Dwan Gallery, New York

Richter, Gerhard
born 1932 Waltersdorf, Oberlausitz, Germany;
lives Düsseldorf, Germany
(17) *Emma – nude on a staircase*
(Emma – Akt auf einer Treppe) 1966,
oil on canvas, 200 x 130 cm.
Collection Ludwig, Cologne, Germany
(105) *Female student (Studentin)*
1967, oil on canvas, 105 x 95 cm.

Rivers, Larry
born 1923 New York; lives New York
(145) *Parts of the body* 1962, collage on paper,
30.5 x 25.5 cm. *Dwan Gallery, New York*

Rot, Diter
born 1930 Hannover, Germany;
lives Düsseldorf, Germany
(345) *Extended embryo (Gedehntes Embryo)* 1964,
48.5 x 47.5 cm. *Galerie Borgmann, Cologne, Germany*

Schad, Christian
born 1894 Miesbach, Oberbayern, Germany;
lives Keilberg bei Aschaffenburg, Germany
(118) *Self-portrait with model*
(Selbstbildnis mit Modell) 1927, oil on wood,
76 x 61.5 cm. *Collection Siegfried Poppe, Hamburg,*
Germany

Schlemmer, Oskar
born 1888 Stuttgart, Germany;
died 1943 Baden-Baden, Germany
(IV) *Entry into the stadium (Eingang zum Stadion)*
1930, oil on canvas, 162 x 97 cm.
Galerie der Stadt Stuttgart, Germany
(87) drawing of three youths with outstretched
arms, each one standing a little higher than

the one in front of him, 1929–30, pastels over
charcoal on transparent yellowish paper,
225×150 cm. *Staatsgalerie, Stuttgart, Germany*
(88) *Three figures (Drei Gestalten)* 1928,
pen and ink drawing, 28.5×22 cm.
Staatsgalerie, Stuttgart, Germany
(90) *Two swaying figures in counter-movement
(Zwei Schwingende in Gegenbewegung)* 1928,
pen and ink drawing, 28.5×22 cm.
Staatsgalerie, Stuttgart, Germany
(91) *Suspended kneeling figure
(Knieender in Schwebe)*
1928, pen and ink drawing, 28.5×22 cm.
Staatsgalerie, Stuttgart, Germany

Schröder-Sonnenstern, Friedrich
born 1892 Tilsit, Russia; lives Berlin
(II) *The brand mark of the moon culture
(Das Mondkulturschandmal)* 1960,
coloured chalk on cardboard, 71×53 cm.
Baukunst, Cologne, Germany

Schultze, Bernhard
born 1915 Schneidemühl, Germany;
lives Cologne, Germany
(194) *Orch* 1959, colour relief, polyester,
oil on canvas, 100×95 cm. *Daniel Cordier, Paris*
(195) *Green Migof (Grüner Migof)* 1963,
colour relief, polyester, oil, 115×90 cm.

Segal, George
born 1924 New York; lives New York
(115) *Legend of Lot* 1966, plaster of Paris,
274×243×182 cm. *Sidney Janis Gallery, New York*

Serra, Richard Antony
born 1939 San Francisco, USA; lives New York
(294) Object 1968, iron and lead, 250×43×25 cm.
(300) untitled 1968, iron and lead.
Gallery Ricke, Cologne, Germany

Smith, Tony
born 1912 Orange, New Jersey, USA;
lives South Orange, New Jersey, USA
(290) *Playground* 1966, wooden dummy
for a steel sculpture, 162.5×162.5×325 cm.
Fischbach Gallery, New York

Soto, Jesus Rafael
born 1923 Ciudad Bolivar, Venezuela, USA;
lives Paris

(234) *Black and white relationship
(Relation blanc et noir)* 1965. *Galerie Schmela,
Düsseldorf, Germany*

Stein, Dieter
born 1924 Würzburg, Germany, lives Würzburg
(VIII) *Composition (Komposition)* 1967,
oil on canvas, 45×35 cm. *Private collection*
(40) *Self-portrait with nude (Selbstporträt mit Akt)*
1966, pencil on paper, 31×22.5 cm.
Private collection
(58) *Nude* 1968, pen and ink drawing, 24×33 cm.
Private collection
(107) *Nude* 1969, ball-point pen on paper,
29.5×21 cm. *Private collection*

Sugarman, George
born 1912 New York; lives New York
(293) *Ritual place* 1964–5, painted wood,
127×168 cm. *Galerie Schmela, Düsseldorf, Germany*

Tajiri, Shinkichi
born 1923 Los Angeles, USA;
lives Baarlo, Holland
(282) *Granny's knot* 1968, polyester-fibreglass,
350×180 cm. *Artist's collection*

Takis
born 1925 Athens; lives Paris and London
(228) *Electromagnetic (Electro-magnétique)* 1964.
Galerie Iolas, Paris

Tanguy, Ives
born 1900 Paris; died 1955 Woodbury,
Connecticut, USA
(203) drawing 1935, pencil, 25×19 cm.
*Collection Lilo and Konrad Klapheck, Düsseldorf,
Germany*
(204) pen and ink drawing 1935, Indian ink.
Galerie Borgmann, Cologne, Germany

Tapiès, Antoni
born 1923 Barcelona, Spain; lives Barcelona
(335) *Collage* 1961, 65×69 cm.
Collection Heinz Simon, Würzburg, Germany
(340) *Rose tip (Bout de rose)* 1960
collage and drawing, 34×50 cm.
Collection Ursula Zwirner, Cologne, Germany

Tilson, Joe
born 1928 London; lives London

(216) *Secret* 1963, painted wood relief,
109.2x101.6 cm. *Marlborough Gallery, London*

Tinguely, Jean
born 1925 Basle, Switzerland; lives Paris
(50) *Stedelijk Fountain (Fontaine du Stedelijk)*
1968–9, felt pen on paper, 70x49 cm.
Galerie Borgmann, Cologne, Germany
(51) sculpture made from hosepipe 1966,
iron and rubber tubes, 160 cm. high.
Galerie Zwirner, Cologne, Germany
(52) sculpture made from machine, *c.* 1967, iron.
Galerie Iolas, Paris

Tobey, Marc
born 1890 Centerville, Wisconsin, USA;
lives Basle, Switzerland and Seattle, Washington,
USA
(264) *Space rose* 1959, tempera, 40x30 cm.
Galerie Jeanne Bucher, Paris
(310) *White lights* 1959, tempera, 32x25 cm.
Collection Frowein, Wuppertal, Germany

Toyen, Marie Cernisova
born 1902 Prague, Czechoslovakia; lives Paris
(60) pastel on paper, 1943, 49.8x34.8 cm.
*Collection Lilo and Konrad Klapheck, Düsseldorf,
Germany*

Twombly, Cy
born 1929 Lexington, Virginia, USA; lives Rome
(338) oil on cardboard and linen, 1957, 70x100 cm.
Collection A. O. Müller, Cologne, Germany
(339) drawing 1959, pencil on paper, 61x91 cm.
Private collection
(341) *Mars and Venus* 1962, pencil and coloured
pencil on paper, 50x70 cm. *Galerie Zwirner,
Cologne, Germany*

Uecker, Günther
born 1930 Wendorf, Mecklenburg, Germany;
lives Düsseldorf, Germany
(226) *New York dancer* 1966, kinetic,
nails in linen over metal, 183 cm. high.
Galerie Schmela, Düsseldorf, Germany
(260) *Nail-object (Nagelobjekt)* 1962,
nails, linen, wood, 60x52 cm.
Peggy Guggenheim Foundation, Venice, Italy
(304) *Nail-object (Nagelobjekt)* 1958, nails, wood,
20x47 cm. *Collection Graubner, Düsseldorf,
Germany*

Ursula, Schultze–Bluhm
born 1921 Mittenwald, Germany;
lives Cologne, Germany
(197) *Lirads labyrinth* 1921–63, 1963, pen and ink
drawing using Indian ink, 30x40 cm.
Private collection
(275) *Fur bird jewel case (Pelzvogelkasten)* 1968,
assemblage using fur and bird, 65x32x36 cm.
Collection Wolfgang Hahn, Cologne, Germany

Vasarely, Victor
born 1907 Pecs, Hungary; lives Annet-sur-Marne,
France
(303) *Bora III* 1958–62, tempera on cardboard,
38x39.5 cm. *Collection Dr Hans Hohkrämer,
Mühlheim/Ruhr, Germany*

Warhol, Andy
born 1930 Philadelphia, USA; lives New York
(28) *Elvis Presley* 1964, silk screen print on canvas,
206x148 cm. *Collection Ludwig, Cologne, Germany*
(29) *Marilyn Monroe* 1967, silk screen
print on canvas, 92x92 cm. *Collection Ludwig,
Cologne, Germany*
(125) *The kiss* 1965, film strips, silk screen print
on Plexiglass, 56x31 cm. *Collection Ströher,
Darmstadt, Germany*

Wesley, John
born 1928 Los Angeles, USA; lives New York
(140) *Captives* 1962, oil on canvas, 152.4x182.8 cm.
(141) *Six maidens* 1962, oil on canvas,
137x137 cm. *Elkon Gallery, New York*

Wesselmann, Tom
born 1931 Cincinnati, Ohio, USA;
lives New York
(147) drawing 1968, pencil, 60x75 cm.
Galerie Zwirner, Cologne, Germany
(148) drawing 1968, pencil, 60x75 cm.
Galerie Zwirner, Cologne, Germany
(153) drawing 1963, pencil on paper, 21x14 cm.
Collection Ströher, Darmstadt, Germany

Westerman, H. C.
born 1922 Los Angeles, USA;
lives Brookfield Center, Connecticut, USA
(181) *Rotting jet wing* 1967, glass, wood,
green material, 97x69x37 cm. *Galerie Borgmann,
Cologne, Germany*

Wols, Wolfgang Schulze
born 1913 Berlin; died 1951 Paris
(332) *Monstrum horrendum* 1945, gouache.
Collection Raymonde Cazenave, Paris

Wunderlich, Paul
born 1927 Berlin; lives Hamburg, Germany
(VI) *Leda and the swan (Leda und der Schwan)* 1966,
oil on canvas, 162 x 130 cm. *Galerie Brusberg,*
Hannover, Germany
(160) *Woman (Frau)* 1968, sprayed wood
92.5 x 92.5 cm., onyx on mahogany console

114 cm. high, total height: 205 cm.
Baukunst, Cologne, Germany
(164, 167, 168 and 169) *Self-explanatory*
(Qui s'explique) plates 6, 8, 10 and 11,
lithographs each measuring 61 x 43 cm.
Galerie Brusberg, Hannover, Germany

Zorio, Gilberto
born 1944 Andorno Micca, Italy; lives Turin, Italy
(266) *Fluorescent sponge (Spugna fluorescente)* 1968.
Galerie Sonnabend, Paris

Bibliography

Bayl, Friedrich
Der nackte Mensch in der Kunst (Cologne 1964)

Bellmer, Hans
Die Puppe (Berlin 1962)
Bilder-Lexikon der Erotik
vol. 1, *Kulturgeschichte* (Vienna and Leipzig 1928);
vol. 2, *Literatur und Kunst*
(Vienna and Leipzig 1929)

Brassai, Pierre
Conversations with Picasso (New York 1966,
London 1967)

Cowles, Fleur
The case of Salvador Dali (London 1959,
Boston 1960)

Dali, Salvador
Diary of a genius (New York 1965, London 1966)

Demarne, Pierre
'René Magritte', *Rhétorique*, No. 3,
September 1961

Davis, Douglas M.
'The New Eroticism', *Evergreen*, No. 58,
September 1968

Duca, Lo
Die Erotik in der Kunst (Munich 1965)

Freud, Sigmund
Introductory lectures on psycho-analysis
(eleventh impression, London 1968), ch. 10,
'Symbolism in Dreams'

Fuchs, Eduard
Geschichte der erotischen Kunst (Berlin 1908)

Gorsen, Peter
Das Bild Pygmalions, Kunstsoziologische Essays
(Hamburg 1969);
Das Prinzip Obszön (Hamburg 1969)

Hofmann, Werner
Henry Moore, Schriften und Skulpturen
(Frankfurt 1959)

Jean, Marcel
Geschichte des Surrealismus (Cologne 1959)

Klein, Yves
'Das Wahre wird Realität', *Zero 3*, 1961

Kronhausen, Eberhard and Phyllis
The first international exhibition of erotic art
(Lund 1968);
Erotic art (New York 1968, London 1971)

Léger, Fernand
Katalog der Kunsthalle (Baden-Baden 1967)

Magritte, René
Katalog des Museums Boymans van Beuningen
(Rotterdam 1967)

Magritte, René
Katalog der Kestner-Gesellschaft (Hannover 1969)

Mergen, Armand
Sexualforschung (Hamburg 1963)

Pierre, José
Konrad Klapheck (Cologne 1970)

Rembrandt, das graphische Werk
(Vienna 1968, second edition)

Schlemmer, Oskar
Briefe und Tagebücher (Munich 1958)

Stein, Gertrude
Picasso (London 1938, New York 1939)

Time April 1970, pp. 58–9, 'Beauty in the Bizarre'
(Paul Wunderlich)

Waldberg, Patrick
Surrealism (London 1965, New York 1965)